Frank Whitford
was born in 1941 and educated at
Wadham College, Oxford, the Courtauld Institute,
London and the Freie Universität, West Berlin. After a career
as a journalist and cartoonist, he taught at University College
London, and then in Cambridge, where he is still attached
to Wolfson College. Well known as a broadcaster and
lecturer, he was for many years Tutor in Cultural History at
the Royal College of Art, London. His other books include
Klimt and *Bauhaus* (also in the World of Art series); *Oskar
Kokoschka, A Life*; *Expressionist Paintings* and
the prize-winning *Japanese Prints
and Western Painters*.

Thames & Hudson world of art

This famous series
provides the widest available
range of illustrated books on art in all its aspects.
If you would like to receive a complete list
of titles in print please write to:
THAMES & HUDSON
181A High Holborn, London WC1V 7QX
In the United States please write to:
THAMES & HUDSON INC.
500 Fifth Avenue, New York, New York 10110

Printed in Singapore

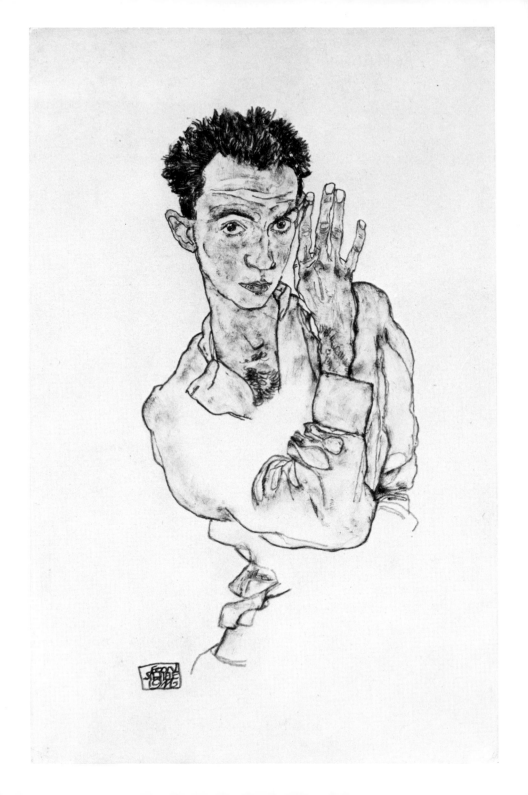

FRANK WHITFORD

EGON SCHIELE

151 illustrations, 20 in color

Thames & Hudson world of art

To Charlotte Lenz and Paul von Kodolitsch

1 *Frontispiece* Self-portrait for *Die Aktion*, 1916

© 1981 Thames & Hudson Ltd, London

Published in paperback in the United States of
America in 1986 by Thames & Hudson Inc.,
500 Fifth Avenue, New York, New York 10110

thamesandhudsonusa.com

Reprinted 2002

Library of Congress Catalog Card Number 85-52290
ISBN 0-500-20183-8

All Rights Reserved. No part of this publication
may be reproduced or transmitted in any form or
by any means, electronic or mechanical, including
photocopy, recording or any other information
storage and retrieval system, without prior
permission in writing from the publisher.

Printed and bound in Singapore by C.S. Graphics

Contents

Preface

Footnotes have no place in a book of this kind. While some readers may breathe a sigh of relief the author is faced with a problem. If he cannot acknowledge the sources of his information he risks creating the false impression that he has discovered everything for himself.

The bibliography lists my main sources. The monographs by Alessandra Comini and Erwin Mitsch were especially helpful. My major unpublished source is the wealth of material in the Egon Schiele Archive preserved in the Albertina, Vienna.

Soon after I had finished my labours in Viennese archives Professor Christian M. Nebehay's extensive and well-organized publication of Schiele documents appeared. It prints material from places to which I did not have access and puts forward many stimulating and fresh ideas about the artist, his work and its public reception.

Access to documents and indeed to original works by Schiele in private collections is anything but easy. There seems to be something about the artist that inspires in his admirers and collectors proprietory feelings, an exaggerated sense of self-importance and the conviction that although others have every right to be interested in Schiele they should not have the temerity to discuss him in print. Not only do many collectors deny access to what they own, they also do their best to prevent it from being reproduced. Thanks expressed here to those private collectors who have allowed drawings and paintings to be illustrated are therefore more than merely formal.

Heartfelt thanks are also due to the British Academy which provided a generous grant towards my research in Vienna. Professor Walter Koschatzky, director of the Albertina, gave permission to work through the Schiele Archive and to inspect the Albertina's collection of drawings, the best and largest anywhere. The staff of the Albertina, especially Herr Rudolf Bartl, proved extremely helpful. Dr Hans Bisanz of Vienna's City Museum assisted me in several ways as did Professor Georg Eisler, the painter and son of Hanns Eisler. He was the ideal guide to Vienna and to the monuments of Viennese

modernism. Many of the opinions expressed here derive from conversations with him. I have also gained much from talks with Dr Wolfgang Fischer and from his reading of the manuscript. A leading Schiele scholar, he has also done much as a dealer to make the artist known in Britain and America. He generously provided access to his own substantial archive and has allowed me to publish photographs from his collection, one of them for the first time. Dr Paul Joannides and Dr Edward Timms also read the manuscript and saved me from several blunders.

What follows is an attempt to make sense of the artist's life and work, to question the conventional notions about Schiele and to distinguish the reality from the powerful and tenacious myth that has done much to prevent a balanced interpretation and assessment of Schiele's paintings and drawings.

Serge (Siegfried) Sabarsky, one of the leading collectors of Schiele's work, has recently written that 'few artists need explanation less than Schiele . . . one can be overwhelmed by the starkness of the imagery or even shocked by it; but no explanation of a "message" is necessary, no analysis is required – the artist has said all he wants to say in his own clear language.' Only minor artists manage to say all they wish to and major artists frequently express things they did not intend to or were even unaware of. Schiele was a major artist whose work seems, at least to me, to benefit from interpretation. I hope that my readers will agree.

F.P.W. Great Wilbraham, Cambridge 1980

The City of Dreams

*How hideous it is here. . . . In Vienna there are shadows, the city is black,
everything is done by rote.*

From a letter to Anton Peschka, 1910

On 31 October 1918, the day on which Egon Schiele died in his
mother-in-law's house in Vienna, delegates were meeting elsewhere
in the city to cut a defeated giant down to size.

The Habsburg Empire, the Dual Monarchy of Austro-Hungary,
was about to be split into many parts and Vienna reduced to the role
of capital merely of the rump: the new Republic of Austria.

Unlike Schiele, who had caught a fatal dose of influenza only four
days before, the Habsburg Empire had been an unconscionable time
dying. In various forms it had been in existence for seven hundred
years and for something like the last hundred of them had been
terminally ill without knowing it.

The empire had been one of the largest and most heterogeneous on
earth. Even in 1914, restricted to a broad swathe of territory up
through Europe from the shores of the Adriatic to the Ukraine, it
encompassed vast territories and had a population of forty-six million
made up of a bewildering variety of nationalities, languages and
dialects. During the nineteenth century when the basic definition of
nationhood required the use of a common language, Austro-Hungary
was an anachronism.

The cracks which appeared after 1815, again during the 1848
revolutions in every part of the realm and yet again following the
country's defeat at the hands of Prussia and Italy in 1866, were not
repaired, merely papered over. By 1914, when the Empire, threatened
once more and even more seriously by nationalist aspirations, declared
war, the paper had worn transparently thin.

It is perhaps not surprising that many of the artists, writers and
intellectuals who grew up during the declining years of Habsburg
power – Schiele among them – were obsessed with change. Decay,

8

death and disaster seemed to haunt their every waking hour and to provide the substance of their nightmares.

The pre-eminent city of the realm was Vienna. It was the metropolis in which the Habsburgs held court, the magnet which attracted the brightest and the best. In 1900, with a population of more than two million, it was the fourth largest city in Europe. And less than half its inhabitants had been born there. All the languages of the Empire, from Rumanian to Romany, from Polish to Italian, could be heard on its streets. It was excitingly cosmopolitan, confident and energetic. It was, it firmly believed, the centre of the world.

Indeed, Vienna lay at the crossroads of Europe, was the link not merely between the East and West but also between the North and South. By train, Trieste and Venice could be reached as easily as Prague and Cracow. Berlin was no farther away than Paris. Even in its geographical position Vienna was singularly blessed. Touched by the Danube, it had beautiful, wooded country on its doorstep. It was there and in the rural suburbs on the edge of the city that the grapes were grown and most of the wine was drunk – in the innumerable wine lodges to which the Viennese repaired whenever they could. There they sang, talked and at the best time of the year enjoyed the new vintage, the *Heurigen*, prepared immediately fermentation was over.

Tales of the Vienna Woods, cloyingly sentimental songs about the *Heurigen*, prints and photographs of the elegant fiacres which plied for hire around the centre of the city are all essential components of that pleasant picture of the Habsburg capital which, reproduced in countless operettas, novels and books of memoirs, remained unfaded in the minds of those many émigrés driven out by Hitler. But this picture of the city is no more accurate than the description of the River Danube as blue. It is grey-green.

Scarcely more accurate is that other picture of Vienna as the laboratory in which the modern world took shape. This picture, in which every café bubbles with erudite conversation, in which every salon bursts at the seams with philosophers, physicists, psychoanalysts, provocative prose writers and revolutionary politicians has come to supplant the other, no more romantic picture of the city during the last years of Habsburg rule.

Any description of Viennese society is bound to be inexact. If we see Vienna now through the eyes of a cultured, articulate minority, we

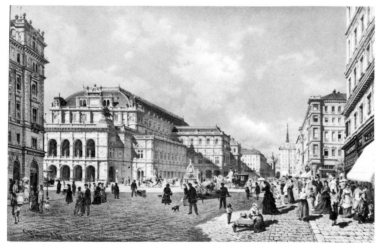

2 The Ringstrasse,
Vienna

do so not because that is the most objective picture we can achieve but
rather because it is the most detailed and lively picture available.

During the 1860s the Empire built a monument to itself in Vienna,
a symbol not only of its own anachronism but also of the romantic
longings of most of its inhabitants. This was the Ringstrasse, the broad,
horseshoe-shaped boulevard encircling the old city. But while the
Ring was partly designed for the most modern purpose – to facilitate
the dispersal of rioting mobs with grapeshot – the bombastic private
mansions and public buildings on it (the Parliament, for example, the
Opera, Theatre, Votive Church and the museums) were erected in
styles emptily mimicking those of past and genuinely glorious ages.
The Classicism was false, the Gothic mock and the Renaissance pseudo.
The imperial grandeur these buildings were meant to embody was
scarcely less superficial than their ornate façades; and even they were
covered not in real stucco but in cement moulded to look like it.

It is hardly surprising that so many of the artists, writers and intel-
lectuals who grew up during the years in which the Ring was being
developed came to nurture a hatred of all that was false and pretentious.

The Ring enclosed the old city as securely as the fortifications it
replaced had done. A labyrinth of narrow alleys fingering their way
from the cathedral to the royal palace and back again, touching noble
mansions, Baroque churches and elegant stores in between, old Vienna
was largely the province of aristocrats and the wealthy middle class, a
time capsule sealed against the outside world.

10

Out beyond the Ring were the suburbs which were steadily advancing into the surrounding countryside. This was where most of the ordinary people lived: the armies of petty bureaucrats who kept the ship of state afloat, the shop-keepers and factory workers, many of whom were immigrants in search of glittering prizes. During the second half of the nineteenth century the population of Vienna quadrupled and most of the increase came from immigration, the Czechs, Hungarians and Jews from the eastern part of the Empire attracted by the high wages that industry alone could offer. They were soon disillusioned. The city's slums, where most of them landed, were among the worst in Europe.

Vienna was not only the hub of the Empire. It was also one of the most exciting cultural centres on earth, envied for the quality of its theatre and music. Its relaxed way of life, its refusal to take the world too seriously, were legendary, especially in such foreign parts as Prussia where no one had ever learned to relax.

Abroad, Vienna also had the reputation of being naughty in the nicest possible way. Paris may have had better nightclubs and cabarets, Berlin may have catered better for those with more specialist tastes, but Vienna was famous for the availability and willingness of its girls. For many who had never been there, the thought of an evening in a *séparée* with a plump and merry young Viennese *mäderl* was more than enough to set the pulse racing. After all, had not the most suggestive dance known to man, the waltz, been invented in Vienna?

This view of Vienna was also superficial. Victorian moral rectitude was preached as loudly here as it was in every other European city, and people, especially male, were as energetic in their refusal to practise what was preached as in pretending to do so. Carefully educated middle-class daughters were closely guarded while their fathers were engineering themselves into a new affair or passing a few desperate minutes with a whore in a *séparée* or seedy hotel bedroom.

In the pre-penicillin age the problems which arose from this were not all spiritual. Stefan Zweig, a writer who grew up in Vienna during the declining years of the Empire, could not recall

a single comrade of my youth who did not come to see me with pale and troubled mien, one because he was ill or feared illness, another because he was being blackmailed because of an abortion, a third because he lacked the money to be cured without the knowledge of his family, the fourth because he did not know how to pay hush money to a waitress who claimed to have

had a child by him, the fifth because his wallet had been stolen in a brothel and he did not dare to go to the police.

While popular songs romanticized casual sexual liaisons and waxed lyrical about the pleasures of an evening in a *séparée*, a vociferous minority attacked the double standard in morality, dramatized the plight of the prostitute and saw a link between sexual hypocrisy and the contrast between appearance and reality at every level of public life. There was something rotten at the very core of society, they argued, and the epidemic of prostitution was merely one sign of it.

Something else which made Vienna unusual was the amount of serious thought given to human sexuality. Richard Krafft-Ebing, Otto Weininger and Sigmund Freud are only the most famous of those who investigated sexual behaviour in a scientific way. Frank Wedekind, Robert Musil and Arthur Schnitzler were only the most radical of those many writers who introduced sexual problems into their plays and novels.

But such scientists and writers were unpopular, for most Viennese preferred the image of a blue Danube, preferred the dream of a carefree, happy city, its inhabitants dancing the night away in Biedermeier ballrooms to the music of Lehár or Strauss.

This preference for the dream over reality at least partly explains the fanaticism for art and for the art of the theatre especially which touched all classes in Vienna. As Zweig remembered:

The Minister-President or the richest magnate could walk the streets of Vienna without anyone turning round, but a court actor or an opera singer was recognized by every shopgirl and cabdriver.... Every jubilee and every funeral of a great actor was turned into an event that overshadowed all political occurrences.

When modernism arrived in Vienna, it met with great hostility. For the modernists were determined to exploit the rift between dream and reality and to feed off the feelings of instability which every Viennese preferred to suppress.

In 1898, on the fiftieth anniversary of the Emperor Franz Josef's coronation, an exhibition of design and technology was staged in Vienna. A young architect, Adolf Loos, wrote a series of articles about it for the leading Viennese daily, the *Neue Freie Presse*. He was out-

3 Adolf Loos, Michaelerplatz building, Vienna
4 A 1911 cartoon commented: 'Brooding about art, the most modern man walks through the streets. Suddenly he stops transfixed. He has found that for which he has searched so long.'

raged. The philosophy behind contemporary design was based on lies, he argued, for everything was made to look like something else. Referring to the Russian general Potemkin who once erected entire villages in the Ukraine from cardboard and paper in order to convince the Empress Catherine that prosperity existed where there was none, Loos called Vienna a 'Potemkin city', a sham, pretending to be something it was not; and the Viennese equivalent of cardboard and paper houses was to be found on the Ringstrasse.

Such hatred of pretence characterizes most of Viennese modernism in every medium. Whether in architecture, painting, music or literature, it was the false, pretentious façade that had to be demolished in order to reveal the true structure beneath.

One of Loos's most famous designs was the house on the Michaeler- 3, 4
platz (1910–12) which occupies a corner site almost immediately opposite the city entrance to the imperial palace, the Hofburg. It contrasts starkly with the historicist structures all around it and was criticized at the time above all because it lacked cornices over its windows. It therefore became known as 'the house without eyebrows' and, for most Viennese, looked like a calculated insult, situated as it is, within spitting distance of the palace. With such a monstrosity on his doorstep the Emperor refused ever to leave the Hofburg by that route again.

Loos was a member of the circle of artists and writers grouped around another great enemy of sham and pretence. This was Karl Kraus, founder and publisher of the literary paper *Die Fackel* (The 5
Torch) which, after 1911, he also wrote single-handed. Like some Old Testament prophet, Kraus saw the evidence of hypocrisy all around

him and foresaw the ruin it would cause. He perceived this nowhere more clearly than in the state of the German language, bloated as it was with empty formal phrases and elaborate conceits signifying nothing. This was especially true of Viennese journalism, which Kraus saw as supporting the façade of corrupt bourgeois morals.

Linking himself with Loos, Kraus said:

> He literally and I grammatically have done nothing more than demonstrate that there is a distinction between an urn and a chamber pot and that it is this distinction above all that provides culture with elbow room. The others, those who fail to make this distinction, are divided into those who use the urn as a chamber pot and those who use the chamber pot as an urn.

According to Kraus, language is not merely a tool, a vehicle of expression, but an absolute standard which its users maltreat at their peril. Grammar is an ethical system and can only be used properly by those with a high moral sense. For Kraus, the decline of civilized values which was inevitably registered by a similar decline in language, had gone so far that it could no longer be halted. Vienna itself was a 'proving ground for world destruction' and *Die Letzten Tage der Menschheit* (*Last Days of Mankind*, Kraus's greatest work, an unstageable play of mammoth proportions about the corruption of the ruling class and the Great War, written in 1922) were not far away.

A belief in imminent doom and destruction obsessed many writers of the period, not only in Vienna but throughout the Empire. The Salzburg poet Georg Trakl, for whom Vienna was a city 'in which lives a putrefied species cold and evil', conjured up apocalyptic visions in his verse. The artist Alfred Kubin, born in Bohemia, described in his only novel, *Die andere Seite* (*The Other Side*) of 1907, a utopia gone wrong which comes to an end in scenes of terrifying destruction. This extraordinary work has been compared in its power and atmosphere

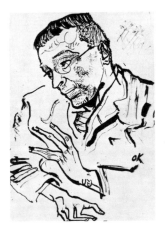

5 Oskar Kokoschka, *Karl Kraus*, c.1910

to the novels and short stories of Franz Kafka who, in Prague, was also inventing memorable symbols for the decline of the traditional way of understanding the world.

Martin Buber, the Jewish scholar, working in Vienna at the time, drew attention to the number of contemporary writers whose major theme was death. He quoted the words of one of them, Schnitzler, who considered that 'they are surrounded by an intimation of the end of their world . . . the end of their world is near'.

Born in 1862, Schnitzler was the son of a professor of laryngology at Vienna University. Schnitzler, too, became a physician, specializing at first in skin diseases and then, significantly, in hypnosis and the relationship between physical disorders and the mind. Even though he came to concentrate on writing he never abandoned medicine entirely.

In his plays and stories old beliefs and standards are subtly questioned and undermined. In *Der Reigen* (1900), for example (usually translated into English with the title *La Ronde*), which presents a series of ten casual sexual encounters between people of different stations and professions, love is shorn of all glamour, reduced to an expression of urgent sexual need just as all the characters are reduced to the single common denominator, the desire for immediate gratification.

Schnitzler's short story *Leutnant Gustl* (1900) was radical in style as well as attitude. The first successful use in German of a stream-of-consciousness technique, it questions conventional ideas of honour and presents a convincing picture of one man's most private thoughts. Its exposure of the emptiness of the military code caused trouble. The authorities withdrew from Schnitzler the rank of officer of the reserve.

The public was even more outraged by the dramas of Frank Wedekind, whose works lack Schnitzler's brittle cynicism and frothy humour. Consciously employing sensational subjects, Wedekind shows sex, or rather hypocritical attitudes to it, to be a mercilessly destructive force. Although not Viennese – he was born in Hanover and spent most of his life in Germany – Wedekind was well-known to Kraus and his circle which was largely responsible for establishing his reputation in Vienna.

In *Frühlings Erwachen* (*Spring's Awakening*), written in 1891 but not performed until 1906 because it was considered obscene, the action points to the hollow romanticism of the title. It presents the story of a schoolboy who makes an adolescent girl pregnant. She dies after her

parents take her to an abortionist and he considers committing suicide. In his two plays about the irresistible sex goddess Lulu, *Der Erdgeist* (*Earth Spirit*) and *Die Büchse der Pandora* (*Pandora's Box*) of 1892–4, Wedekind shows men caught between consuming lust and rigid social conventions, and ruined by both.

Kraus gave an introductory lecture to *Pandora's Box*, later published in the *Fackel*. 'All the whims of naturalism are as though blown away', he wrote. 'What lies within and behind human beings is again more important than the speech impediments they have. They deliver once again – one hardly dares to say it – monologues. Even when they are not alone on stage.'

The novelist Musil also examined the inner lives of his characters, emphasizing above all the importance of sexuality as a motivating force. His early semi-autobiographical novella, *Die Verwirrungen des Zöglings Törless* (*Young Törless*) of 1906, which concerns the spiritual growth of a young cadet at military college in one of the most distant parts of the Empire, is incisive in its presentation of the young man's thoughts, of his confusion caused by the difference between what he is told and what he feels to be true, of his growing awareness of his sexual drive and of the way in which the weak are persecuted by the strong. Like Wedekind, Musil did not shrink from mentioning distasteful facts by name. *Young Törless* contains scenes of explicit homosexual activity, in which desire and revulsion are combined.

The battle for a more honest approach to sexuality was also being
6 fought in laboratories and consulting rooms. Freud had already made his name and a number of enemies with two pioneering works: *Studien über Hysterie* (*Studies in Hysteria*) of 1895 and *Die Traumdeutung* (*The Interpretation of Dreams*) of 1900. He was an admirer of Schnitzler, his interest having been aroused by the affinity which he perceived between his own investigations of the subconscious mind and Schnitzler's convincing descriptions of the way people truly think rather than the way in which writers had previously made them seem to think. On Schnitzler's fiftieth birthday Freud described him as a 'colleague' who was also examining the 'underestimated and much-maligned erotic' which Freud had come to see as one of the most important triggers of human motivation.

In his own way Freud was as successful a destroyer of the façade as Loos or Kraus. Abandoning all conventional definitions of personality, he uncovered layer after layer of pretence and delusion, finally arriving

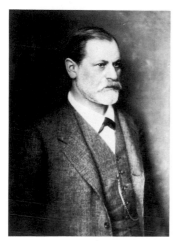

6 Sigmund Freud in 1912

at the subconscious where, he believed, the root of all decisions and actions could be found.

What ruled the subconscious for Freud was the libido, the desire for sexual gratification which is present even in infant children and which, if repressed, leads to incalculable problems and psychic damage. In proposing this shocking theory, Freud was announcing the end of the old order and at the same time establishing the framework for a new order, for a way of looking at the world that is fundamentally still our own.

The libido as a vital part of the human personality fascinated not only Freud. His near-contemporary Krafft-Ebing, whose important *Psychopathia sexualis* had been published in 1886, specialized in sexual disorders and perversions, while the younger Weininger attempted to develop a theory of personality based on the belief in the continual conflict between male and female principles present in everyone. Weininger committed suicide (in the house where Beethoven also died) at the age of twenty-three in 1903 soon after his book *Geschlecht und Charakter* (*Sex and Character*), although widely read, had been dismissed unfairly as a plagiarism of Freud.

The imminent collapse of a comfortable, self-satisfied world was meanwhile being prophesied by philosophers such as Ernst Mach and Ludwig Wittgenstein (who, like Kraus, was obsessed with language). Composers such as Arnold Schoenberg and his disciples Alban Berg and Anton von Webern were reformulating the principles of musical

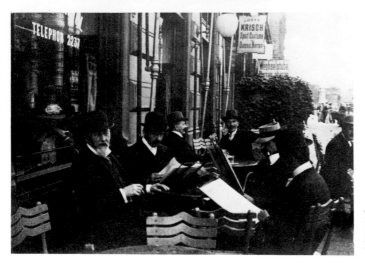

7 Otto Wagner, Josef
Hoffmann and Koloman
Moser at a café in
Vienna, c.1912

composition so dramatically that their critics thought that they had
destroyed them all. And revolutionaries of another kind – Adolf
Hitler, Theodor Herzl, Josef Stalin and Leon Trotsky – were all in
Vienna at the same time working out their various theories in different
cafés.

To their enemies (and they had many) all the modernists seemed to
present a united front. It still surprises to learn how close they were and
how much they learned of and from each other's disciplines. Thanks
7 largely to the café, the Viennese version of the London club, to the
salons of wealthy and cultivated people, and to the incestuous nature
of much Viennese intellectual life, many of them lived virtually in
each other's pockets. Freud saw affinities in Schnitzler. Musil sought
in his writing to incorporate the relativist theories of Ernst Mach, the
physicist on whom he had written his doctorate before turning to
literature. Weininger's book influenced the painter Oskar Kokoschka
who also wrote poetry and plays. The composer Gustav Mahler
brought his psychological problems to Freud. Kraus was an intimate
of Loos.

Such intimacy with and sympathy for the problems of others may
explain why so many of Vienna's modernists tried their hands at
disciplines other than their own. Freud was so interested in art that he
wrote a study of Leonardo. Schoenberg learned to paint, exhibiting
with the *Blaue Reiter* group in Munich, and his teacher was the brilliant
but disturbed young Richard Gerstl, who introduced a new kind of
8 portraiture to Vienna during his brief career. Kokoschka's plays

18

belong to the Expressionist literary canon. Ludwig Wittgenstein designed a house for his sister, and its clear geometric forms and lack of decoration seem even more radical than anything by Loos. Even Egon Schiele took himself seriously as a poet and aphorist.

This extraordinary sense of unity was strengthened by their belief that, in the eyes of the general public, all the modernists were tarred with the same brush. This was more a comfort than a curse, for they liked to think that Vienna always treated its great men badly and that public rejection was consequently almost a guarantee of artistic importance. The cultural history of nineteenth-century Vienna was littered with the wreckage of intellectual and artistic giants who apparently had been destroyed by an uncomprehending public. The case of Franz Schubert was as tragic as that of the physician Ignaz Semmelweis who had died in a lunatic asylum in 1865, fifteen years after discovering the cause of puerperal fever, a discovery that was discredited by his colleagues for selfish and political reasons.

Modernism in the visual arts in Vienna shares much, as we might expect, with modernism in other fields. Architects and designers, in fact, were some of the prime movers behind the organization in which for a time all modernist artists came together in Vienna. This was the *Vereinigung bildender Künstler Österreichs* (the Austrian Association of Visual Artists), which also called itself the Secession, borrowing the name from a similar exhibiting body in Munich.

8 Oskar Kokoschka, illustration for his play, *Mörder, Hoffnung der Frauen*, performed at the 1908 *Kunstschau*

Like its Munich equivalent, the Vienna Secession (whose first exhibition opened in March 1898) wanted to give artists with advanced ideas an opportunity to show their work in public denied them by the only existing, and highly conservative exhibiting organization, the *Genossenschaft bildender Künstler* (the Association of Visual Artists), which had almost all the established artists of Vienna as its members and owned the only exhibition building in the city, the *Künstlerhaus* (Artists' house). The Secession also wanted to educate and inform a public which, not without reason, it considered insular and ignorant. It therefore planned to show the work not only of Viennese artists but also of foreigners who also espoused advanced ideas.

No such foreign work had ever been shown in Vienna. There was widespread ignorance of what had been produced by the most exciting artists in France, to say nothing of developments in England, Germany and the Low Countries. Few people had even heard of Manet, let alone of Gauguin, Seurat and Van Gogh.

That the public could become interested in such things, that not all modernism was anathema, was proved by the unexpected success of the first Secession exhibition. It made so much money that the organization immediately made plans for a building of its own which, designed by Josef Maria Olbrich, one of the instigators of the Secession, housed all its future shows. It was nicknamed the *Krauthappel* or 'cabbage head'.

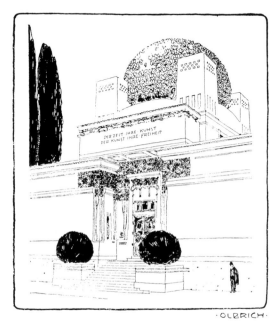

9 Josef Maria Olbrich, *Vienna Secession Building*, 1898

The Secession's early exhibitions were not as radical as all that. Among the many foreign artists invited to show at the first exhibition, for example, were such relatively conservative figures as Arnold Böcklin, Franz von Stuck and Fernand Khnopff, and the most advanced of the Secessionists worked in the already fashionable Art Nouveau style, known as *Jugendstil* in Germany and soon to be called *Sezessionsstil* in Austria because the Secession came so quickly to be identified with it.

The second exhibition concentrated on the applied arts, an important Art Nouveau concern, seeking to catch up with developments elsewhere, and especially in England, where the influence of the Arts and Crafts Movement had been strong for some time. Later exhibitions were much more adventurous and did introduce the Viennese public to the work of the best Post-Impressionist painters. Thanks to the Secession, an important landscape by Vincent van Gogh passed into a Viennese public collection as early as 1903.

The first president of the Secession was Gustav Klimt – an excellent choice, for his attitudes and achievements were typical of those of many of his fellow members. As we shall see, Klimt's work also came to embody many of the most important qualities of Viennese modernism in general.

Born in 1862, Klimt hovered between two styles: a kind of soft-focus Impressionism which he used in portraits and an altogether harder, more decorative approach, related to both Symbolism and Art Nouveau, which he brought to his imaginative compositions.

In such compositions he began to experiment with a variety of decorative materials, applying, for example, gold and silver leaf to the painted surfaces. Clearly, Klimt saw himself as a decorator as well as a painter, but his ambitions in this direction suffered a setback when work commissioned by Vienna University for the ceiling of its great hall and first shown at the Secession caused a major scandal and was rejected by the authorities. This was partly because Klimt had seen fit to symbolize Philosophy, Medicine and Jurisprudence in a highly personal and obscure way with much use of the female nude, partly because the pubic hair of many of these nudes was visible and partly because he consciously introduced ugliness as a means of expression.

This humbling clash with the authorities turned Klimt in upon himself and into a modernist artist who disregarded the wishes of the public in favour of the cultivation of a highly personal style.

10 Gustav Klimt, 1912/14

11 Gustav Klimt, *Adele Bloch–Bauer*, 1907

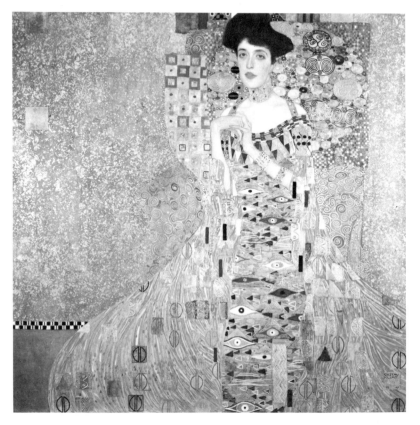

The introduction of personal symbolism, combined as it was with rich decoration and unusual compositional schemes, marks a significant shift in Klimt's development. Rich areas of pattern, some of them 11 derived from Byzantine and exotic sources, appeared in his portraits of women, transforming them almost into secular icons, their physical beauty enhanced by the intricacy of abstract motifs. It was an irresistible mixture, and Klimt quickly became Vienna's leading portraitist of society ladies.

By 1904 the Secession had virtually split into two groups: one, led by Klimt, determined to stress the importance of the applied arts, the other, whose leader was Klimt's successor as president, Josef Engelhart, equally determined to concentrate on 'pure' painting.

In 1905 the Klimt group, convinced that the Secession was being taken over by mediocre talents, resigned as a body and left the Secession so weak that it never managed to repeat the successes of its early years. The future of Viennese modernism was now firmly in the hands of Klimt and his friends: in the Wiener Werkstätte, the 12 craft workshops founded by two of them, Koloman Moser and Josef Hoffmann, and in the increasingly exciting painting and designs of Klimt himself.

12 Wiener Werkstätte signet, c. 1905

Klimt's portraits provide a perfect picture of society in the declining years of Habsburg Vienna – not least because their style is so rhetorical and, ultimately, superficial. They show people trapped within a web of precious substances and highly sophisticated decoration. There is always a conflict between the necessarily realistic way in which Klimt painted their hands and faces and the clever patterns which surround them. He could not reconcile the demands of reality and the seductions of art for art's sake. The result is that same quality of unease which we find in the work of writers of the same period.

When true modernism arrived in Viennese painting it owed much to Klimt, fastened on to the conflict between artifice and reality and dramatized it to the point of torment. Kokoschka, who stripped away the façade in his portraits to reveal the personality beneath, worked for the Wiener Werkstätte and first achieved notoriety when he showed his work at an exhibition organized by Klimt and his group. Schiele, in many ways as radical as Kokoschka, was even more indebted to Klimt who encouraged him, found him patrons and gave him the chance to exhibit. Schiele, much more than Kokoschka, owed his early style to Klimt and throughout his brief life took Klimt's subjects and elements of his style and attempted to transform them into something new, something more powerfully expressive. It is in Schiele's work that so many of the concerns which characterize Viennese modernism in literature and which are only hinted at in Klimt's painting come completely to the surface in the visual arts: the obsession with death and decay, the penetration of appearances and façades to investigate the darker side of the human personality, and the curiosity about sex.

Klimt remained fascinated by the dream. In Schiele it has become a waking nightmare. In Klimt we find the seductive smile. In Schiele it becomes a cry of anguish, a grimace caused by mental and physical unease, hopeless responses to an uncertain and unstable world of which the artist is an impotent and unwilling victim.

In an incomprehensible and uncomprehending world, Schiele retreats not so much into aestheticism as into himself, weaving fantasies about his inner life and drawing sustenance from them. But his encounter with the self, however glamourized or otherwise imagined, proved even more horrifying than the confrontation with the outside world. Significantly, masochism provided a temporary solution to the problem. The artist came to glory in his own distress and presented himself to the public as a tormented martyr. Equally significantly, this dramatization of the artist's own distress found an echo in the minds of at least a limited public. Schiele's art mirrored something, dimly apprehended, that had wormed its way into their brains. It was a specific quality of unease, a suspicion that the dividing line between sanity and madness is exceedingly narrow, a conviction that we are all rapacious animals beneath the skin, a sense of decline and mortality in all things. Schiele's art proved and proves so fascinating because it gave and gives coherent form to so many fears.

During his lifetime Schiele was often described as an Expressionist and the word has commonly been used of his work. With Kokoschka he is conventionally seen as the most brilliant Viennese exponent of that highly subjective, emotional and visionary style which appeared in Central European and especially German art around 1910.

Schiele does indeed share much with Kokoschka and with German artists such as Ernst Ludwig Kirchner, Emil Nolde and Ludwig Meidner, for whom the external world was to varying degrees like a mirror in which a distorted image of their emotional life was reflected. Like them, Schiele employed the self-portrait as a major vehicle for the expression of exaggerated and sometimes abnormal feelings. Like them, Schiele used heightened unnatural colour and bold graphic devices in order to provoke a strong emotional response. Like them, he believed that art should be primarily about feelings and that the pictorial means should be bent to express them forcefully: it is not how but what one paints that matters.

Schiele's work cannot, however, be described as Expressionist in every sense. In spite of his eloquently distorted line, bold colour, pronounced subjectivity and essentially pessimistic vision, there is always a control and discipline and a refined aesthetic sense that are at variance with the Expressionist wilful disregard of most if not all artistic conventions.

The preciosity inherited from Klimt, the refined feeling for the rightness of a composition, the calculated way in which figure is made to relate to ground are all present to a remarkable degree in Schiele's work. It is this conscious and even intellectual concern for the appearance of a painting or drawing as well as for what it says which ultimately disqualifies Schiele from a place in the Expressionist ranks.

It is also often thought that Schiele had no public, that he was an artist universally misunderstood, rejected and reviled during his lifetime. This belief was held not only by Schiele himself but also, paradoxically, by the various people who bought his work and assured him of a tolerable living. Schiele and his public wanted to believe in the myth of the artist as someone who creates his best work out of misery and deprivation. Together they conspired to demonstrate that the myth was true. But, as in the case of Vienna itself, we must search for the reality elsewhere.

Childhood and youth 1890-1909

Have adults forgotten how . . . sexually stimulated and excited they were themselves as children?

Arthur Roessler ed., *Egon Schiele im Gefängnis*, 1922

In view of his family circumstances it is surprising that Schiele at no time wished to become an engine driver. His father was in charge of an important station. One of his grandfathers was a railway builder of genius. His uncle (who was also his godfather and, later, his guardian) was also a railway engineer. His elder sister, Melanie, worked all her adult life for the railways and married a railway executive.

13 Schiele was born at his father's station in Tulln on the River Danube on 12 June 1890 and spent his childhood there. Tulln, about nineteen miles to the west of Vienna, was on one of the busiest lines in the Austro-Hungarian Empire.

Schiele wished only to become an artist, and a prodigious talent for drawing revealed itself when he was very young. This talent seemed to come from his grandfather and father, both of whom were keen amateur draughtsmen.

Years later, Schiele's mother, reminiscing about her son's childhood in an interview with a Viennese newspaper, claimed that he had begun to draw before he was two years old and had spent most of his early life with a pencil and paper in his hand. 'Once when he was seven,'

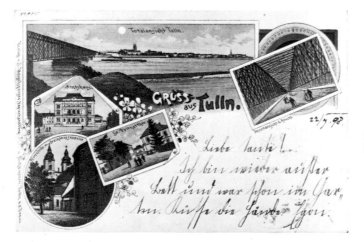

13 Postcard of Tulln from Schiele to his aunt, 1898

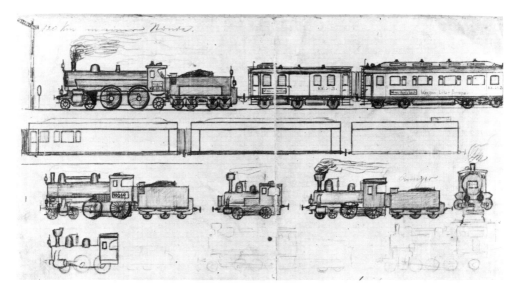

14 Drawing of trains, c.1898

she remembered, 'he sat himself down on a window ledge from
morning until evening and filled a thick book with drawings, setting
down on paper all the trains, the lively and varied activity of the
station, the tracks, the signals and so on.' Several such drawings still
exist.

14

Schiele's father, Adolf, was proud of his position. Although he
tended to live above his means (Schiele later believed he had a right
to do the same) he was, as a civil servant, assured of a secure future
and could provide his family with a comfortable, middle-class life.
There were hundreds of thousands of such families in the Habsburg
Empire: moderately well-off, concerned for appearances, narrow-
minded and incapable of imagining a different world.

Except for a single reference to it in the *Nibelungenlied* and for the
fact that Schiele was born there, Tulln was, and is, entirely without
distinction. It did not even have a secondary school so, in 1901, Schiele
was sent to live with relatives in the nearby town of Krems. But a year
later Schiele changed schools, moving to the town of Klosterneuburg
on the northern outskirts of Vienna. Towards the end of 1904 the
rest of the Schiele family which included Egon's two sisters also

moved there. The reason for this was the increasingly eccentric behaviour of Schiele's father which had forced an early retirement and soon deteriorated into certifiable madness. Schiele's father died in 1905 at the age of fifty-four after, it is said, throwing all his stocks and bonds on the fire.

Egon was fifteen. As his younger sister, Gertrude (Gerti), remembered:

Adolf Schiele died during a stormy December night. Egon, who had gone out into the meadow to draw during the previous day, something he always did when he was depressed . . . entered the room in which his father was laid out in the dress uniform of a high railway official – a dagger was part of it – and sat down quietly in a corner. He loved his father very much and expressed his love in his own way.

It has been suggested that the cause of both the madness and the death was syphilis, a disease which Adolf Schiele had allegedly contracted before his marriage and had kept secret from his wife. Although the couple's first two children were still-born and although their next child, a daughter called Elvira, had died of encephalitis when she was ten, there is no real evidence that venereal disease was the cause of it all.

The loss of his father had a profound effect on Schiele's personality. There are striking similarities between Schiele's family circumstances and those of Edvard Munch, an artist who later impressed Schiele

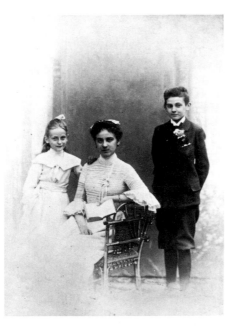

15 Schiele with his mother and sister Gerti, c.1903

deeply, and whose art was profoundly affected by the deaths and sickness in his immediate family. Although in Schiele's case the connection is not as clear, as he grew up he thought of his father often and once believed that he had been visited by his ghost. In 1913 he wrote to his brother-in-law:

I don't know whether there's anyone else at all who remembers my noble father with such sadness. I don't know who is able to understand why I visit those places where my father used to be and where I can feel the pain. . . . I believe in the immortality of all creatures. . . . Why do I paint graves and many similar things? – because this continues to live on in me.

Schiele's increasingly cool relationship with his mother was also due in part to her real or imagined neglect of her husband's memory. He never ceased to harbour this resentment, and she wrote to relatives from time to time complaining of his behaviour. 'I wouldn't have any sympathy for the ruffian,' her sister replied to one of these complaints, 'a boy must learn and behave himself . . . only useful people make anything of their lives.' Schiele also complained about his mother. As he later told his biographer, the art critic Arthur Roessler: 'My mother is a very strange woman . . . she doesn't understand me in the least and doesn't love me much, either. If she had either love or understanding she would be more prepared to make sacrifices.'

Schiele's relationship with Gerti was especially close and not without erotic implications. As an adolescent she regularly posed for him naked. When he was sixteen and she no more than twelve, he had the extraordinary idea of taking her by train all the way to Trieste where they spent the night in a double room at an hotel. He had chosen the destination because it was where their parents had spent their honeymoon.

Schiele's parents were not happy about this relationship. Once, Adolf Schiele became aware that Egon and Gerti had locked themselves into a room. Fearing the worst, and perhaps with reason, he broke down the door to discover them both innocently developing a film, for Egon had become a keen photographer. 'Have adults forgotten', Schiele wrote later, 'how depraved, i.e. how sexually stimulated and excited, they were themselves as children? Have they forgotten how the terrible passion burned within them and tortured them when they were still children? I have never forgotten it, for I suffered from it dreadfully.'

Adolf was also alarmed by his son's unusual talent. He wanted Egon to follow in his footsteps and work in some capacity for the State where there was security and respect. Schiele's godfather, Leopold Czihaczek, who became his guardian after his father's death, was even more determined that the boy should be discouraged from his artistic ambitions. Czihaczek was more eminent in the railway business than Adolf Schiele, his brother-in-law. He was also better-off and much more interested in music than the visual arts. Czihaczek was distressed by his ward's performance at school, for Schiele was constantly feeble in all subjects except art and gymnastics.

Schiele was probably not a pleasant child. He was certainly intensely lonely and withdrawn, fonder of daydreams than mundane reality and convinced that he was generally disliked and misunderstood. As he wrote in about 1910 of his years in school: 'I came into endless and apparently dead towns and grieved. . . . My coarse teachers were always enemies. They – and others – did not understand me.'

He did, however, have allies both in and out of school in Klosterneuburg. One of them was the art teacher who began to work there in 1905. This was Ludwig Karl Strauch who, apart from having studied at no less a place than the Academy of Fine Arts in Vienna, had led a highly colourful life, fighting with the Boers in South Africa and travelling to such distant parts as India and the Far East.

The extent of Strauch's influence on Schiele is disputed. The teacher later claimed that he had tried to introduce his pupil to a more adventurous use of colour, while Schiele later accused Strauch of having done his best to stamp out his individuality. Certainly the teacher recognized his pupil's enormous talent and even allowed him the use of his studio at home. Whatever the precise nature of the relationship, Schiele produced some noteworthy work at Klosterneuburg. A watercolour drawing of the town seen from the school art room and made under Strauch's supervision is remarkable for a fifteen- or sixteen-year-old.

Strauch later remembered:

[Schiele] was always outside on the meadows, on the slopes, by the brooks and covered page after page with his impressions of nature, mostly in pastel. He drew quietly and without pausing as though nothing existed but nature, his pencil and drawing paper. His thin, earnest face, his earnest eyes were immovable. His black mane of hair was combed back on to his collar. He

was a strangely quiet lad, rather mannered in the way he intertwined his long hands. . . . Among his relatives he was considered a prodigy.

Strauch was probably instrumental in persuading Schiele's mother and, through her, his guardian, to have the boy leave school early and apply for a place at an art school. Egon took his work, mostly portraits of the family, to the School of Arts and Crafts, the Kunstgewerbe-schule, in Vienna, which at the time had a reputation as great as that of its grander sounding rival, the Academy of Fine Arts, which was the oldest art school in Central Europe. Klimt had studied there and in 1906 Kokoschka, soon to become the most notorious of younger Viennese artists, was still in the middle of his studies at the same place. Schiele would eventually compete with him for the leadership of the modernist faction in the capital.

16 *Klosterneuburg*, 1906

17 *Self-portrait*, 1906

But Schiele did not go to the Kunstgewerbeschule. The professors there were apparently so impressed with his work that they told his mother to enter him for the Academy. This advice appears to reflect an altruism and a belief in the superiority of a rival institution that are most unusual in teachers of any subject. It is easier to believe that they saw signs in the young man of a troublesome student and so wished him on the opposition.

Schiele passed the entrance examination to the Academy and began to study there in the autumn of 1906. If another candidate who presented himself for the same examination a few months earlier had also been successful, Schiele might have shared a studio with Adolf Hitler.

When Schiele enrolled at the Academy he was only sixteen. He lived in Vienna, coming to the metropolis after a childhood spent entirely in provincial towns. He may have had a room in his guardian's house in the Zirkusgasse, one of the better streets in the poor and ghetto-like Leopoldstadt District, walking daily to the Academy which is on the Schillerplatz not far away and close to the Kunsthistorisches Museum. Schiele did not care for his uncle, and Czihaczek had little time for his nephew, although he rarely refused a request for a loan

18

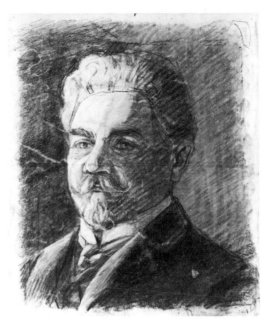

18 *The artist's guardian*, 1906

and, to judge from the number of drawings Schiele made of him, willingly sat for his portrait.

Information about this period of Schiele's life is scanty. Much later, his aunt told a newspaper reporter everything she could remember, which does not amount to very much. He sold 'landscapes in oils to Summer guests at Steinach am Brenner', where he went with the Czihaczeks on holiday and, more significantly, once 'painted the dead child of a local shopkeeper. Egon painted it on its bier. It was a sensation.'

The biographies of almost all modern artists make it seem inevitable, even vitally necessary, that the young genius should quickly fall out with his teachers, realizing that his own unconventional gifts are incompatible with the reactionary instruction he receives. Certainly the Academy curriculum seems old-fashioned now, but at the time there was scarcely an art school in the world that did not offer the same instruction: copying from the Antique, drawing from life, composition, anatomy and perspective – all hard work within a rigidly imposed pattern. If the student wished to experiment or to use his imagination, then there was always his free time.

Schiele eventually did revolt against such hide-bound teaching, but he at first buckled down with a will. Many of his monochrome

33

Academy drawings have survived: studies in pencil and charcoal, sometimes on dark paper and heightened with white. They are highly competent but no more, a judgment shared by his teachers who rarely gave him a grade better than 'satisfactory' for such things. There is no hint in them of the slightest desire to treat a conventional exercise in an original way.

It might seem strange that little more than a faint spark of Schiele's prodigious gifts as a draughtsman can be seen in the Academy drawings. This may be because he was becoming increasingly interested in painting but was not allowed to paint at the Academy. For the first three years students were only allowed to draw prescribed subjects. So Schiele concentrated on painting landscapes whenever he could and came merely to fulfil his obligations at the Academy. These early landscapes, such as the view of Trieste harbour, are lively and fresh, quite different from his monochrome work.

Schiele's main teacher was Professor Christian Griepenkerl. He was extremely old-fashioned, renowned in Vienna for his portraits, history paintings and murals. A professor at the Academy since 1874, Griepenkerl specialized in subjects which, according to the Thieme-Becker lexicon of artists, 'were allegorical and used Classical mythology

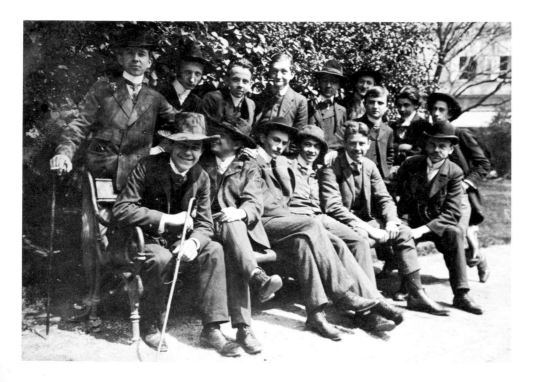

as was customary around the middle of the nineteenth century. . . . The substance of his teaching consisted of a thorough treatment of technical matters.'

Griepenkerl was regularly alarmed by any signs of wayward originality in his pupils. This alarm may be partly explained by the fact that he had recently taught Gerstl, an extraordinary young man of truly frightening ability who had committed suicide after an abortive affair with the wife of the composer Schoenberg; to make matters worse, Gerstl's style seemed to pay no attention to those standards of technical excellence which Griepenkerl emphasized so much.

Schiele and Griepenkerl did not get on. On one occasion the teacher is alleged to have said to his pupil: 'The devil has shat you into my classroom!'; and on another: 'For God's sake don't tell anyone that I was your teacher!' But Schiele was not the only student to feel the sharp edge of his teacher's tongue. He was one of a sizeable group increasingly dissatisfied with the kind of instruction it was receiving.

In 1906 when Schiele came to Vienna from the provinces the Secession had long since established itself as the leading exhibiting organization in the city, but was still reeling from the decision of Klimt and his friends to resign from it. To those Viennese with a liberal cast of mind, and to art students in search of exemplars other than those praised by their teachers, Klimt represented everything that was best in modern painting. For the teaching staff at the Academy his work was a flash in the pan, a momentary aberration interrupting the development of true art. Students were consequently advised to have nothing to do with Klimt, or indeed with the Secession, and Griepenkerl is said to have forbidden visits to Secession exhibitions. This merely made them seem more attractive and exciting.

Schiele began to infiltrate the circle around Klimt and it was probably as early as 1907 that he succeeded in meeting him. Given the Viennese café society of that time this was not difficult.

The café was, arguably, the city's finest social and cultural achievement. It provided an extension of one's own living-room with the addition of service, a full range of national and foreign newspapers and magazines and frequently billiards as well. One could have post addressed to one's café and eat and drink there for weeks on end on credit. Each café was known for and proud of a particular kind of clientele which gave the café its character, and most of the cafés in the city centre could boast at least one regular guest especially eminent in

35

19 Academy class, Schillerplatz, Vienna, June 1907. Schiele is in the back row, second from the right

his field. If you wished to move in literary circles, for example, and meet Kraus or the leader of the *Jung Wien* group of writers, Hermann Bahr, then you only had to visit the appropriate café and wait for the appropriate moment to introduce yourself. If you wished to meet Klimt or any of the artists associated with him, then you went to the Museum Café, close to the Secession building itself.

The Museum Café was a remarkable place, not least because it had been designed inside and out by Loos. In keeping with his radical ideas about decoration it was suitably plain, even spartan in appearance, a fact which had earned it the nickname 'Café Nihilism'.

It was probably there that Schiele first met Klimt. He was as impressed by the man as he had been by his work, and Klimt, it is said, was also impressed by Schiele. On his first visit to the master's studio Schiele took some drawings with him and asked whether he had talent. 'Yes,' Klimt replied ambiguously, 'much too much!' Schiele may well have been too talented for his own good, may have found drawing too easy. And the obtrusive and self-indulgent mannerisms in much of his work suggest that he was never entirely successful at coping with this.

20
21
22

Klimt's effect on Schiele is clear enough. The birthday greeting which Schiele drew for his aunt in 1907 has many of the characteristics of Klimt's illustrations for *Ver Sacrum*, the Secession journal. Equally, a painting such as the *Young woman in a black dress* presents the sitter full-face and plays with a strong tonal contrast, important hallmarks of Klimt's style.

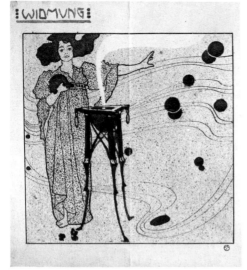

20, 21 Birthday greeting for Marie Czihaczek, 1907; Gustav Klimt, illustration for *Ver Sacrum*, 1900: 'To thine own self be true: the ages will be true to thee.'

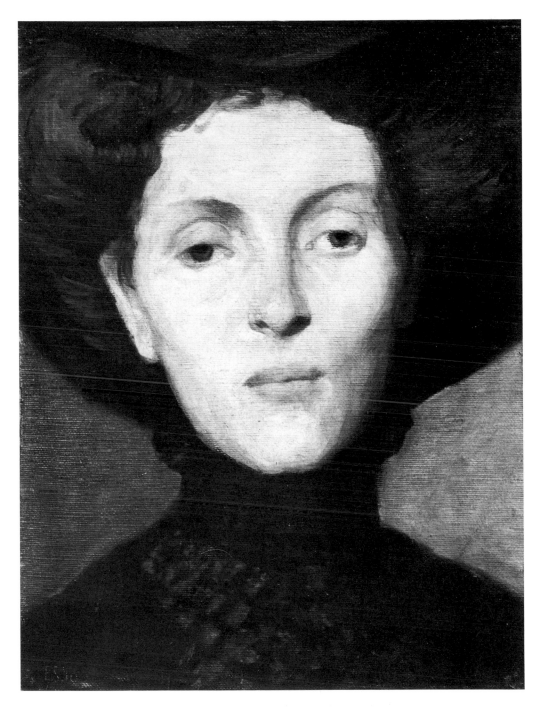

22 *Young woman in a black dress*, 1907

23 *Sunflowers*, 1907

The influence of Klimt is not evident in all the works of 1907. Schiele was still a student. He was still finding his way and experimenting with a variety of styles and approaches. An oil painting of sunflowers employs a subject to which Schiele returned at intervals and which must have been suggested to him by Van Gogh. Only the exaggerated vertical format connects it with Secessionist work.

One of the most assured paintings of this period is the view of part of Trieste harbour. Schiele sometimes went there by train, sketching furiously as it went along. His chief interest in the subject was not so much the boats themselves with their bright colours and complicated rigging, as the reflections they made in the calm water. These have been highly stylized and were scratched into the drying paint with the pointed end of the brush. They are more than descriptions of reflections. Lively and energetic, they possess an identity of their own, independent of what they represent. It is work like this, rather than student exercises or tentative explorations of Klimt's manner, which makes Schiele's talent clear.

24 *Trieste harbour*, 1907

Klimt took a personal interest in Schiele and began to encourage him in many ways. He occasionally bought or exchanged a drawing, arranged for models to sit for Schiele and introduced him to potential patrons. He also introduced Schiele to the Wiener Werkstätte, for which Schiele began to work towards the end of 1908. Klimt had done as much for Kokoschka, some of whose most interesting early work had been produced by the Werkstätte, including his richly illustrated poem *The dreaming youths* (1908) which was dedicated to Klimt.

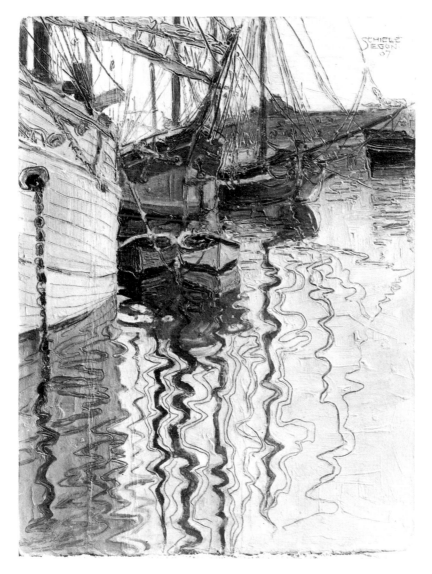

The Wiener Werkstätte was a business organized to produce and sell arts and crafts of all kinds. An offshoot of the Secession, it was founded in 1903 by the architect Hoffmann, the designer and painter Moser and the industrialist and banker Fritz Wärndorfer. The usual translation of Wiener Werkstätte is 'Vienna Workshops' but its activities were wider than this suggests. It published and printed books and postcards, designed and made clothes as well as concerned itself with the manufacture of ceramics, glass, metal and furniture. It also ran its own retail outlets not only in Vienna, selling its modern designs to an increasingly art-conscious public, but also in the 1920s in New York.

One of its most important functions was the patronage of young and promising talent. Hoffmann was almost like an agent in the way he put Wiener Werkstätte artists and designers in touch with patrons and commissioned them to collaborate on projects which he himself had been given. After Schiele had made contact with the Werkstätte he would write often to Hoffmann for a letter of introduction, in the hope of a sale, or to ask the architect to use his influence on his behalf. He also succeeded in persuading the Werkstätte to employ Gerti. An attractive young girl mad about the latest fashions, she made an excellent model showing off Werkstätte clothes.

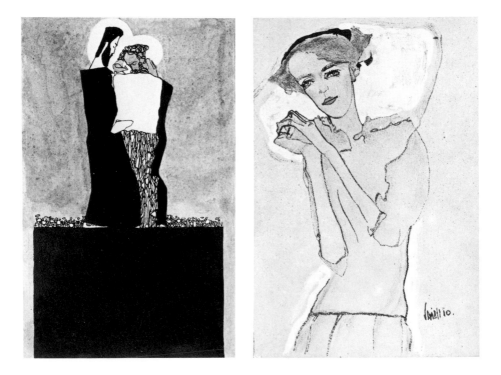

One of Schiele's tasks for the Werkstätte was actually to design some clothes, not for women but men. He also designed some shoes for women and made drawings for postcards (once using Gerti as a model). 25, 26

Strange though these activities were for a painter, it was part of the Werkstätte philosophy that every artist should be able to turn his hand to many things. They probably also appealed to the self-obsessed and narcissistic side of Schiele's character. He was always concerned about the way he looked. Anxious to present an impressive image, he preferred to wear clothes made to his own design, was determined to cut a figure and, whenever possible, to strike a pose. Throughout his life, portrait photographs of him reveal a person 101, 103
regarding the lens as though it were another human being and calculating the effect he might be having. He had also always been fascinated by mirrors, and was still never able to walk past one without 102
stopping to examine his features intently.

Schiele's attitude to himself is also reflected in the almost neurotic attention he paid to his signature and handwriting. Even as a child he signed almost everything he drew, often writing his name in a very mannered fashion. For some time he experimented with a variety of eye-catching signatures. This was no doubt partly due to the attention paid to their signatures by all the Secession artists, but it was equally the result of Schiele's deep involvement with himself. There is scarcely a painting or drawing in which Schiele's signature is not prominently placed or so positioned that it becomes an essential part of the design or composition.

He was equally concerned for the appearance of his handwriting, almost always using one of several mannered varieties of German Gothic script. The look of what he wrote was more important than 116
legibility, a fact which not only annoyed his uncle but also caused difficulties for many of his correspondents who frequently misread his address. In the Schiele archive there is, for example, a postcard from Zürich addressed not to Hietzinger Hauptstrasse, the street where Schiele was living, but to Kintzinger Honigstrasse. It was delivered nevertheless.

The work of 1908 shows Schiele's continuing desire to experiment and his continuing search for an individual voice. Two works demonstrate the wide variety of styles and subjects he employed. *Meadow with flowers and trees* is a bright, bold essay in pointillism, a 27

41

25 Drawing for a Wiener Werkstätte postcard, 1908

26 Wiener Werkstätte postcard, after a drawing of Gerti Schiele

technique employed by some Secession members, one of whom was Adolf Boehm, a painter from Klosterneuburg whom Schiele had met.

28 *Madonna and child*, on the other hand, is an elaborate chalk drawing which may owe something to the kind of Symbolism which the Secession regularly exhibited in Vienna and especially to the mesmeric female faces of Khnopff. But in style and subject it also looks forward to the works of Schiele's maturity. Although the expression on the face of the Christ child is conventionally sweet, verging on kitsch, the mother appears as a sinister figure. Her eyes, almost devoid of pupils, the lower part of her face masked by the boy's head, the hands which seem both protective and menacing, all combine to create the impression of a demonic presence, more like the image of Death come to snatch away an innocent infant than any traditional interpretation of madonna and child. The sickly yellow halo and the disembodied, almost skeletal, hands reinforce this impression. They and the exaggerated gestures prefigure some of the elements in later compositions in which the confrontation between Death and burgeoning Life is made much more explicit.

In 1908 Schiele had his first exhibition. He was invited to show work beside that of local, but by no means only locally known, artists in Klosterneuburg. The most important result of this first exposure of Schiele's work was that it came to the attention of a visitor to the exhibition who would later play an important role in Schiele's life as both patron and friend. This was Heinrich Benesch, yet another executive with the Imperial Railways.

27 *Meadow with flowers and trees*, 1908

28 *Madonna and child*, 1908

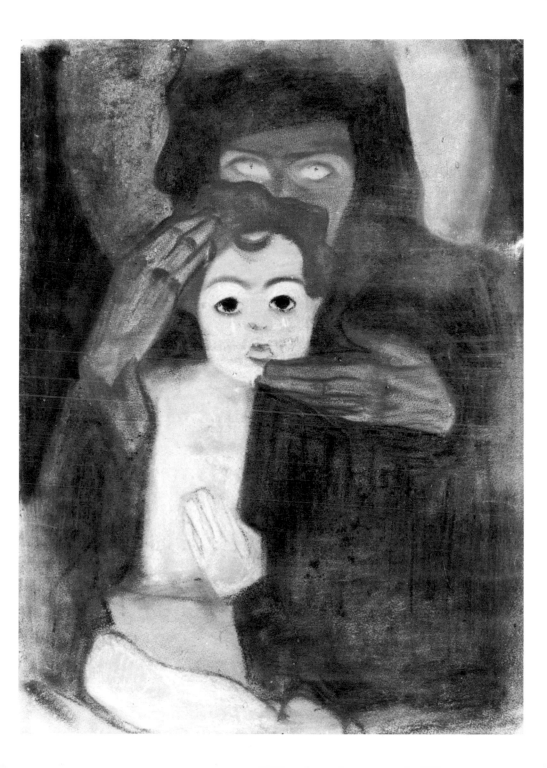

Early independence 1909-1910

I heard
. . . the children,
who looked wide-eyed at me and returned my gaze
with caresses. . . .
The white, pale girls showed me their black
legs and the red garters
and spoke with black fingers.

From 'Visions', *Die Aktion*, 1914

Schiele left the Academy in the early summer of 1909 after completing his third year, the minimum period of study necessary for a basic qualification. There was a minor exodus of students at the same time, the result of a general dissatisfaction with the academic view of art especially as understood by Griepenkerl.

Before Schiele and the others left they presented the professor with thirteen rhetorical questions which caused consternation among the teaching staff. These included the following: 'Is Nature only that which the professor recognizes as such? . . . Is the Academy . . . the only place where the quality of a work of art can be judged? . . . May the young under no circumstances attempt to achieve for their beloved homeland Austria a leading position in the artistic affairs of Europe?'

Similar questions had been in the minds of those painters, architects and designers who founded the Vienna Secession in 1897. They were asked again when Klimt and his friends resigned from the Secession itself in 1905, believing that it had already lost sight of its original aims. The list was a declaration of independence, an assertion that the students had learned enough to doubt the validity of what they had learned and were confident enough of their abilities to work on their own.

Throughout Schiele's time at the Academy his relationship with Czihaczek had been strained. Both were strong-willed: the one convinced of his own talent and of the world's duty to recognize and reward it, the other a living monument to gentility and middle-class virtues. Schiele was desperate to live on his own, liberated from the

constraints imposed by Czihaczek's almost militarily organized household, from the strict moral code observed there and, perhaps most important, from a house in which it was impossible to work. He also wanted to live in a way which reflected his idea of what kind of artist he was. So, before he left the Academy, he found a flat and studio at 39 Alserbachstrasse in the Ninth District. For the time being he could rely on the financial support of his uncle whose sense of duty was so well-developed that he felt obliged to subsidize a life of which he disapproved.

Schiele's assiduous cultivation of his own image demanded that he should devote time, imagination and money to the furnishing of his studio. A vivid picture of it was given by Roessler, soon to become the artist's friend and mentor:

You looked around and found yourself surrounded by chalk white walls and black objects: black boxes, black tables and chairs, black curtains, black silk covers, black cushions, black lacquer boxes and black glass ash trays, black bound books, black vases on black shelves, black Japanese stencil cuts in black frames. In the midst of this choir of polyphonic blacks the young artist stood before a black easel in a white painter's smock which looked like a monk's habit. On the easel was a large stretched canvas on which he was painting a picture which glowed, fierily, in all the colours of the spectrum, bright as jewels and flowers.

The decor conforms to artistic fashion. A smock like a monk's habit had been made fashionable by Klimt. An obsession with black and white can be seen in the work of many of the Secession artists. 10

Schiele may have been rash to set himself up on his own without being able to support himself with sales of his work. But there was already some sign that he would be able to survive as an artist. Even before Schiele left the Academy, Klimt had invited him to participate in an exhibition that would be staged during the summer of 1909 and would include work by those Viennese artists whom Schiele most admired.

When Klimt and his friends left the Secession in 1905 they had denied themselves access to possibly the best exhibition space in Vienna. Klimt, anxious to keep alive the original aims of the Secession, was continually on the look out for suitable alternatives but did not find anything until 1908. It was then that he and his friends were given permission to erect spacious but temporary buildings on a plot of land on the Lothringerstrasse (where the Konzerthaus now stands) and it

was here that Klimt organized a *Kunstschau* – art show. He followed it with another a year later.

Klimt hated making speeches but he did deliver one on the opening of the 1908 *Kunstschau*. It not only touched on the aims of the exhibition but also expressed his exasperation at the current state of art in Vienna. He spoke of 'public life continuing to be preoccupied with politics and economics' and of the 'years without exhibitions' which he and his friends had had to endure since leaving the Secession. He also said that the artists exhibiting belonged to no group and followed no particular programme. 'It is in vain', he added, 'for our opponents to try to resist the modern movement in art and to declare it dead. For they struggle against growth, against the act of becoming, against life itself.'

The 1908 *Kunstschau* was dominated by Klimt's work. However, it quickly gained notoriety from paintings and a play by Kokoschka. This play, *Mörder, Hoffnung der Frauen* (Murderer, the Hope of Women), influenced by Weininger's ideas about sexuality, was performed in the Kunsthaus garden theatre. It greatly contributed to the young man's growing reputation for incomprehensibility and offensiveness. Klimt probably did not understand what Kokoschka was doing and almost certainly did not care for it either. But it was his way to help anyone with talent, and Kokoschka clearly had talent in abundance. So Klimt resisted all the arguments of his friends that Kokoschka

8

29

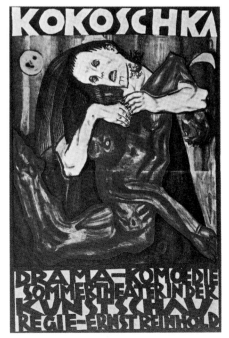

29 Oskar Kokoschka, *Pietà*, poster for the garden theatre at the 1908 *Kunstschau*

30 *Hans Massmann*, 1909

should not be given space at the exhibition even though it meant that the critics had a field day and most of the public came merely to laugh.

Even though Schiele's work was not nearly as radical as Kokoschka's at this time, Klimt may have had trouble persuading his friends that yet another young artist should be included in the 1909 *Kunstschau*.

Schiele exhibited four paintings, three of them portraits (including one of Hans Massmann), at this exhibition. It must have been a memorable occasion for him, marred only by the lack of attention his

30

work received. This is not surprising, given the wealth of material on show, Schiele's age and the fact that he was still obviously under Klimt's influence. What mention Schiele did receive in the Press was entirely in terms of his debt to the older man.

Nevertheless, Schiele could only have felt honoured by his appearance in such illustrious company. With hindsight we can see that the 1909 *Kunstschau* was a very important exhibition. Among the many foreign artists invited were Munch, the Belgians Jan Toorop and Khnopff, Henri Matisse, Pierre Bonnard and Edouard Vuillard. Works by Van Gogh and Paul Gauguin were also shown.

Klimt's influence on Schiele was more obvious in 1909 than it had been in 1908. Two portraits make the debt especially clear. The *Woman with a black hat*, actually Gerti, employs the square format favoured by the Secessionists in general and presents us with a bold, clearly defined shape set against a flat, light background. The figure is rigid, her gaze unblinking, her hands frozen in a contorted gesture.

31 *Woman with a black hat*, 1909

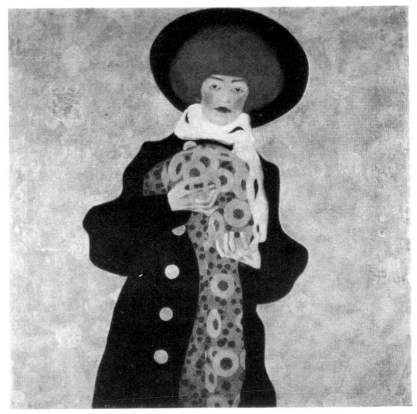

32 *Danae*, 1909

The circular motifs on Gerti's dress are used in a manner reminiscent of Klimt, asserting the shape of the area to which they are applied and giving movement to the surface of the rigid figure. But Schiele (and this will become important in later works) does not cover the background with decorations as Klimt would have done, nor is the figure encrusted with patterned devices.

Equally indebted to Klimt is the portrait of Hans Massmann, a 30 painter who had studied with Schiele at the Academy. Again the square format has been used, and although the figure is devoid of decoration the background has been realized in terms of wriggling decorative devices and the cane of the chair on which Massmann sits is shown as a stylized pattern of curving lines. Everything tends to be conceived firstly as decoration, and compositional features such as the border around two sides of the canvas make it clear that Schiele was as interested in formal effects as he was in achieving a likeness.

Not only Schiele's portraits owe much to Klimt. *Danae* is frankly 32 based on Klimt's symbolic figure compositions: decorative, erotic, it is a mythological subject seen through the eyes of a Viennese aesthete. Klimt had exhibited his own *Danae* at the previous *Kunstschau* where Schiele had certainly studied it.

49

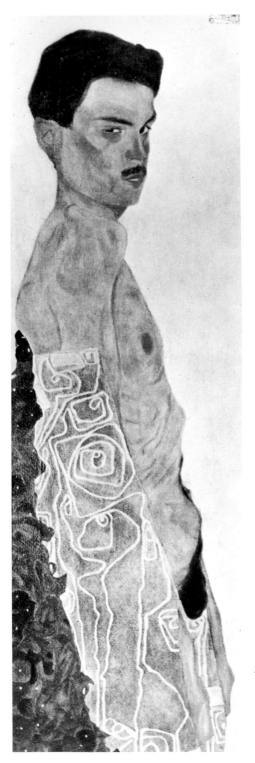

33 *Nude self-portrait*, 1909

But if such works are little more than pastiches of the older man's style, others produced by Schiele in 1909 clearly indicate the growth of something new.

The *Nude self-portrait* illustrated here owes to Klimt its unusual 33 format, its pronounced flatness and its interest in linear decoration. But the implications of the nudity and the self-assured, seductive, facial expression are quite different from anything in the work of the older painter. Indeed, the ornate *Jugendstil* shift is falling from Schiele's body as though the artist were emerging from a chrysalis. The metaphor is apposite for, by shuffling off this hard, decorative skin, Schiele is entering a new and more mature phase of his creative life.

It is significant that Klimt never painted himself, dressed or naked. Unlike the artists of the next generation he was not sufficiently interested in his self-image to think such a subject worthwhile. Indeed, he always retreated behind a style that was both contrived and impenetrable.

From now on Schiele, however, regarded the self-portrait as one of his major subjects and showed himself more often than not fully or partially nude. It was the best way of exploring and exhibiting himself. Here the gaze demands an immediate response from the spectator, and the shift, slipping from the arms and barely covering the genitals, adds an unmistakable sexual dimension. The painting is immature, of course. The calculated and artificial facial expression, the emphasis on the pubic hair and the failure to resolve the contradiction in the mannered description of the cloth and the more naturalistic painting of the body radiate a confusion that is both emotional and stylistic. This picture reveals the adolescent's search for both artistic and psychological identity. Seen in the context of contemporary Viennese art such self-revelation, self-advertisement even, is unsettling. Only Gerstl, who painted himself a year earlier confronting the spectator with his nakedness, had the nerve to do something similar, although both he and Schiele may have seen a reproduction of a remarkable drawing by Albrecht Dürer, which he made around 1503 while convalescing from a serious illness, in which the artist's nakedness complements the vulnerable expression on his face.

In Schiele's painting the artist is doing more than invite us to look at and admire him. He is announcing that he has become the subject of his art, whether directly and obviously in the form of self-portraits, or indirectly by making whatever he draws and paints a record of his

feelings and ideas. This self-portrait even includes a suggestion of disdain. We are less privileged than he. His highly subjective interpretation of the world, in some way special, can provide us with revelations.

34 Less disturbing but no less self-absorbed is the relaxed drawing in coloured pencil which dramatizes the artist in another, altogether more precious, way. All Schiele's self-portraits present the public with a carefully contrived image of the artist as an object of special interest. Furnished with various pieces of fashionable dress, these two self-portraits are related to the pin-up, in which the subject, permanently inaccessible but the embodiment of an ideal, implies an intimacy which can never be realized.

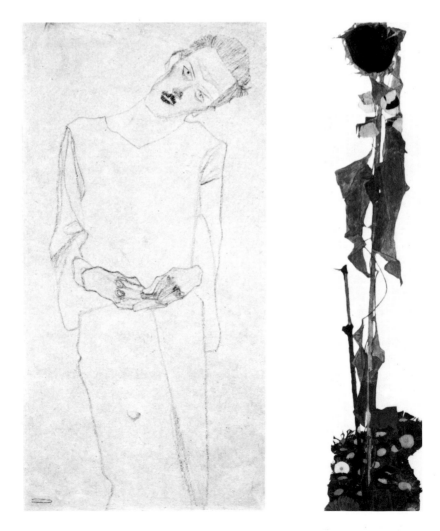

36 *Plum tree with fuchsias, c.*1909

Paintings and drawings of flowers also reveal the speed at which Schiele was liberating himself from Klimt's influence. Klimt's landscapes and depictions of natural things are highly original in composition, rich in colour and pattern. But they rarely evoke a mood. Mood is the main purpose of Schiele's studies of plants and trees. Like his *Sunflower* they are portraits, but of non-human living things. The 35 sunflower maintains only a tenuous grasp on life, having already begun to wither and decay. Its leaves droop and hang dejectedly along its hard, woody stalk, its days of glory are over. The plant demands interpretation in anthropomorphic terms. So, too, does the *Plum tree* 36 *with fuchsias*: a gaunt, bleak and contorted image of death.

53

Schiele never ceased to be fascinated by decline and decay, whether registered in the faces and bodies of human beings or in the autumnal configurations of natural things. Unlike Klimt's work which is optimistic and celebrates life, Schiele's paintings and drawings dramatize the mortality of everything. 'Alles ist lebend tot,' he once wrote – everything is both living and dead. Even at the moment of its greatest perfection and glory a flower has begun to decay.

Thematically, although not stylistically, such works owe a great deal to Van Gogh, as does the change then occurring throughout Viennese painting. Nature in his work is not merely reality perceived by a strong temperament. Reality actually consists of those powerful emotions through which it is perceived. His painting was first brought to the city by the Secession and frequently shown there after that. Schiele had seen forty-five Van Goghs at the Miethke Gallery in 1906, but the eleven works shown in Room XIV of the 1909 *Kunstschau* proved even more important. At least two of Van Gogh's paintings, including that of the artist's bedroom, provided Schiele with motifs which he then transformed.

72

The ways in which Schiele's self-portraits and his studies of flowers and trees reflect or express emotion distinguish them sharply from most other contemporary Viennese art. They announce, however tentatively, the arrival of a new kind of painting in which concern for the refined use of formal devices gives way to an interest in the personality and emotions. A handful of other Viennese artists, also deeply affected by Van Gogh, had developed the same interests at around this time. Chief among them were Kokoschka and Gerstl.

37

Kokoschka's portraits, of which several were shown at the *Kunstschau*, were dramatically different from Klimt's. Devoid of decoration, unconcerned for immaculate surfaces, scornful of the merely sensuous attractions of colour and gracefully manipulated line, they are pre-eminently concerned with the revelation of personality and present their sitters in a way which, although stressing their individuality, also implies that they are types representative of the society to which they belong – not social types, like Klimt's sitters, but psychological types. These are often depressing, always worrying paintings. Their subjects often appear as lost souls, incapable of communicating their neuroses.

But even Kokoschka was not the first painter to work in a way best described in a vocabulary borrowed from psychoanalysis – although

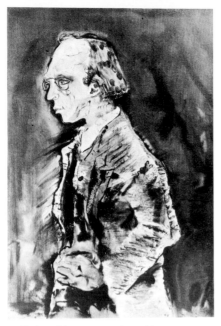 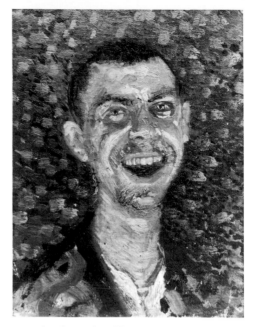

37 Kokoschka, *Herwarth Walden*, 1910 38 Richard Gerstl, *Self-portrait laughing*, 1907

he was the first such artist to attract public attention. Much of what he did, in portraiture at least, was anticipated by Gerstl, whose tragic life is as revealing of his generation's spiritual predicament as are his paintings.

Gerstl was born in 1883, three years before Kokoschka, and committed suicide in 1908. Before he did so he burned as many of his paintings and drawings as he could lay his hands on. Gerstl's work was known only to very few during his brief life. Although he painted some energetic landscapes, his main subject was portraiture. Some of his portraits are of people like wraiths who seem to be attempting to re-materialize in a world they have long since left. Gerstl saw himself as someone physically frail, his unnerving laugh simultaneously an expression of scorn and of his own fruitless attempts to cope with his problems. The complicated emotions which Gerstl's portraits provoke, the problems of alienation which appear to plague his sitters, are quite different from the luxury and affirmation expressed by Klimt. Gerstl's world has begun to crack under the weight of inexorable change. Dissatisfaction with the present and uncertainty about the future had begun to make people mad. Gerstl even refused to have his work hung in the same room as Klimt's.

38

55

Other Viennese portraitists, such as Max Oppenheimer, Paris von Gütersloh and Anton Faistauer, were also attempting, whether by exaggerated pose and gesture, by means of caricatured facial expression or by a rough handling of paint, to dramatize the human personality, to create the impression that their portraits laid bare the soul. Was it significant that this new kind of painting appeared in Vienna at about the same time as Freud and others were investigating the soul in other ways?

The phenomenon was widespread. While portrait painting had declined in the rest of Europe during the nineteenth century, in every German-speaking country it had survived and was receiving a new lease of life, the self-portrait everywhere acquiring special significance.

Portraits always reveal much about the times in which they were created. Originally mostly commissioned, they show the way in which their sitters wished to be seen as much as they mirror their true appearance.

The invention of photography in the nineteenth century is one obvious reason for the fundamental change in the development of portraiture, seen at its clearest in the work of Van Gogh, Gauguin and Paul Cézanne. The camera lens suddenly released the artist from the obligation to record a physical likeness.

The modern portrait is typically uncommissioned and frequently of the artist himself, partly because of the decline in patronage and partly because the artist came to believe there was nothing as fascinating as himself. But even in paintings of friends and colleagues the artist hunts for the elusive signs of personality and individuality even at the expense of the physical appearance of his subject. This is especially true of Viennese portraiture which, we can now see, was merely one expression of a widespread and essentially new interest in the human psyche in every area of scientific and artistic endeavour.

The reasons for this new interest are complex. The political solutions (anti-semitism, pan-Germanism and Zionism) to perennial problems, proposed in Vienna by such people as Karl Lueger, Georg Schönerer and Herzl, became increasingly irrational while the scientific enquiry not only of Freud but also of the physicists Mach and Ludwig Boltzmann undermined faith in traditional modes of thought and action. A belief in conventional methods of description crumbled and in their place appeared the suspicion that reactions are fundamentally instinctive and otherwise inexplicable.

Equally, the pioneers of modern drama, Henrik Ibsen and August Strindberg (as celebrated in Vienna as they were in Berlin), questioned most traditional definitions of human motivation and no longer saw an inevitable and logical progression from cause to effect. In Strindberg especially we see the emergence of a new human type whose often irrational behaviour cannot be explained in any conventional fashion and whose actions are the result of inner forces which even the character cannot comprehend.

The subconscious mind now seemed more powerful and more interesting than conscious thought processes. The darker, sinister side of the human personality therefore seemed an appropriate field for investigation – whether by Freud through the allegory of dreams, or by Musil in his fictional depictions of inner lives. The old values, the old, once reliable world-system had collapsed. Nothing could now be trusted – not even language which once appeared unambiguously to communicate feelings, facts and philosophies.

Schiele was certainly unaware of Gerstl's work but he knew a great deal about Kokoschka's. It was Kokoschka's drawings rather than his paintings which interested Schiele, and the similarities between the figure studies produced by Kokoschka in 1908 and 1909 and by Schiele in 1910 are unmistakable. The pronounced linearity of Kokoschka's drawings, their hard, crumpled contours and the awkward postures of the figures reappear in Schiele's work, as do the occasional patches of bright colour which Kokoschka often applied to clothes and skin.

Many of Kokoschka's drawings, such as *The juggler's daughter* 39 (1908), were made after models whom the artist found in the working-class districts of Vienna. Almost all of them were children forced to live in squalor and the privations of a city which could not keep pace with its spectacular growth. The skinny bodies and inelegant gestures of the proletarian children sought out by Kokoschka appealed to him not so much for political reasons as because they possessed in nature the kind of exaggerated and unnatural qualities he was attempting to achieve in his art.

Schiele now also searched the proletarian areas for children to draw and some of the most powerful works of these years depict such models. According to Roessler:

For months he was occupied with drawing and painting working-class children. The ravages of disease ... fascinated him. He looked with astonish-

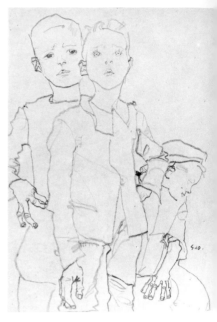

39 Oskar Kokoschka, *The juggler's daughter*, 1908

40 *Three street urchins*, 1910

ment at the strange transformations of the skin through whose tired veins thin, watery blood and polluted liquids slowly wound their way. Astonished, he also saw the green eyes that were sensitive to the light behind their red inflamed lids, the swollen joints in the hands, the wet mouths – and – the souls within these damaged bodies.

40 One such drawing shows a group of street urchins, all boys. Most
41, 42 of Schiele's models were girls, however. Thin, nervous, on the edge of puberty, their eyes expressive not only of hunger and bewilderment but also of a growing awareness of their own sexuality, they provided Schiele with an irresistible mixture of cunning and naïvety.

Schiele's friend, Gütersloh, once recalled these models and how Schiele dealt with them:

There were always two or three small or large girls sitting about in his studio, brought there from the immediate neighbourhood, from off the street or picked up in the Schönbrunn park that was nearby. They were ugly and pretty, washed and unwashed and they did nothing – at least to the layman they might have seemed to do nothing. . . . They slept, recovered from beatings administered by parents, lazily lounged about – something

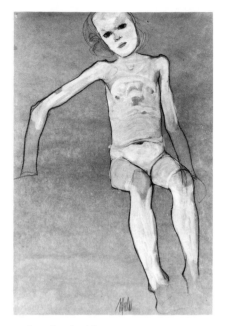

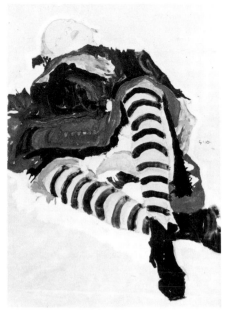

41 *Seated nude girl*, 1910 42 *Girl with striped stockings*, 1910

they were not allowed to do at home – combed their hair, pulled their dresses up or down, did or undid their shoes . . . like animals in a cage which suits them, they were left to their own devices, or at any rate believed themselves to be. But that was not the case at all. They were all taken in by Schiele's Jesuitical artistic personality. With the aid of a little money and much charm he had managed to lull these little beasts into a false sense of security. . . . They feared nothing from the sheet of paper which lay by Schiele on the divan.

Kokoschka was later scathing in his criticism of Schiele, claiming that much of Schiele's style had been stolen from him. But in spite of stylistic similarities between the drawings of the two artists at this time, the way in which their subjects are used is quite different. Kokoschka is interested in his urchins mostly because of their bodies; Schiele tries to get inside their heads, to see the world as they see it. That is why he did his best to have them relax, although it is difficult to believe Gütersloh's account in its entirety. The children picked up from the street or in the park were clearly flattered to be invited into the house of a real artist and the temptation to show off must have been irresistible.

Schiele's developing style also owed something to an artist of an earlier generation whose work he first saw in 1909 in a large exhibition at the Miethke Gallery. This was Henri de Toulouse-Lautrec who, as Otto Benesch, son of one of Schiele's earliest patrons, wrote, 'made an enormous impression on Schiele through his mercilessly bitter representation, through his investigation of the female psyche'. His technique also made an impression: Schiele's use of pencil, gouache and watercolour, his frequent recourse to areas of white on coarse, coloured paper, were all devices brilliantly exploited by Lautrec.

43 The clearest evidence of Schiele's debt to the French artist's work is provided by a portrait of his sister Gerti, *The scornful woman* (1910). Naked to the waist and wearing a huge hat, she sneers at someone apparently at her side. The almost caricatured expression, the eccentric placing on the paper and the truncation of the hat and figure recall Lautrec, as does the medium, but the painting is equally a distortion of a Klimt. His fine society lady in a black hat has been transformed into a fish wife, scornful of the world yet vulnerable to its injuries. It need only be compared with the portrait of Gerti done the year before to make plain the distance Schiele had travelled in less than a year.

The response to Schiele's work in the 1909 *Kunstschau* had been luke-warm, but the eighteen-year-old artist quickly had another chance to become known. In December he was represented at the exhibition of *Neukünstler* or 'new artists' which was held at Gustav Pisko's gallery.

These 'new artists' were, in fact, chiefly those who had left the Academy at the same time as Schiele and who saw themselves following the struggle for independence of the Secessionists and the Klimt group. Most of Schiele's fellow exhibitors are now virtually forgotten. They included Schiele's future brother-in-law Anton Peschka, Faistauer and Gütersloh, not only a painter, but also an actor and writer of unusual talent.

Schiele did much of the organization for this and for the next (and final) *Neukünstler* exhibition and probably saw himself emulating and perhaps even rivalling Klimt, the moving spirit behind the *Kunstschau*. He even wrote a manifesto which was later printed in a slightly changed form in a 1914 issue of the Berlin Expressionist journal *Die Aktion*. This shows Schiele attempting, not entirely successfully, to manipulate high-sounding phrases. Here are some extracts:

60

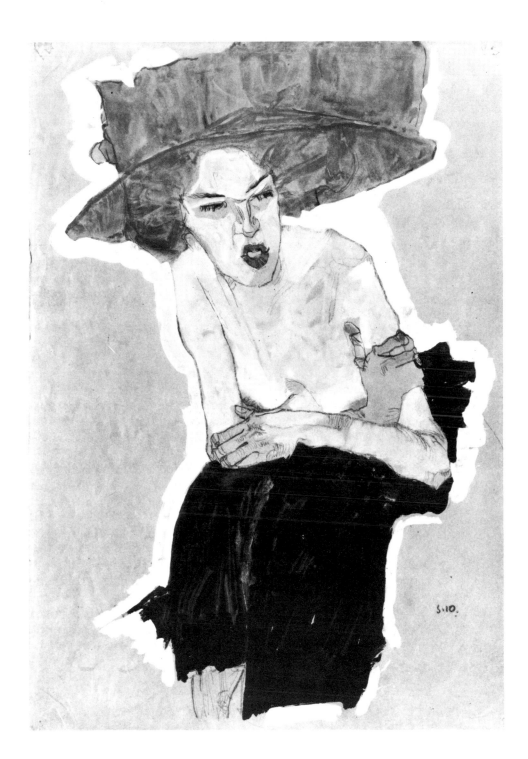

narrow shoulders, long arms and long-fingered, bony hands. His face was sunburned, beardless and framed by long, dark, unruly hair. His broad, angular forehead was furrowed by horizontal lines. The features of his face were usually fixed in an earnest, almost sad expression, as though caused by pains which made him weep inwardly. Whenever he was spoken to, he met one's gaze imposingly with his large dark eyes from which he had to chase away a dream . . . his laconic, aphoristic way of speaking created, in keeping with the way he looked, the impression of an inner nobility that seemed the more convincing because it was obviously natural and in no way feigned.

Roessler's review of the *Neukünstler* exhibition in the *Arbeiter Zeitung* is of special interest because it contains his first mention of Schiele. The new artists, he wrote,

come from the area [mapped out by] the *Kunstschau*, by Van Gogh, Gauguin, Hodler, Klimt and Metzner. The influence specifically of Klimt is unmistakable. . . . Probably many of these artists will not complete the course, but there are some nevertheless whom I consider inwardly and outwardly strong enough to win through. I regard one of them as the extraordinarily gifted Egon Schiele.

It is not clear whether Roessler first met the artist at the *Neukünstler* exhibition. It seems likely that he had got to know him earlier in 1909 and had already introduced him to two of the most important collectors of modern art in Vienna, Carl Reininghaus and Oskar Reichel.

Both Reininghaus, an industrialist with a penchant for pornography as well as an appreciation of great art, and Reichel, a successful physician and surgeon, were important for Schiele not merely as suppliers of funds. In their houses he could study the works of many of the masters of modernism. Reichel's collection, for example, included paintings by Manet, Gauguin, Lautrec, Van Gogh, Munch and Khnopff as well as examples of contemporary Viennese painting. Kokoschka's *Still life with tortoise and hyacinth* was there, for example.

These patrons were to prove vital during the early part of Schiele's career. So, too, did another, far less wealthy collector, who had first seen Schiele's work at the 1908 exhibition in Klosterneuburg. This was Benesch, who supported the artist through thick and thin, buying whenever he could afford to, providing loans whenever possible and giving advice and encouragement. Sometime in 1909 Benesch introduced himself to Schiele and bought his first drawing.

45

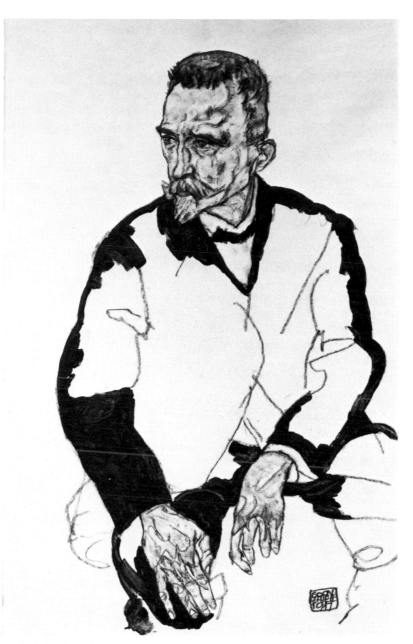

45 *Heinrich Benesch*, 1917

Benesch later recalled his first meeting with Schiele at the artist's studio:

I . . . found a slim young man of more than average height and of upright, unaffected manner. Pale, but not sickly, thin in the face, large dark eyes and full, longish dark brown hair which stood out in all directions. His manner was a little shy, a little timid and a little self-confident. He did not say much, but when spoken to his face always lit up with the glimmer of a quiet smile.

Benesch was remarkable. A railway official with a limited income, he spent every available penny on his art collection and, not surprisingly, worried his wife who could not understand his interest in strange-looking, self-assured young artists like Schiele. In spite of frequent visits to the Benesch home, the artist was never invited to stay for dinner.

One of Benesch's earliest letters to Schiele gives a vivid impression of the collector's enthusiasm. 'I want to ask you one thing more. Don't put any of your sketches, no matter what they are, even the most trivial things, on the fire. Please write on your stove in chalk the following equation: "Stove equals Benesch." '

Both Benesch and his son Otto (later to become a prominent art historian and director of the Albertina where so many of Schiele's best drawings are preserved) have left vivid impressions of the artist. In 1943 Heinrich Benesch wrote the following description:

The basic trait of [Schiele's] character was seriousness: not the bleak, melancholy seriousness which hangs its head, but the quiet seriousness of a person dominated by a spiritual mission. Everyday matters could not affect him. He always looked beyond them towards the elevated goal of his ambition. Together with that he had a keen sense of humour and liked a joke. But he was never noisy. His humour was expressed in short and not very loud bursts of laughter.

It might be thought that in 1909 Schiele had much to laugh about. Not yet twenty, not yet completely mature as an artist, he had secured the services of a critic and mentor and had attracted the interest of three patrons who would soon buy his work at regular intervals. But Schiele was not overly delighted with his luck. He seems to have been ever anxious to create the impression of severe poverty, although his situation in 1909 was not as bad as this account, quoted by Roessler, would have us believe:

After I had made myself independent against the wishes of my mother and guardian in order to live as an artist, things quickly became miserable. I wore my guardian's cast-off clothes, shoes and hats, all of which were too large. My clothes, their linings ragged, the material worn thin, hung loosely on my skinny limbs. The shoes were worn out . . . so that I could only shuffle along. I had to push entire newspapers into the faded, crumpled and mouldy hat to stop it falling down over my eyes. My underwear was an especially precarious item of my wardrobe in those days. I don't know whether . . . netting . . . can be described as underwear at all. My collars had been handed down from my father and were much too large and too deep for my thin neck. On Sundays and on special occasions I therefore wore paper collars which I had cut myself and had shaped in an original way . . . in addition to all this my hair was too long and I was frequently unshaven. I did not give the impression of being a nice young man from an upright, middle-class official's family, which is what I basically was.

We know that Schiele was still receiving an allowance from his guardian in 1909. His description of his plight is also at odds with contemporary photographs of him and other accounts of his appearance at this time. One such account was provided by Gütersloh:

Egon Schiele was unusually handsome and had nothing at all artistic about him: his hair was not long, he never had even a day's growth of beard, his finger nails were never dirty and he never wore poor-looking clothes even in his poorest period. He was – and this is not merely a trick played by my memory – an elegant young man whose good manners contrasted with what at that time was his poor painting technique. And what right the revolutionary Schiele would have had to dress like a *sansculotte* and speak like a *petroleuse*! But, you see, the true revolutionaries are like the Jesuits. You don't know what it is they really want. For as long as possible they speak our language as fluently as every other, act as though the Schism or the heresy were not worth talking about, the heretic not worth the candle, and then suddenly they force a crucifix against our breast.

This conflict between the facts and what Schiele wanted to believe helps to explain some of the artist's tormented personality. His behaviour seems to show a desire to rebel against the class values he had inherited from his family not so much because he disliked them as such but rather because they clashed with what many had come to believe were the necessary qualifications for the important artist. Schiele claimed poverty whilst cultivating the image of a dandy and being spendthrift with money, and seems to have longed simultaneously for notoriety and for the kind of secure and comfortable

surroundings enjoyed by his parents and guardian. For, in spite of energetic attempts to conceal his background, after rejecting his uncle and everything he stood for, Schiele eventually married into a family that was just as bourgeois.

The promising start to Schiele's career might have reconciled his mother and guardian to the fact that the young man, still legally in their charge, had not chosen a more conventional profession. It did nothing of the kind, largely because of Schiele's attitude towards them. He appears to have distanced himself from his mother because of differences about the memory of his father; and he loathed his uncle and his narrow-minded attitudes while regarding him as an inexhaustible supply of funds.

His guardian's patience, already worn thin, finally collapsed in May 1910 when Schiele went off to Krumau, a town in southern Bohemia, with a friend, the painter and eccentric Erwin Osen. Schiele had withdrawn a substantial amount of money from his savings account before leaving but, on arrival, sent a telegram to his uncle asking for a loan. He put the wrong house number on the telegram which consequently arrived in the middle of the night, the messenger waking the entire household.

This comical episode was the last straw. Czihaczek announced that he no longer wanted any responsibility for his ward. Schiele occasionally attempted to regain his uncle's sympathy after that and wrote several letters telling him about his patrons and successes. The letters remained unanswered. On the envelope of one of them Czihaczek wrote the word *Galimathias* – rubbish. Schiele was now on his own.

46 *A hill near Krumau*, 1910

Portraits and pornography 1910

A pollution of my love – yes. I was in love with everything. The girl
came, I found her face, her unknown qualities, her worker's hands; I was
in love with everything about her. I had to draw her because of the look
in her eyes and because she was so close to me. – Now she has gone. Now
I encounter her body.

From 'The Portrait of the Pale, Still Girl', 1910

Schiele's journey to Krumau was but the first of a series of attempted
escapes from Vienna into rural surroundings. Some time before he
left the capital in 1910 he had expressed his desire to escape in a letter to
Peschka. Although something of a literary exercise, creaking with
rhetoric, the letter sheds light on Schiele's state of mind at this time:

I want to leave Vienna very soon. How hideous it is here! Everyone envies
me and conspires against me. Former colleagues regard me with malevolent
eyes. In Vienna there are shadows. The city is black and everything is done
by rote. I want to be alone. I want to go to the Bohemian Forest. May, June,
July, August, September, October. I must see new things and investigate
them. I want to taste dark water and see crackling trees and wild winds. I
want to gaze with astonishment at mouldy garden fences. I want to experi-
ence them all, to hear young birch plantations and trembling leaves, to see
light and sun, enjoy wet, green-blue valleys in the evening, sense goldfish
glinting, see white clouds building up in the sky, to speak to flowers.

The friend with whom Schiele went to Krumau was Osen, one of
the *Neukünstler* and a man about whom we know too little. He was
not only a painter but also a theatrical performer, appearing on stage
with his mistress, an exotic dancer who went under the name of Moa.

47

Krumau, now Česky Krumlov in Czechoslovakia, was where
Schiele's mother was born and where she sometimes went to stay with
relatives. But Schiele steered clear of family connections. He had met a
schoolboy who, blinded with Schiele's importance, found him
accommodation and managed to pay for it himself. An embarrassing
letter written by that boy and containing a protestation of undying
love ('If you stay with me I shall be strong, but if you leave me it will

69

47 Moa and Erwin Osen

be the death of me') seems to indicate a homosexual relationship, but it may simply have been an unrequited adolescent passion. What it does certainly show, however, is Schiele's gift for manipulating people and for inspiring them to make sacrifices for his art.

Schiele, Osen and Moa must have made a strange sight in the rural surroundings of Krumau. Moa was a weirdly attractive woman. According to Roessler, she was

as slender as a twig with a bone-white face fixed in a mask-like expression. She had blue-black hair and the look of an Egyptian princess. . . . Her large, jet-black and melancholy eyes shone dully beneath heavy lids which had long lashes and were shaded in blue and brown. Her voice was guttural but cooing. . . . All this, plus her name which was reminiscent of a Vahine from Tahiti, enchanted the artist in Schiele completely.

Osen was conventional by comparison. 'Tall, slim, lean as an Arab, with the pale, beardless face of a "fallen angel", in elegant clothes . . . the adventurer did wear extraordinary jewellery however.'

Osen's stage act which employed bizarre and exaggerated gestures (some of them sexually suggestive) probably gave Schiele many ideas for the extraordinary and theatrical poses so characteristic of his work from now on. His several drawings of Osen himself are typical of the work he now produced for some considerable time: the face frozen in an expression of rapture, the thin body naked, the bony arms and hands contorted in a gesture of barely articulate emotion.

48, 49

70

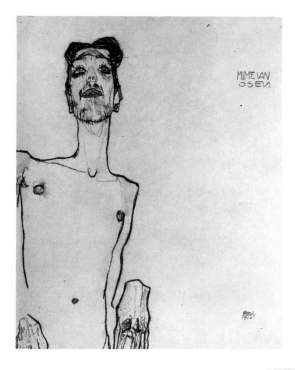

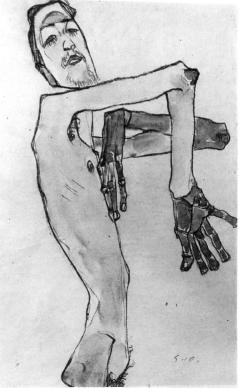

48, 49 *Erwin Osen*, 1910

The artist was not alone in drawing inspiration from the dance. The Viennese Wiesenthal sisters, stage performers known for their energetic choreographic routines, gave Klimt many ideas for his poses. Mata Hari once danced for the members of the Secession, as did Isadora Duncan, dressed, it is said, only in red roses. Kokoschka, too, was fond of drawing circus people and acrobats because of the extraordinary things they could do with their limbs. At the same time in Germany artists such as Kirchner and Erich Heckel were excited by such dancers as Mary Wigman and the disciples of Rudolf Laban. It was not merely that the gestures of such dancers were dramatic and graphic. They were all exponents of the free school of dancing which saw the body as the vehicle for the spontaneous expression of emotion, as versatile an artistic instrument as the orchestra. This drastic break with convention was bound to appeal to Schiele.

Osen seems to have given Schiele a great deal in the way of ideas and inspiration. He probably introduced his friend to the work of Arthur Rimbaud which made Schiele try his hand at writing his own poetry and, more importantly, he seems to have encouraged Schiele in his attempts to master a kind of portraiture in which the often unusual personality of the sitter is given full expression. One of the few details we have of Osen's multifarious activities is that he spent some time in 1913 in the Vienna Steinhof lunatic asylum studying the inmates as an aid to what he described as pathological expression in portraiture.

Pathological expression is a telling description of the portraits Schiele painted in 1910 for, although all of his sitters were apparently normal and in full command of their faculties, Schiele presents them as highly-strung emotional creatures. Many of them, indeed, seem to be on the edge of madness.

That year Schiele emerged as a portrait painter of remarkable gifts. He painted no fewer than eleven portraits, of which four are of special interest. All are square. In each the figure is isolated against a more or less blank background and in each the position of the hands and body are the main vehicles of expression. Only in the portrait of Roessler are the legs extended below the thighs. These pictures range from the pleasantly smiling likeness of the boy, Herbert Rainer, to the intense, brooding and unnerving image of Eduard Kosmak.

Rainer was the young son of a university lecturer and Schiele may have given him such an appealing face because the portrait was com-

44

50

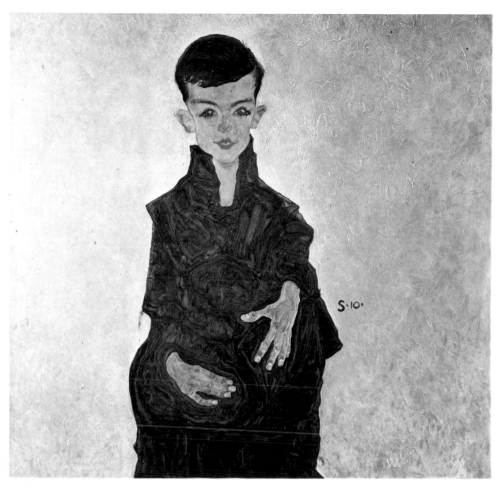

50 *Herbert Rainer*, 1910

missioned. Whatever the reason, this is one of the least complicated portraits Schiele ever painted. In spite of the unnaturally placed and virtually disembodied hands, Rainer is clearly a normal child, untouched by the problems and neuroses which seem to dominate the lives of all the other children, adolescents and adults portrayed by Schiele.

By contrast the publisher Kosmak appears to be in urgent need of 52 psychiatric treatment, an appearance not entirely explained by his amateur dabbling in hypnotism. His body clenched, his hands pressed between his knees as though recalling his life in the womb (and yet

73

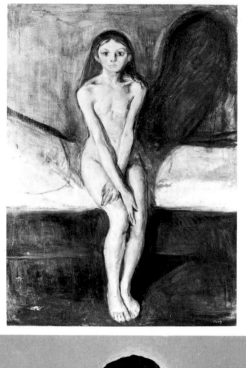

51 Edvard Munch,
Puberty, 1895

52 *Eduard Kosmak*, 1910

53 *Poldi Lodzinsky*, 1910

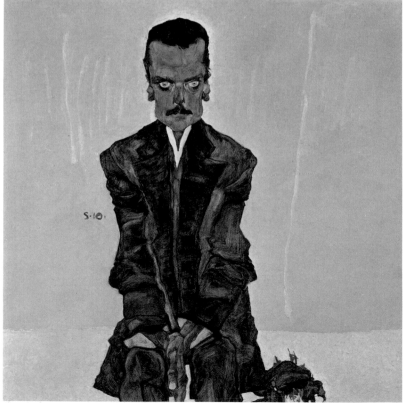

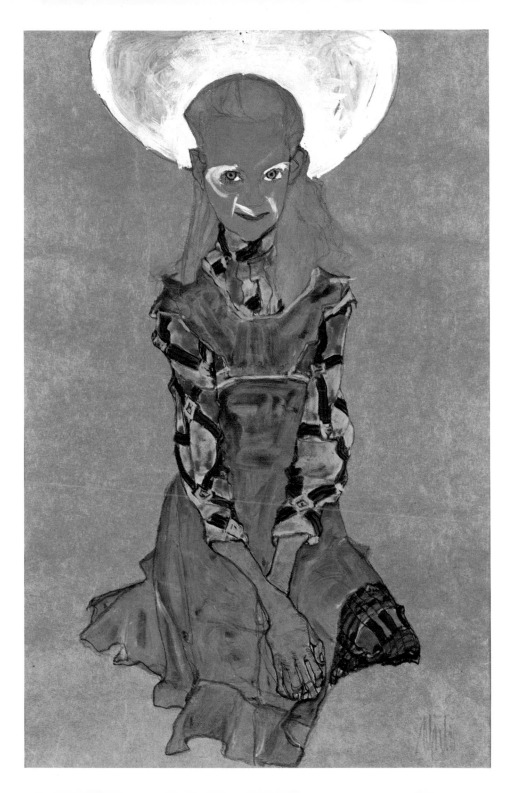

also resembling his genitals), he looks out at us with the inescapable gaze of someone who has a great message to impart but lacks the words to express himself. Not without reason has this portrait been
51 compared to Munch's *Puberty* (1895) where the pose and facial expression speak eloquently of the girl's anxiety in the face of a growing awareness of her own sexuality.

Even more like the Munch is the gouache of a young girl called
53 Poldi Lodzinsky whose facial expression and bony hands clearly echo those in *Puberty*.

Schiele seems to have been looking carefully at Munch's work. The curious billowing shape which encloses Roessler in Schiele's portrait of him is a transformation of the wraith-like shadow which appears to emerge from Munch's adolescent like a menacing *Doppelgänger*. But unlike Kosmak, Roessler seems assured and confident. Eyes closed, he seems to be communicating with someone on a higher plane.

55 The portrait of Karl Zakovsek, a painter and one of the *Neukünstler*, is one of Schiele's most stylized works to date. So thin that his hands are little more than skeletal, and so contorted that his limbs seem fractured and dislocated, from red-rimmed eyes he directs a gaze at us that is both weary and melancholy. Like Kosmak, Zakovsek is clearly abnormal. Both are introspective, creatures of the mind to such an extent that their bodies seem like inconvenient appendages, the prisons within which their true selves are trapped.

In the place of Klimt's rich, mosaic-like areas of decoration, Schiele has set a void which threatens and occasionally overpowers the figure it envelops. This void, present in all these portraits along with a growing sense of the picture-frame as a kind of prison, emphasizes the sitters' isolation and alienation from society. This helpless realization of being unable to find contact comes across more strongly in Schiele's paintings than in those of his contemporaries. It calls to mind Kraus's celebrated description of contemporary Vienna as 'an isolation cell in which one is allowed to scream'.

Portrait drawings made in the same year have many of the same
54 qualities, although the splendid likeness of the painter Oppenheimer has something actively evil, even demonic about it, an impression created by the rich black coat and the sickly green and yellow skin Schiele has given him.

Schiele clearly thought that there was a future in portrait painting and must have been delighted when he was approached in 1910 by

76

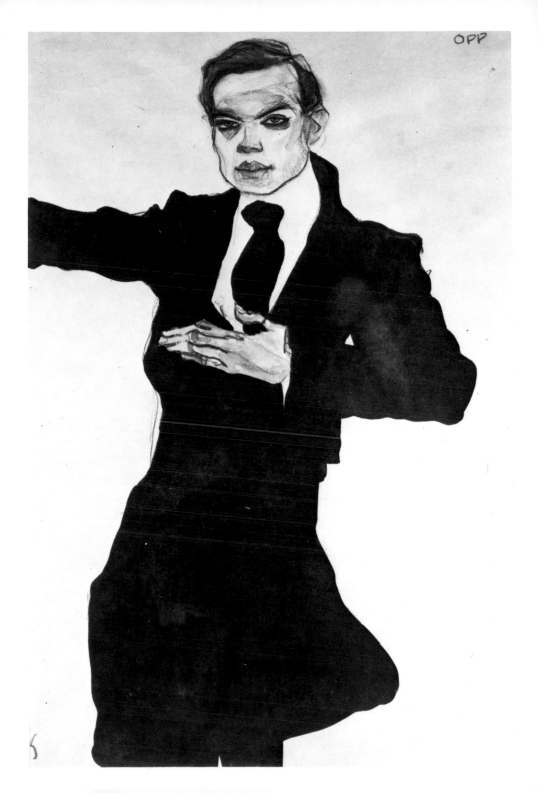

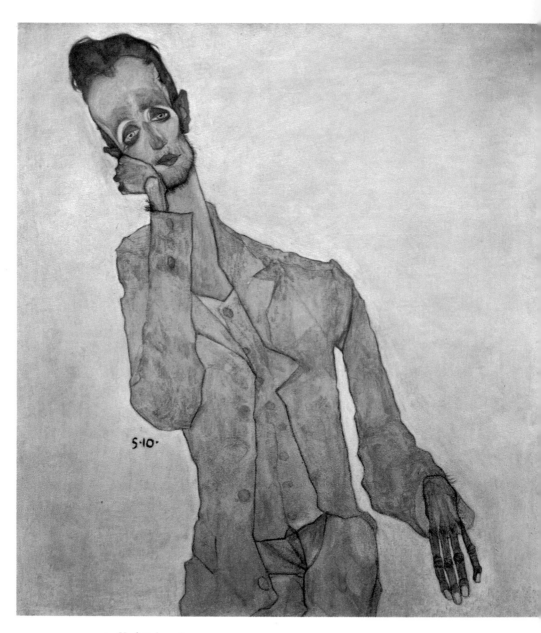

55 *Karl Zakovsek*, 1910

one of Vienna's greatest architects who wished to be painted by some-one young and promising. This was Otto Wagner, best known for his designs for the city railway and for the Post Office Savings Bank. Made aware of Schiele by Klimt and Roessler, Wagner was deter-mined to play the patron in a big way and suggested that his portrait be merely the first of a series of Viennese artists and intellectuals, among them Hoffmann, Bahr and Mahler, all of whom Wagner would persuade to sit and all of whom would provide the necessary canvas and paint.

There seems to have been no shortage of eminent people prepared to risk their likeness at the hands of unconventional painters, although Wagner, as it happened, was not prepared to risk very much. When he saw what Schiele was doing to his face and, incidentally, how long he was taking to do it, he cancelled everything and failed to put Schiele in touch with the other worthies on his list.

If Schiele saw so many of his sitters as isolated beings tortured by some nameless mental anguish, then his vision was provoked as much by his own perception of himself as by what he perceived in the sitters themselves. In a sense, all his portraits are likenesses of his inner self, mirrors in which he saw his own anxieties reflected. It is his own relationship with the outside world that is dislocated.

This is made clear by a series of brilliant and profoundly disturbing self-portraits of 1910. Perhaps the most unnerving of them is the nude 56 self-portrait which shows the artist emaciated, his skin bruised and tender, his face registering agonizing pain, the hairs on his legs bristling as though reacting to an electric shock. His pose is vulnerable and defenceless.

There is even a passage in Robert Musil's *Young Törless* which might well be a description of one of these self-portraits:

When he imagined the body free from clothes he found it impossible to allow the impression of its quiet slimness to remain. Restless, turning movements appeared immediately before his eye, a twisting of the limbs and a distortion of the spine of the kind one can see in representations of martyrdom or in the grotesque presentations by performers at a fair.

The grimacing self-portrait with a single tooth hanging in an open 57 mouth also shows a cry of pain. Here, as in the curious likeness of himself in which he pulls down on his cheek, he sees himself as a 58 victim, but as a victim who glories in his own misery.

79

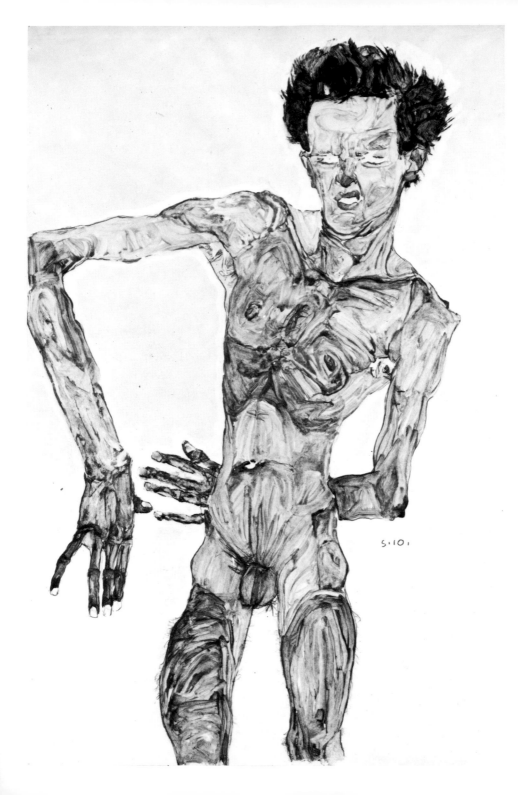

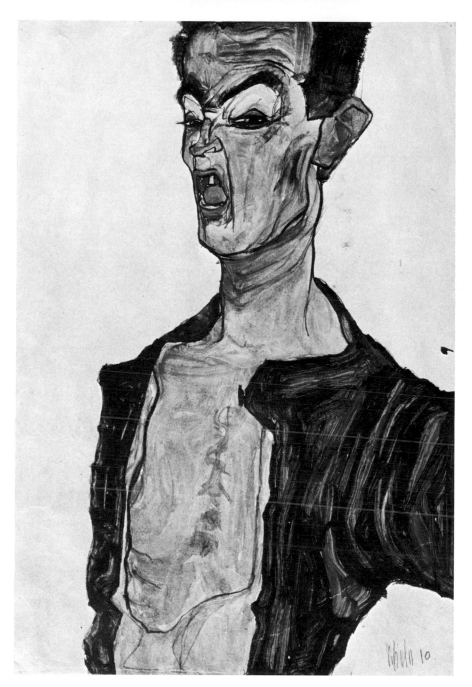

57 *Self-portrait with tooth*, 1910

56 *Self-portrait standing*, 1910

Mitsch has pointed out that the cheek-pulling self-portrait relates iconographically to the subject of the Man of Sorrows. It therefore secularizes a religious theme, drawing on its many implications to heighten its own expressive power. Maybe a genuine despair at his own alienation and loneliness forces Schiele to draw attention to himself in a hopeless attempt to make contact. But whatever these works reveal of his mental state, they also show the need the artist had to dramatize himself and to strike impressive postures. As a result the portraits tread the tightrope of powerful expression across the void of mawkishness and empty rhetoric.

59 One of the most interesting self-portraits of 1910 is *Self-portrait drawing a nude model in front of a mirror*. In it, the self-portrait and that most necessary piece of equipment for the artist depicting himself, the mirror, are combined with what has already become another of the painter's preferred subjects, the female nude.

Schiele sits, his eyes directed away from his model, while we, actually in Schiele's position, see her both from the back and, as a reflection, from the front. Slim, small- but firm-breasted, she looks invitingly at us, her eyes dark, her lips sensuous and full. The extravagant hat, the stockings, the hand placed on the hip so as to draw attention to the pubic hair are all devices designed to emphasize that this is no academic life drawing: what Schiele is interested in is sex.

Both Matisse and Picasso were fond of depicting themselves drawing nude models, with or without the aid of mirrors, and the results are frequently highly erotic. But the eroticism in, say, Picasso's *Vollard suite*, comes as much from the voluptuous lines as from the pose and expression on the faces of the sitters. The sensuous quality of the drawing becomes an equivalent of the sexuality of the subject. In Schiele's drawing, sex is implied in another way. It is as though we were in Schiele's place, sharing his enjoyment of his model's body.

Clearer still are the intentions of a series of remarkable and frankly
60, 63 erotic drawings of young girls which Schiele made in the same year. Physically immature, thin, wide-eyed, full-mouthed, innocent and lascivious at the same time, these Lolitas from the proletarian districts of Vienna arouse the kind of thoughts best not admitted before a judge and jury. One of them, decked out in stockings, neck-band and
62 earrings, is even shown masturbating, her face registering pleasure and longing for the real thing.

82

58 *Self-portrait pulling cheek*, 1910

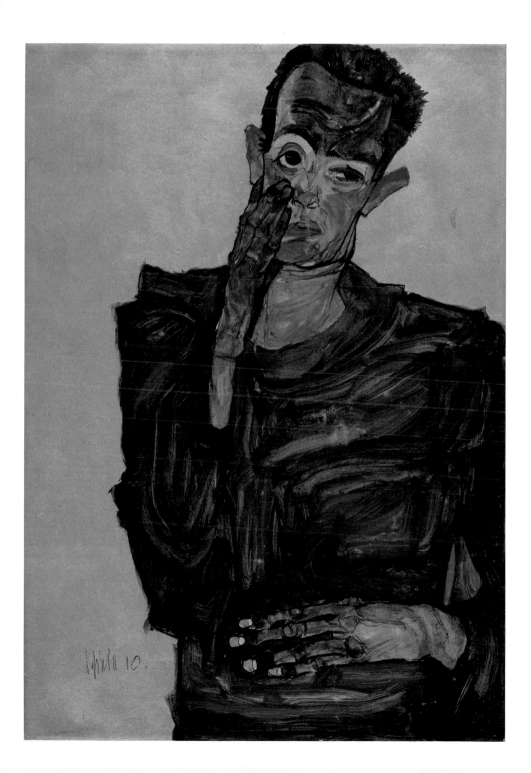

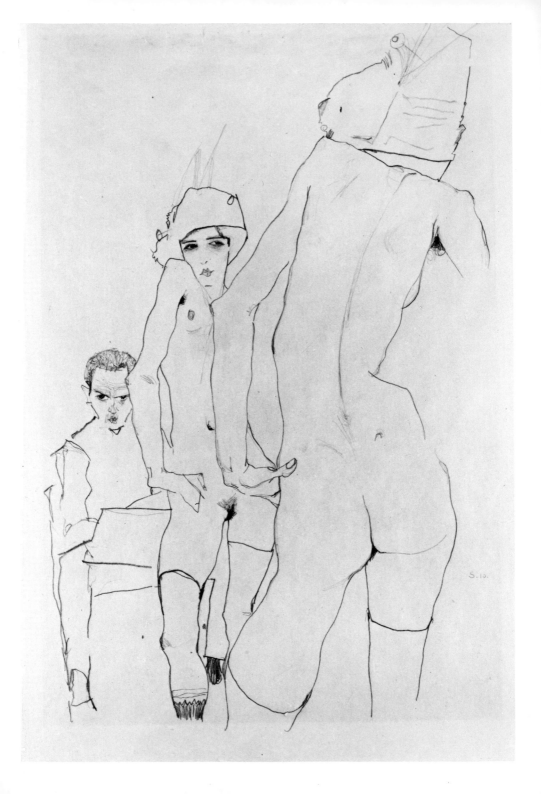

59 Self-portrait drawing a nude model in front of a mirror, 1910

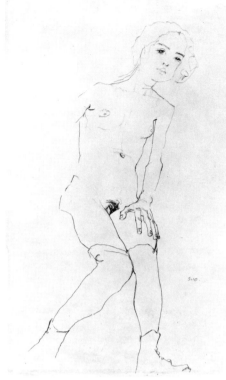

60 Seated girl, 1910

61 Reclining woman, 1911

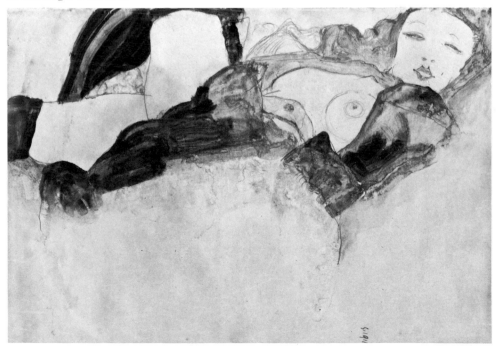

Even now it is disturbing to see an intensely private act portrayed so openly. And we must remember that in Schiele's Vienna masturbation was hardly admitted to. It was widely believed to cause blindness, madness and other terrors. Drawings which depicted masturbation were therefore deeply shocking in a way which we are no longer able entirely to understand.

Perhaps most disturbing of all are the questions such drawings force us to ask about Schiele himself, especially as this drawing was obviously made not from his imagination but from life. Did he make them because he was sexually aroused by young girls? Was he aroused by them because he feared adult women? Did he draw them because they appealed to certain collectors with unusual appetites who were prepared to pay good money for them?

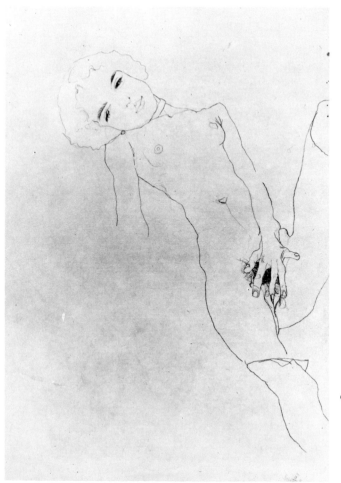

62 *Reclining girl*, 1910

63 *Standing nude girl*, 1910

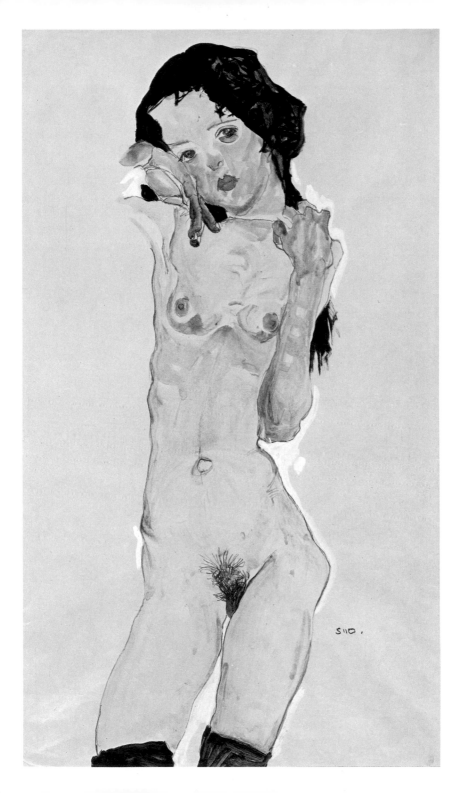

Mitsch has suggested that some of Schiele's erotic drawings betray the influence of that notorious nineteenth-century pornographer

Félicien Rops whose work Schiele knew and admired. Rops was an extreme example of that kind of Symbolist who delighted in providing pleasant shocks by suggesting or depicting in detail explicit sexual acts, often of an unusual nature. He manipulates the spectator shamelessly, giving them sight of things like a cartoon Arab shuffling a set of dirty postcards.

What separates Rops from Schiele is the deep personal involvement of the latter. What in Rops is a laugh or a snigger is in Schiele a cry for help. In his loneliness Schiele seems to be asking us to look at his fantasies in a desperate attempt to establish contact, and to share something with him which we usually keep private from everyone except those we know extremely intimately.

Most of Schiele's friends, understandably enough, have been at pains to argue that he was not a pornographer and that the often frenzied sexuality of his drawings was not matched by his own behaviour. Roessler wrote:

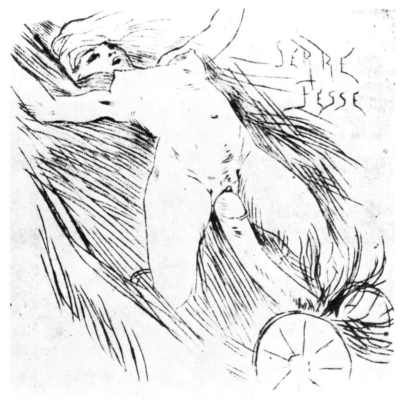

64 Félicien Rops, *Serre-Fesse*

65 Viennese postcard,
c. 1910

In spite of his 'eroticism', Schiele was not depraved. His friends did not know him as a 'practising' eroticist. . . . What drove him to depict erotic scenes from time to time was perhaps the mystery of sex . . . and the fear of loneliness which grew to terrifying proportions. The feeling of loneliness, for him a loneliness that was totally chilling, was in him from childhood onwards – in spite of his family, in spite of his gaiety when he was among friends.

That there is more to such drawings than the desire to arouse and titillate can be ascertained by comparing almost anything by Schiele with contemporary photographs of similar subjects. Pornographers 65
are idealists. For them every woman is physically perfect and entirely a creature of her sexual desires. She is instantly and permanently available. Her flesh is firm and smooth, her breath sweet, her feet clean. By contrast, Schiele's girls and women are real. They are not conventionally beautiful. Their bodies are mottled and, in places, raw. Skinny and awkward, they are anything but ideals. Their flesh is stretched taut over the bones beneath.

There is an obvious tension between the erotic elements in these drawings and the style in which they are described. Especially striking is the way Schiele applies colour to the faces and bodies of his women.

89

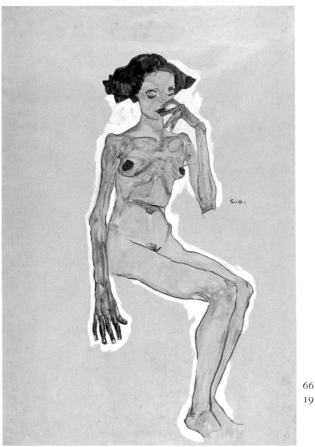

66 Seated young girl,
1910

66 The colour on the *Seated young girl*, the red around her eyes, in her hair, on her skin, make her look less than healthy, but she nevertheless does her best to look seductive. The effect is very unsettling.

67 Colour plays a similar role in the *Nude girl with crossed arms*. This is actually a drawing of Gerti, who regularly posed for Schiele at this time. Gaunt as a medieval wood-carving, she stands protecting herself as best she can from our inquisitive gaze. Her body is covered with patches of green, red and yellow which suggest sickness. It is such suggestions of imperfection and vulnerability which make Schiele's erotic drawings so worrying. Even at the moment of the most direct invitation we are made to think of post-coital tristesse. We are never allowed to forget that human flesh is a perishable, imperfect substance, that the most appealing body hides the skull and skeleton beneath.

67 Nude girl with crossed arms, 1910

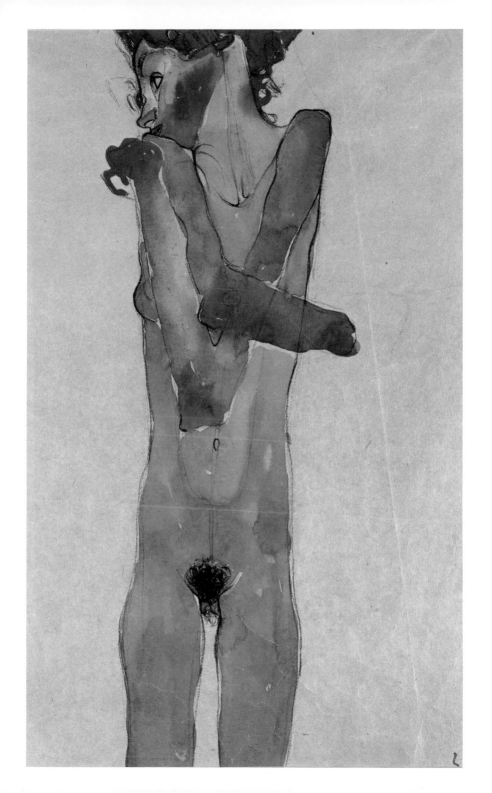

Schiele's obsession with sexuality seems less remarkable when viewed against the background of contemporary Vienna. We have already seen something of Zweig's memories of the extensive prostitution and of the mental and physical miseries it caused. Zweig hated the Victorian morality, its double standards and the 'sticky, perfumed, sultry, unhealthy atmosphere' in which he grew up, and he hated the huge pornographic industry which flourished in it. He remembered:

'Art' and nude photographs in particular were offered to half-grown boys for sale under the table by peddlers in every café . . . pornographic literature of the very worst sort, called *sous le manteau*, printed on bad paper and written in bad style, found a tremendous public as did magazines of a racy nature. . . . In the final analysis that generation, to whom all enlightenment and all innocent association with the opposite sex was prudishly denied, was a thousand times more erotically inclined than the younger generation of today with its greater freedom of love.

Zweig might have added that the feverish interest in sex, stimulated by the strict moral code, led only to frustration. For pornography and prostitution raise expectations which they cannot satisfy, and the more often they fail to satisfy the greater those expectations become.

We have also seen how this interest in sexuality emerged on elevated and serious levels in, for example, the work of Freud and in much contemporary literature which, reacting as Zweig did against dishonesty, attempted to bring everything out into the open and, in the case of Wedekind, far more. But there were also famous pornographers, the most collected artist being Bayros, a true bourgeois voyeur. The pornographic books of the time, or at least the classics among them, range from Sacher-Masoch's *Venus im Pelz* (*Venus in Furs*) of 1890 – while a relative gave the first part of his name to a cake, Sacher-Masoch gave the second to a variety of sexual deviation – to *Josefine Mutzenbacher* (1906). This deals in explicit and often hilarious fashion with the wild sexual adventures of a young Viennese girl who embarks on her career as a whore well before the age of consent. Significantly, it is set in the proletarian Ottakring District of the city. Published anonymously, it has been ascribed to Felix Salten, later to achieve world fame with a very different kind of book – *Bambi*.

That Josefine Mutzenbacher has experience of sex as a child is significant. For paedophilia was rife in Schiele's Vienna, and many of

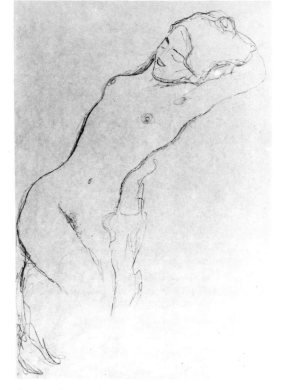

68 Gustav Klimt, *Naked woman turning to the right*, 1913

the girls and boys from the working-class districts helped to support their families by selling themselves. Several artists and intellectuals were known for their preference for sexually immature children, and it was this which haunted the writer Peter Altenberg. Indeed, it would not be long before Schiele was accused of the crime himself.

In contemporary Viennese painting sex was also widely celebrated. Klimt's paintings, and above all his drawings, are dominated by a powerful and heady eroticism. This is unmistakable even in his symbolic figure compositions and portraits where ladies from polite Viennese society are shown as sensuous creatures, the riotous decoration in which they are fixed acting as visual signs of their magnetic sexuality.

Klimt's eroticism is direct and uncomplicated. His soft, caressing line emphasizes the femininity and passivity of his women who lie, more often than not, luxuriating on rich and delicate materials, their faces transfixed by sensual delight. The spectator is both voyeur and potential participant.

68

Although such drawings were not intended to have wide circulation, the message is clear enough in public works. *Judith*'s joy may be perverse, holding as she does the severed head of Holofernes, but the half-closed eyes and half-open mouth signal invitation and her luminous skin and delicately coloured nipples seem to tingle with excitement. She may be a member of that extensive family of vamps, beloved of nineteenth-century artists and writers who celebrated the irresistible woman who ruined men, but she is equally the forerunner of the modern pin-up, whose expression and gestures are calculated to cause stirrings in the loins.

Schiele's attitude to sexuality was, however, as fundamentally different from Klimt's as his psychological portraits were from the older artist's decorative ones. It is worth repeating here what Otto Benesch once wrote on the subject:

The problem of the erotic, the sexual is common to Klimt . . . to the Kokoschka of *The dreaming youths* and to the Schiele of the drawings of 1910 and 1911. In Klimt and Schiele the common interest becomes a true affiliation, a related manner of seeing and experiencing. But what in Klimt is a music of intoxicating sweetness and lyrical magic becomes in Schiele shrill, rough dissonances, . . . a demonic vision.

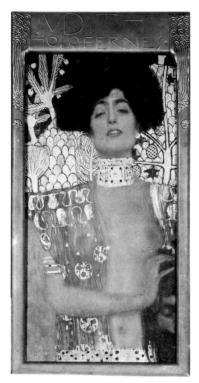

69 Gustav Klimt, *Judith*, 1901

Scandals 1911-1912

I was in love with everything –
I wanted to look with love at the angry people
so that their eyes would be forced to respond;
and I wanted to bring gifts to the envious and tell them
that I am worthless.

From 'Visions', *Die Aktion*, 1914

In January 1911 Schiele was in danger of losing one of his most valuable friends, Roessler. Annoyed by the artist's behaviour, he wrote Schiele a letter accusing him of

making mischief, writing spying letters to third persons behind my back and gossip . . . you tell other people what I told you in confidence in a childish search for notoriety. . . . I must restrict my dealings with you until you bring to your behaviour – which I hope will become more adult – as much consideration and cultivation as you devote to your art. You should be less anxious to make capital by hawking around details of your relationship with Klimt and also less keen to try architect Wagner's patience or tactlessly to damage well-meaning friendships. I'm not bluffing.

On the same day, unwittingly providing evidence for one of Roessler's accusations, Schiele sent the critic a brief note whose entire point was to boast of his intimacy with Klimt. He said that he had been given 'two lovely drawings by Klimt. I spent the afternoon with K. He showed me everything.'

Schiele did not reply to the points Roessler made. Instead and by return, he posted a long, emotional and incoherent monologue in which he seems to be saying that all his gestures of friendship have gone unrewarded: 'I, eternal child – I sacrificed myself for others whom I pitied and who were far away and who looked but did not see me. I bought gifts, sent them glances and trembling entreaties; I gave them opportunities to reach me and – did not speak.'

Schiele probably exaggerated how close he was to Klimt to enhance his own importance in the eyes of potential patrons and spread gossip

about the Viennese art world to make it seem as though he was at the centre of things. He often tried to imply that he was in the same league as Klimt and other famous painters. Just two months earlier he had written to Roessler asking:

Why can't there be a large international exhibition in the *Künstlerhaus?* – I've said this to Klimt. For example, each artist has a room to himself – Rodin, Van Gogh, Gauguin, Minne . . . Klimt, Toorop, Stuck, Liebermann, Slevogt, Corinth, Mestovich etc. Only painting and sculpture. What a sensation for Vienna! – A catastrophe!

At other times the boasting gave way to self-pity. In January 1911 he wrote to Roessler:

Are things to go on like this? I haven't worked or been able to work for days. I haven't even got any wrapping paper . . . won't anyone help me – If only I could have an exhibition. . . . I must borrow money, now in the very best years and days of my life when I want to work – How unfair people are . . . who will help me? – I can't buy canvas, want to paint but have no colours.

It was in 1911 that Schiele met the woman who was to serve as the model for some of his best and most chilling erotic drawings. Her name was Wally Neuzil and she was seventeen.

Wally had previously posed for Klimt, who passed her on to the younger man. The verb is intentionally ambiguous. Given Klimt's habit of sleeping with his models, she probably shared his bed. She certainly shared Schiele's, living with him until he married another woman in 1915.

It is frustrating that we know little more about Wally than the information contained in a handful of poor snapshots and in the drawings Schiele made of her. What kind of a family might she have come from? How unusual was it for a girl, scarcely more than a minor, to pose for and sleep with artists? What kind of education might she have had? Was she one of the poor from Ottakring?

Wally was obviously devoted to Schiele. According to Comini, she not only posed for him and performed the household chores but also acted as a messenger, taking drawings, some of them erotic, to clients who occasionally made remarks to her so lewd that they reduced her to tears.

96

But Wally was certainly no innocent. She inspired in Schiele the kind of erotic fantasies on which his art throve. In a series of superb drawings she stares out at us, inviting and expectant, her doll-like 70, 107, 110, 114 eyes and full, sensual mouth innocent and knowing at the same time, the naked portions of her body dramatized by a bright red blouse, lacy drawers, coloured stockings and garters. These drawings are the expression of a physical passion so far unequalled in Schiele's life. Earlier drawings of similar subjects are, by comparison, those of a voyeur. These speak with delight of participation.

Soon after meeting Wally, Schiele decided to return to Krumau. Vienna had again become oppressive, and he had in any case not abandoned hope that he would one day discover the rural paradise where, he believed, his art would flourish. But Krumau defeated him now as it had done before.

Openly living with his model in the midst of a small, intolerant, self-righteous community (which no doubt relished the prurient gossip Schiele's presence provoked), the artist quickly became the subject of disapproving glances, mutterings and much more. Life was made so difficult that the couple was forced to return to Vienna, though Schiele immediately began to look for somewhere else to go.

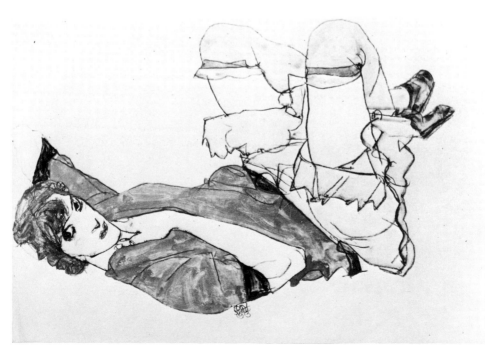

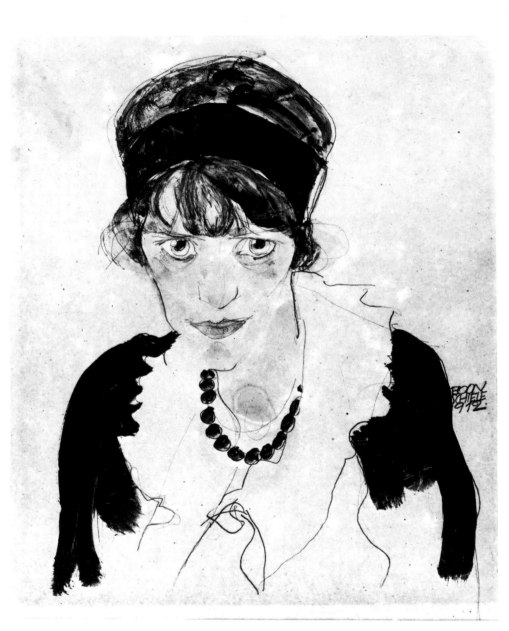

71 *Wally*, 1912

The artist's reaction to his expulsion seems to have been ambivalent: maybe it provided him with evidence that he was right to think of himself as someone beyond the confines of conventional mores. It was not without a certain pride that Schiele wrote to Roessler on the last day of July: 'You know how much I like to be in Krummau [sic] and now life is made impossible. People boycott us simply because we're red. Of course I could defend myself, even against all 7,000 of them, but I don't have the time and why should I bother?'

'Red' had nothing to do with politics; it was a common description of someone who did not go to church. But that must have been the least of the community's objections.

This conviction that he was special continued to grow. In 1911 he sent a picture to one of his patrons, Reichel, together with a letter in which he described it as being 'SURELY at present the best thing that has been painted in Vienna'.

Soon after returning to the capital from Krumau, Schiele found a house in the rural town of Neulengbach, no more than half an hour's train ride to the west of Vienna, and he quickly moved there with Wally. It was in Neulengbach that the events took place which forced Schiele to take stock of himself as he had never done before.

Schiele was enchanted by his new surroundings. The house he rented was in the middle of lush meadowland, completely isolated on the edge of the town and with a view of a wooded hill with a castle at the top. As so often when he changed addresses or felt especially confident he tried to repair relations with his uncle by attempting to impress him with news of exhibitions and sales:

I don't want you to think of my failure to see you for eighteen months as a sign of vanity. Someone in a café recently asked to have my visiting card or to know my name. I replied that an audience with me cost 300 Crowns. He was shocked by that piece of information, but it was pride, pure pride. My understanding of psychology tells me that it is small people who are vain, that small people are too small to be proud and that big people are too big to be vain.

He closed the letter with 'some of my aphorisms' which included: 'Artists will always live. . . . A single "living" work of art is enough for the immortality of an artist. . . . My pictures must be placed in buildings like temples.'

Not surprisingly, this arrogant letter was as unsuccessful in regaining Czihaczek's sympathy as all the others had been.

One of the most remarkable works that Schiele produced in Neulengbach is a painting of his room. Obviously inspired by Van Gogh's picture of his own bedroom in the yellow house at Arles (a version of which was owned by Schiele's patron, Reininghaus), Schiele's picture is equally intimate and personal. The details of the furniture, the mundane paraphernalia of the room have been lovingly described, but the effect is unsettling. The rickety bed, the tall, spindly legs of the table beside it and the unusually high viewpoint from which everything is seen make the entire world seem fragile; and the carefully placed blocks of local colour, which shine out from the predominant black, white and yellow, do nothing to modify the sombre, even oppressive atmosphere which it radiates.

The painting was executed on a smooth piece of wood and the colour was applied in several very thin layers, a technique very close to the traditional one of glazing and which, in Schiele's case, produced effects much like enamel. The artist was obviously pleased with the results, for he painted several pictures using this technique in 1911 and 1912, exploiting to the full its potential for rich luminosity and resonant colour.

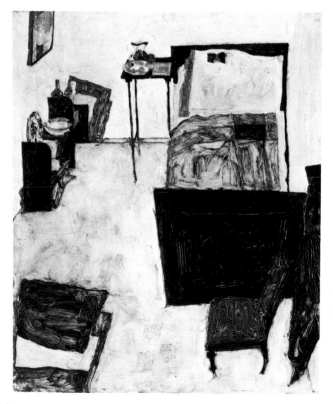

72 *The artist's room in Neulengbach*, 1911

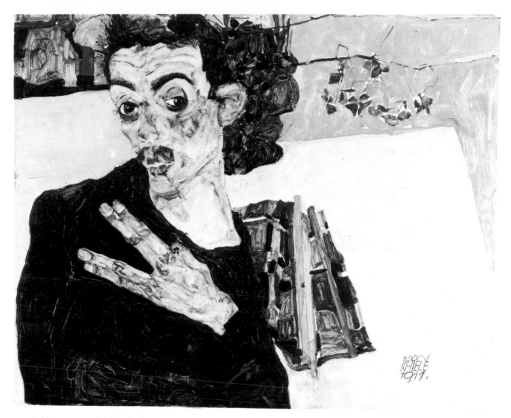

73 *Self-portrait with black clay vase*, 1911

He called these works his *Bretterl* (little boards). One of the best of
them is the *Self-portrait with black clay vase* which shows the artist, 73
wide-eyed and vulnerable, trapped against a geometric, patterned
background. The gesture of the hand (impossible for all but the double-
jointed) is as mannered as the composition itself and is clearly intended
to contain a meaning as specific as anything in the gestural repertoire
of medieval representations of saints. The hand protects the breast,
but the parted fingers seem to invite attack at one particular spot. The
thumbs appear already to have been amputated. The vase itself is a
representation of a man's head and has been merged, Janus-like, with
Schiele's own, suggesting a second, darker identity. It recalls Gauguin's
painting of himself with a ceramic head, a work Schiele may have
seen in reproduction.

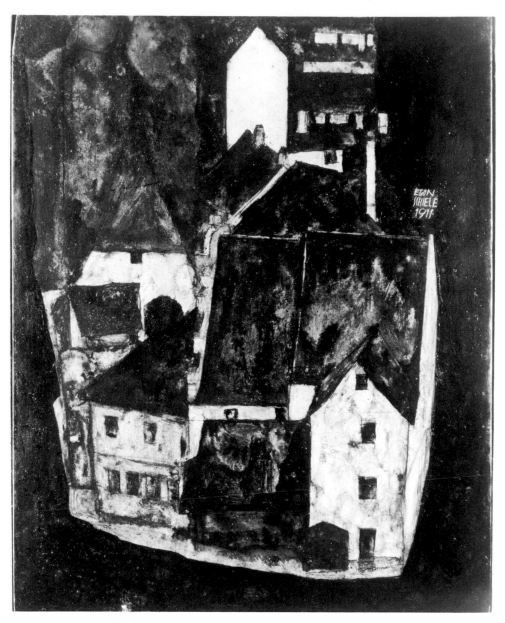

74 *Dead town*, 1911

75 Gustav Klimt, *Schloss Kammer on the Attersee*, 1910

During 1911 Schiele continued to paint autumnal, natural subjects especially sunflowers and trees with bare branches and withered leaves. But he also began to explore the possibilities of a new kind of landscape motif: the small town, isolated, menacing, devoid of people and seemingly dead.

The title of one, *Dead town*, makes it clear what these pictures are 74 about. Tightly interlocking buildings enclosed by a protecting river or wall, their lines gaunt, their windows blank, evoke a mood of lifeless rigidity. Once again Schiele has adapted one of Klimt's favourite motifs, using it to make statements that were quite foreign to Klimt's mentality. In place of Klimt's celebration of nature he has 75 set a metaphor for a pessimistic view of the human condition. His towns, like his flowers and trees, speak of life ebbing away or irrevocably departed. They are mere shells, dull and dry now that the spirit has fled.

None of the studies of trees and flowers or the paintings of towns which Schiele made now or later persuades us to think of him as an

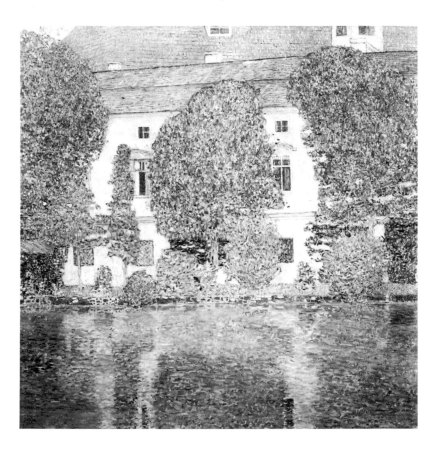

artist who drew his primary inspiration from nature. In spite of his search for a rural paradise he seems resolutely to have been an urban creature, interested above all in other human beings and in nature only as an adjunct to them. Yet what he wrote in letters, diaries and in the verse which he composed from time to time suggests otherwise. The brief autobiography he wrote, for example, is largely a celebration of the emotions which nature inspired in him:

The impressions of my childhood which clearly remained with me afterwards were of flat landscapes with rows of trees in Spring and of raging storms. In those first days it was as though I heard and smelled the miraculous flowers, the mute gardens, the birds in whose blank eyes I saw myself pinkly mirrored. I often wept through half-closed eyes when Autumn came. When Spring arrived I dreamed of the universal music of life and then exulted in the glorious Summer and laughed when I painted the white Winter.

These reactions to nature are conventional: they have the musty smell of the second-hand about them. What Roessler wrote about the town paintings sounds more genuine, considering the nature of Schiele's pictures:

I learned that Schiele was interested in towns more than in open landscapes because it is in towns that the governing forces of nature . . . are crystallized into powerful and clear cubic forms. . . . Towns impressed him . . . as manifestations of creative forces which are reproduced in flat and formally wonderful shapes.

Roessler also reports Schiele as having admitted that he looked

for the sadness and destitution of dying towns and landscapes with a happy heart . . . not out of perversity, not because I wanted vainly to flatter myself with the power of the dead, but because I am conscious of my humanity, because I know there is much misery in our existence and because I find Autumn much more beautiful than every other season . . . not only as a season but also as a condition of man and things – therefore of towns, also. It fills the heart with grief and reminds us that we are but pilgrims on this earth . . . the builder of the first town was Cain, Cain who slew his brother Abel.

Symbolic figure compositions painted at the same time (the first entirely satisfactory works of this kind in Schiele's oeuvre) convey a similarly pessimistic message, prefigured in *Dead Mother* of 1910.

76

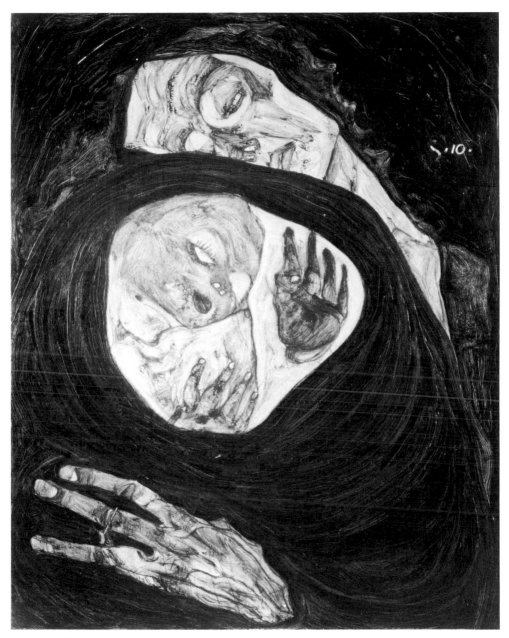

76 *Dead mother*, 1910

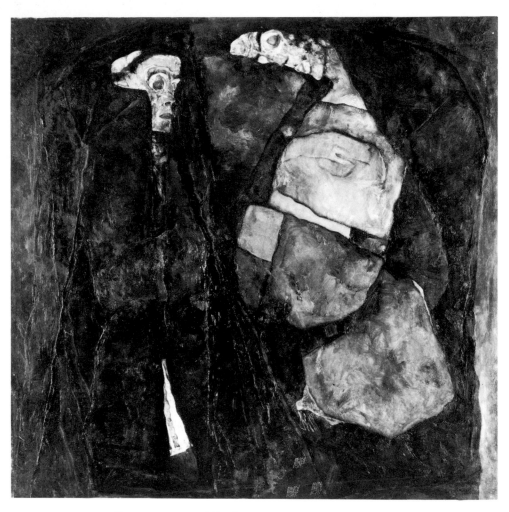

77 Pregnant woman and Death, 1911

77, 78 Among them are the *Pregnant woman and Death, The prophet* and *The*
 79 *self-seers.* In spite of their heavy and obvious reliance on ossified
 nineteenth-century Symbolism (*Pregnant woman and Death* is a re-
 working of that most clichéd of themes, Death and the Maiden), they
 are eloquent and effective even though they defy all attempts at
 satisfactory interpretation.

106

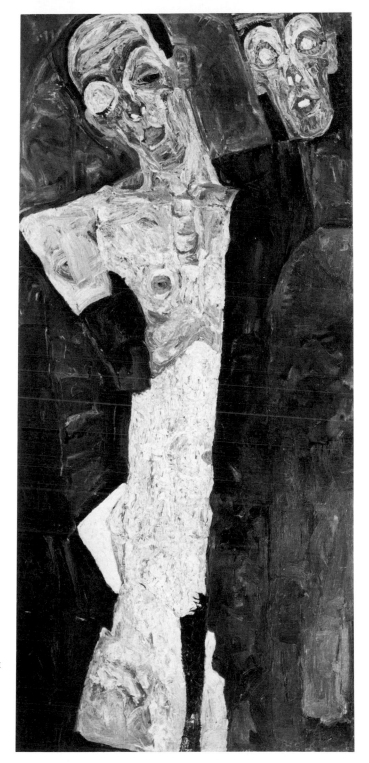

78 *The prophet*, 1911

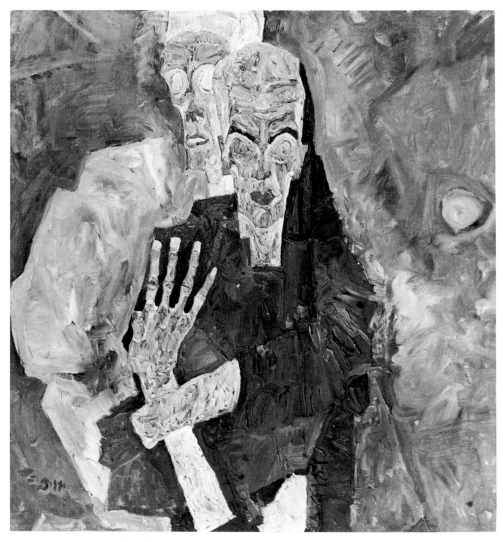

79 *The self-seers*, 1911

The self-seers, of which there are three versions, is a double self-portrait and, as such, relates to the theme of the *Doppelgänger*, so popular in German Romantic literature and, in debased versions, in much contemporary fantasy fiction. The *Doppelgänger*, a person's exact double, almost invariably turns up at the moment of that person's death and many dramatic turns of phrase were devoted to that last, blood-chilling encounter between the usually young protagonist and his mirror image.

These paintings clearly allude to such symbolic confrontations with the self, as they do to those self-portraits, also common in the nineteenth century, which show the artist unaware of the presence of death, usually skeletal, black-cloaked or both, grinning over his shoulder. Given Schiele's inordinate fascination with himself and his love of morbid subjects it is not surprising that he turned to this theme.

It is tempting to think that Schiele has done his best to produce impressive symbolic or allegorical compositions, firstly because Klimt took such subjects so seriously, secondly because it was in such paintings that an artist might demonstrate his intellectual and technical grasp and, as a poor last, because such compositions afforded a way of expressing ideas and feelings more satisfactorily than more familiar subjects.

Empty rhetoric then, or an attempt to do justice to deeply felt emotions and complex ideas? One thing at least is clear. Schiele saw himself as contributing to an important tradition in European figure painting which had recently been revived not only by Klimt but also by the Swiss artist Ferdinand Hodler. Hodler's work had frequently been exhibited by the Vienna Secession and he had become one of the most celebrated painters in Central Europe. His achievement was frequently compared to that of Cézanne – as for example in a very popular book, Fritz Burger's *Cézanne und Hodler* (1900), a copy of which Schiele owned.

Schiele, indeed, thought Hodler the greatest living painter apart from Klimt and he had ample opportunity to study his work in the Reininghaus collection. The Secession had staged a large Hodler retrospective in the Winter of 1903–4 from which Reininghaus had bought seven paintings. Schiele was intrigued by the way in which Hodler attempted to express moods and even to present abstract ideas by means of a complicated repertoire of pose and gesture. Schiele also admired Hodler's practice of achieving compositional

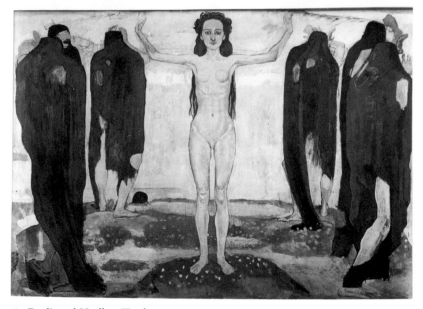

80 Ferdinand Hodler, *Truth*, 1902

80 unity by means of slight alterations in the positioning of his figures across his pictures, as in *Truth*, in a way which recalls the development of a musical melody. Hodler also used contour lines in an expressively articulated fashion.

The beginnings of what was to become an increasing concern for symbolic figure compositions did not prevent Schiele from continuing to work in a more familiar way. Drawings and watercolours of young girls, both naked and clothed, show that even Wally's attentions had not diminished Schiele's interest in pre-pubescent females.

Several of the children of Neulengbach used regularly to visit Schiele's studio just as some of the street urchins of Vienna had done. Fascinated by the spectacle of an artist at work, they were also grateful for the opportunity to escape from their mothers' watchful eyes and to play or laze about in a house which always welcomed them. They were also, no doubt, intrigued by the drawings Schiele showed them and were obviously only too willing to undress to be drawn by the artist in the same way.

81, 82 The *Nude against coloured background* confronts us with a challenging gaze while lying like some immature odalisque on a gaudy cloth. The

110

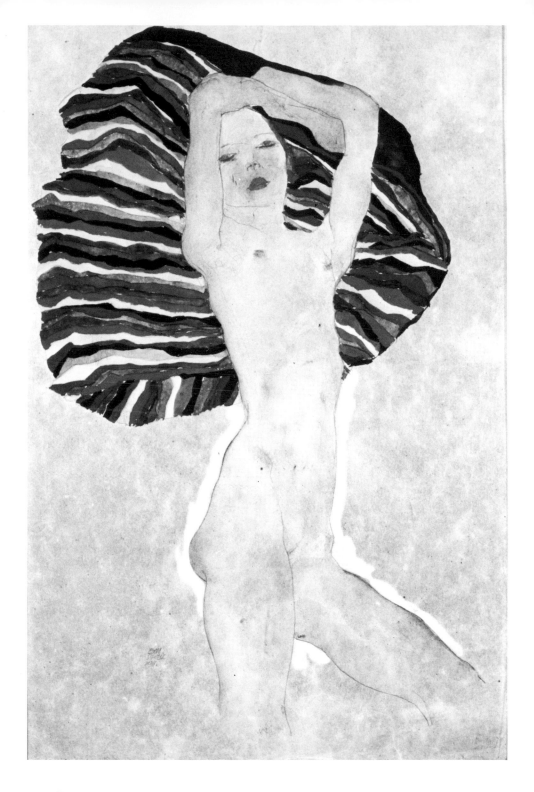

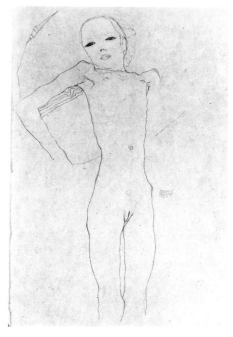

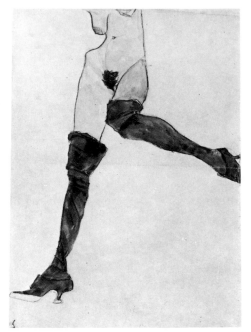

82 Sketch for *Nude against coloured background*, 1911

83 *Nude with mauve stockings*, 1911

84 *Two women* affords the glimpse of a pair of pudenda framed by the hems of hoisted skirts and the tops of black stockings. The *Nude with*
83 *mauve stockings* shows a mature model and is free from such devices, but is powerfully erotic none the less, forcing the eye to dwell on the woman's genitalia.

Schiele produced such drawings alongside equally sexually-inspired pieces in which the artist himself is the isolated, lonely protagonist.
85 In one self-portrait of 1911 he even appears to be masturbating, facing us as he might have faced himself in a mirror. His facial expression is sad and hopeless. What we see is not so much a person attempting to achieve temporary release in private as someone who appears to find fulfilment in making his most intimate actions public.

Mitsch describes the self-portraits of 1911 as a 'monologue' and sees in them an increasing weariness, an emphasis on resignation and submission: 'The cry of affliction is followed by an exhausted collapse. The picture-frame has become a prison from which there is no escape.'

112

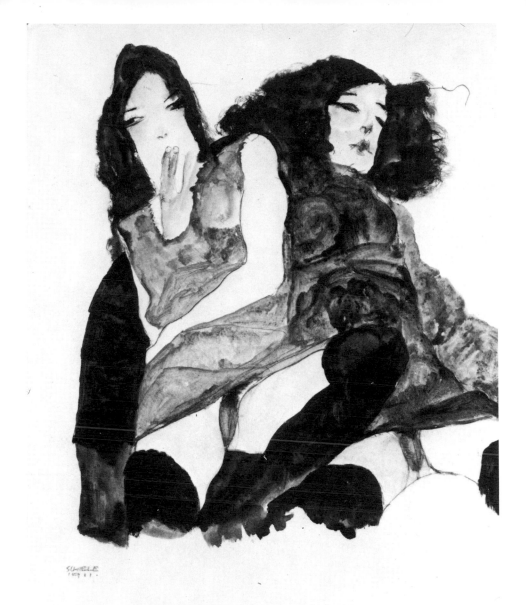

84 *Two women*, 1911

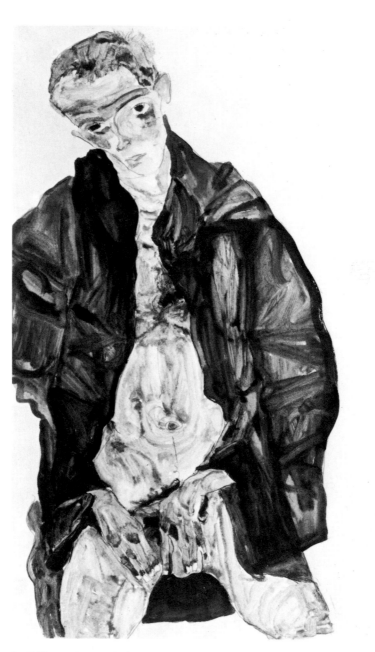

85 *Self-portrait masturbating*, 1911

In April 1912 events took place which have since inevitably become known as the Neulengbach affair. The town's inhabitants were scarcely less affronted by Schiele's behaviour than the villagers of Krumau had been. Indeed, they had a better reason for complaint. Not only was this arrogant-looking artist openly living in sin with his brazen, green-eyed, red-haired model, but his house was frequently bursting with local children whose behaviour there was certain to be scandalous. It was rumoured that Schiele lured them away from home, drew them in the nude and encouraged them to be curious about each other's bodies.

Complaints were made to the police who, when they visited Schiele's house, discovered a large number of erotic drawings in portfolios and pinned to the walls. They confiscated more than a hundred of them as pornography. But there was worse to come. Following a specific complaint, they accused him of seducing a young girl below the age of consent and put him in prison while they investigated the matter.

A letter from Reichel to Roessler, dated 2 May 1912, explained something of Schiele's predicament:

On Saturday Benesch visisted me. Schiele has been in investigative detention for fourteen days. B. visited him. He was imprisoned in Neulengbach and was in a dreadful state. There are miserable conditions there. Since then he has been taken to the district court at St. Pölten. . . . He is not allowed to send or receive letters. Apparently people have taken exception to the fact that he had his drawings hanging up and probably showed them to schoolchildren. B. also has the impression that the judge is not favourably disposed towards him.

After two weeks in gaol Schiele appeared in court. The charges of abduction and seduction were dropped but he was found guilty of exhibiting an erotic drawing in a place accessible to children. At the end of the trial the judge made a point of setting light to one of Schiele's works before the assembled crowd.

The judge was perhaps not as unfavourably disposed towards Schiele as this theatrical gesture suggests or as Benesch suspected. Exhibiting erotica was a serious offence with a maximum punishment of six months' hard labour. But the judge gave Schiele only three days in prison, the twenty-one days he had by this time spent in custody having been taken into account.

The conviction and punishment may seem unjust today, but in the light of the moral climate then prevailing and of the fact that Schiele was clearly guilty of the minor charge, he was lucky in the extreme.

While he was awaiting trial, prospects had looked decidedly grim. Had he been found guilty of seducing a minor he could have been sentenced to twenty years' hard labour.

This dreadful possibility makes it easier to understand and sympathize with the shrill, self-pitying manner in which Schiele described his three weeks in prison and helps to reconcile us to the embarrassing overdramatization of the words and phrases pencilled on the drawings he made while in detention: 'I do not feel punished, rather purified';
86 'To restrict the artist is a crime. It is to murder germinating life'; 'For
88 my art and my loved ones I shall gladly endure.'

The drawings, or at least the self-portraits among them, to which these phrases were added, are similarly self-pitying. Done in prison on miserably thin paper, they show Schiele, as ever, aware of his
87 audience. His face and body racked by some nameless torture, he presents himself to us as the uncomprehending victim of public persecution of artistic genius. Interestingly, these are the only self-portraits Schiele ever produced from memory. At all other times he

86 *Self-portrait as prisoner*, 1912

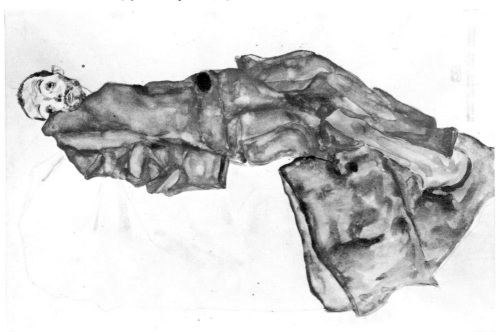

relied on what was for him the most essential piece of studio furniture, a mirror. In prison he was without one.

The Neulengbach affair occupies too large a part of the Schiele myth. The prison drawings and the journal he allegedly kept during his ordeal are the subject of a book and several articles. The affair has been made to seem the pivot on which his artistic achievement is balanced. Soberly viewed, however, it tells us less about Schiele than it does about the times in which he lived. The journal cannot be ignored; however, since it now seems certain that it was ghost-written by Roessler, its significance as a primary source of information about Schiele's personality is seriously compromised.

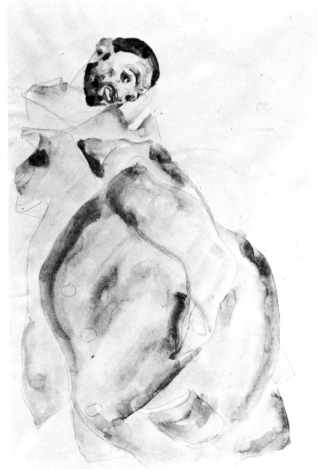

87 *Self-portrait as prisoner,* 1912

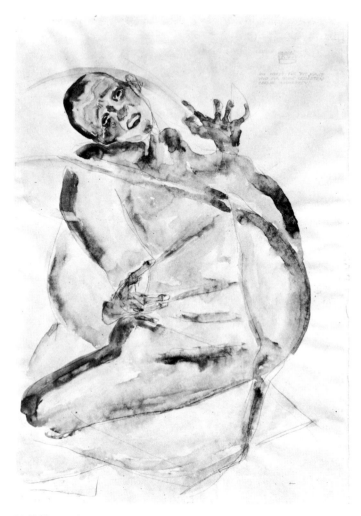

88 *Self-portrait as prisoner*, 1912

The chief importance of the Neulengbach affair rests in the effect
it had on Schiele himself. It provided the artist's image of himself
with rich sustenance. He now had the tangible proof that he was a
victim, even a martyr in the cause of art. At a time when it was
commonly believed that great art was born of suffering and that

public scorn was evidence of genius, Schiele's persecution was eloquent testimony of his importance.

In this regard, some of the prison diary does ring true. The fault, Schiele is made to say, lies entirely with the authorities: 'It is a shame for Austria that such a thing can happen to an artist in his own country.' Although Schiele does not deny making 'drawings and watercolours that are erotic', he insists that 'no erotic work of art is filth if it is artistically significant; it is only turned into filth through the beholder if he is filthy'. And this is the remark that rings truest of all: 'I believe that man must suffer from sexual torture as long as he is capable of sexual feelings.'

News of the affair reached Vienna quickly and ensured that Schiele became more notorious still. It was common knowledge that Schiele frequently produced erotic drawings for sale and some collectors bought nothing else from him. But after Neulengbach the artist was more careful, less eager to admit that he drew such things.

An amusing incident, set down in Roessler's memoir of Schiele, sheds light on some of the collectors and on Schiele's attitude to those he did not know well. A lawyer came to the studio one day and bought some drawings. While he was wrapping them up he said: 'You've surely got something more spicy than what you've shown me!' Only then did it become clear to Schiele

that the collector had only chosen drawings which might more or less accurately have been described as 'erotic' even though eroticism was not my aim while I was drawing them. I found the Herr Doktor's desires completely repugnant and so replied that I certainly did have some other works but that none of them was pornographic . . . he said . . . 'My dear chap, you have apparently forgotten that it was proved beyond doubt in court that you are the author of drawings and watercolours which one must . . . with full justice describe as pornographic or at least as strongly, very strongly erotic – why do you refuse to admit to me the existence of such things?'

Roessler then has Schiele say something impossible to believe: 'Many curious things have occurred during my dealings with those interested in art but never anything like that. The funny thing is that I truly had no drawing in any of my portfolios that was abnormally erotic – let alone pornographic.'

Presumably Schiele thought that Roessler's record of their conversations would be read by Neulengbach judges.

Successes 1912-1913

All beautiful and noble qualities have been united in me. . . . I shall be the fruit which will leave eternal vitality behind even after its decay.

From a letter to his mother, March 1913

Most of Schiele's friends and patrons stood by him throughout the Neulengbach affair which proved to have no serious effect on his career. Indeed, 1912 brought signs that he was about to acquire an international reputation. He was invited to show at the huge and historically important *Sonderbund* exhibition in Cologne and, thanks to Roessler's representations, was taken up by one of the most important dealers in modern art in Germany, Hans Goltz of Munich, who also had the most important *Blaue Reiter* artists under his wing. 1912 also saw plans for a monograph to be published in Germany, although this never materialized.

In 1912 Schiele also exhibited with the *Hagenbund*, a Viennese group which had broken away from the Secession, and got to know two more patrons who were to buy large quantities of his work. One was the industrialist August Lederer, the other was a far less conventional kind of collector: Franz Hauer who, although lacking in formal education, had an unusually sharp eye for the unusual and original. Hauer owned one of Vienna's most famous and popular restaurants, the *Im Griechenbeisl*, where he hung some of his collection which included works by Kokoschka and Faistauer.

The significance of the *Sonderbund* exhibition, at which Schiele showed three paintings, can scarcely be exaggerated. It was the largest show of modern art to be staged anywhere until then, brought together work from as far afield as America and Japan, and sought to explain contemporary art in the light of its sources, especially Post-Impressionism. It also brought to public attention for the first time the fact that there was a modernist school in the German-speaking countries which, although consisting of artists working independently and often far away from each other, had coherent aims.

Schiele therefore appeared for the first time together with his great Expressionist contemporaries, the painters of the *Brücke*, for example, the artists of the *Blaue Reiter* circle, to say nothing of the host of members of the School of Paris. Kokoschka also showed at Cologne, although Klimt was not represented. Clearly Dr Hans Tietze, the Viennese art historian who selected the Austrian section, considered that Klimt's work already belonged to a past age.

Even more important was the large exhibition organized at one of the holiest shrines of modernist art in Germany, the Folkwang Museum at Hagen in the Ruhr. Not until an artist had shown there could he consider himself to have arrived. Now Schiele had achieved this honour, only three years after it had been bestowed on his greatest rival in Vienna, Kokoschka.

Schiele's relationship with the Munich dealer Goltz was never easy and disputes were frequent. Schiele's demands on him were invariably unreasonable; and Goltz's reaction to every request was to repeat that he was not a charitable organization and needed to worry about his enormous overheads. He frequently told Schiele that he could not sell as much as he might since Schiele was not yet good enough to merit the high prices he insisted on. Goltz must also have been annoyed by Schiele's cavalier attitude to his work and to their business dealings. Benesch remembered that Schiele would frequently send to Munich 'dozens of drawings without cardboard protection, simply rolled up in wrapping paper, not stuck down, and simply provided with the necessary postage stamps'.

A letter from Goltz to the artist written in May 1912 is typical of many: 'First Roessler wrote that I have to clear all business matters and payments with him alone, then you send an exhibition to Germany in breach of our exclusive contract and now you demand money without reference to Herr Roessler. With whom, for God's sake, do I now have to negotiate?'

Goltz, whose letters show increasing irritation with his client, believed that Schiele's art was too provincial, too exclusively Viennese in character and advised him to make a long visit to Paris where he would benefit from the exposure to a more cosmopolitan and liberal artistic atmosphere. Schiele must have believed that there was some sense to the suggestion, for he tried unsuccessfully to persuade Reininghaus to finance his trip, after writing to friends about his leaving the country.

It is tempting to speculate about the results such a visit might have had, for Schiele not only would have been forced to come to grips with styles and attitudes quite foreign to his temperament, but he might also have come into contact with artists such as Amedeo Modigliani and Jules Pascin whose main subject was also the erotic nude – which they treated, however, in ways quite different from that adopted by Schiele.

Fortunately Schiele did not rely entirely on Goltz to make a living, and in 1912 his financial position improved, helped by the interest of Hauer, Lederer and the other patrons who, like Benesch, had already been involved with the artist for some time. By November 1912 Schiele was able to move to a new studio apartment on the top floor of number 101 Hietzinger Hauptstrasse in the 13th district, a good area of the city. As usual, however, Schiele was unappreciative of his good fortune, convinced that things could have been better. 'Why don't I have a brother Theo like Vincent Van Gogh?' he once asked Roessler. 'Or a patron of the sort that Konrad Fiedler used to be? That kind of person seems no longer to flourish today. What a pity!'

Not everyone was as supportive of Schiele as his patrons. Among the reviews of Schiele's contribution to the *Hagenbund* exhibition, for example, was one by A. F. Seligmann in the *Neue Freie Presse*. Since Seligmann is generally considered to have been Schiele's most remorseless critic, it is worth quoting from that review here.

Seligmann wrote of 'the dreadful and fantastic caricatures by E. Schiele, the ghostly wraiths with their bloody, spider's fingers and their mutilated, wasted corpses seen as though reflected in a distorting mirror. Even the paintings seem to have been resurrected from thousand-year-old graves.' But even Seligmann was prepared to admit that 'a refined, playful virtuosity of draughtsmanship, a decidedly different sense of colour and a powerful pleasure in the act of painting are nevertheless expressed in these grotesque depictions'.

Another hostile review appeared in the *Neues Wiener Tageblatt*:

We repeatedly have had the chance to discuss Schiele; at first as a most unsatisfactory imitator of Klimt and then, with some surprise, as a remarkable draftsman; today we must state that a genuine talent is in danger of perishing from a thirst for the odd and abstruse. Today Schiele is imitating with energy and devotion the youngest of the young in all their dreadfulness in which the snobbish élite loves to revel. He has a *Self-portrait* here that is

122

difficult to recognize because the decay from which he believes he must show his young face suffering is too far advanced.

The painting referred to is the *Self-portrait with black clay vase*. 73
 There is no doubt that Seligmann at least expressed a generally held view. Most people saw Schiele as a young, prodigious talent, with an ability with pen and pencil unmatched in Vienna. But they also thought his imagination was sick and did not believe that art ought to set out to disturb in the way Schiele's did. Some hoped that it was merely a matter of maturity, that the grotesque and feverish visions would fade once the artist had grown up and settled down.

Apart from portraits (such as the charming *Bretterl* of Roessler's wife, 90
Ida) and the bare and spidery *Autumn tree*, the most important paint- 89
ings of 1912 are symbolic figure compositions which now have a

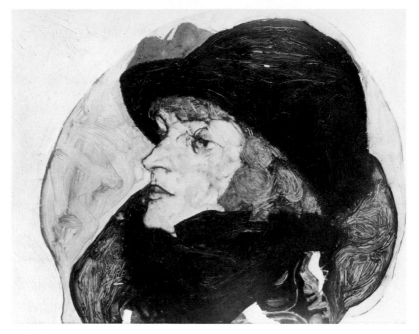

90 *Ida Roessler*, 1912

monumental strength and exploit powerful colours in an impressive way. Like most of Schiele's large symbolic paintings these take as their main themes sexuality and death, which are presented in a highly dramatic, formally powerful fashion, often combined with religious imagery. The sexual act is not only seen as providing intimations of immortality: intimations of immorality, even of sacrilege, are also made.

93 *Cardinal and nun (the embrace)*, a modification of Klimt's *The kiss*
92 (1907–8), introduces the shocking notion of carnal knowledge in the cloisters. It also reveals a growing understanding of the implicit meaning of abstract form and of how this meaning can augment the more conventionally descriptive aspects of a composition. The heavy-limbed figures are locked together, trapped within a system of overlapping triangles; they seem to float against an infinite void. Important though the robes are, it is as shapes and colours rather than as emblems of religious vocation that they function.

91 *Agony* also alludes to religion for the two figures in it appear to be monks. What is most interesting about this painting is not their

124

identity nor the possible meaning of their contorted poses but the way in which they emerge from a semi-geometric patchwork of coloured shapes and a web of crossing lines. Schiele has again adapted Klimt's decorative approach: instead of using pattern to create a richly detailed surface and to energize empty spaces he makes it a vital part of his compositional scheme, the dominant feature of his painting.

This use of pattern which extends from edge to edge contrasts with both *Cardinal and nun* and *The hermits*, another pseudo-religious painting in which Schiele himself appears with another figure which probably represents Klimt. In both, the two figures have been united as a bold, flat shape which asserts itself against the relatively empty, undecorated background. *The hermits*, like the other two pictures, is rhetorical but persuasive nevertheless, assured in the placing of the figures, daring in its distortion and occasional use of local colour. Even the crown of thorns, placed self-consciously on Schiele's head, does little to dilute the power of the painting.

These paintings are also technically interesting. Previously, many of his paintings were like enlarged coloured drawings, but now he is interested in effects which only oils can produce.

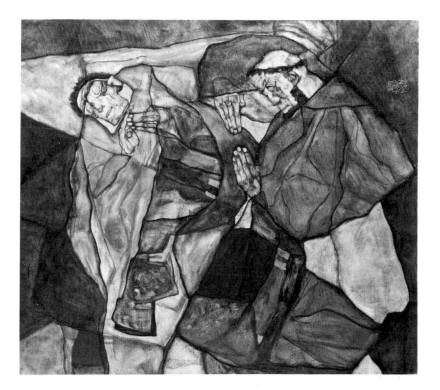

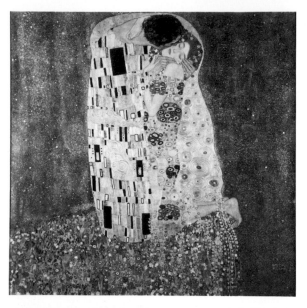

92 Gustav Klimt, *The kiss*, 1907–8

93 *Cardinal and nun*, 1912

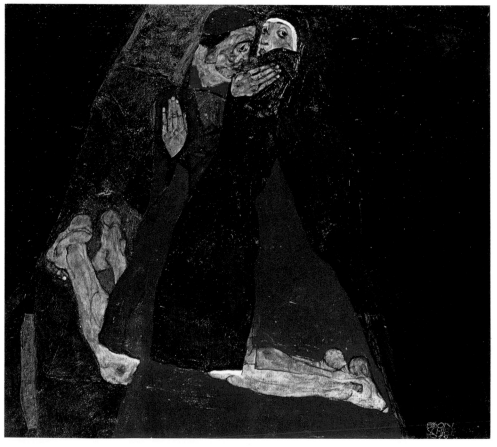

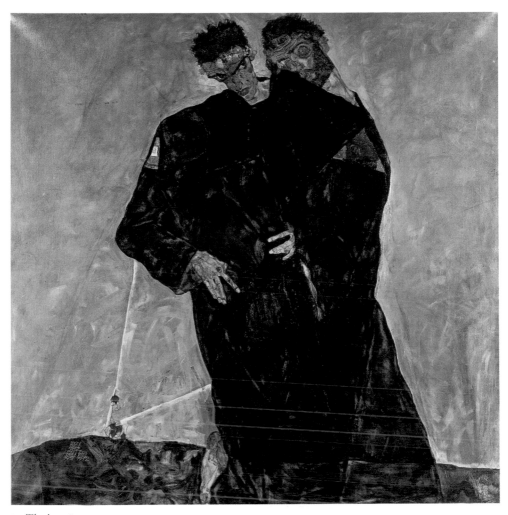

94 *The hermits,* 1912

One of the most interesting paintings made by Schiele either in
96 Hungary or from sketches after he had left the Lederers is *The bridge*,
a view of one of the landmarks of Györ, the place he was visiting. As a
subject it is unique in Schiele's oeuvre. Immediately striking are the
square format and the treatment of the details of the wooden bridge,
the telegraph poles and the decorated barge as elements in a composi-
tion which is on the verge of abstraction. He is not interested in making
the water look liquid, in positioning the barge in space, in explaining
the height or length of the bridge itself. What matters are the patterns
they make and the interplay between busy areas of detailed, graphic
description and relatively open spaces.

This kind of transformation of a landscape motif into a decorative
composition in which the illusion of space is compromised and in
which even empty spaces play a vital role in the pictorial structure is
reminiscent of Japanese prints. Schiele may indeed have had them in
mind when painting the picture. The bridge, as he wrote at the time,
impressed him as being 'completely Asiatic' and he was in any case
very interested in Chinese and Japanese art, examples of which he
collected. Even though Schiele painted nothing like *The bridge* again,
he did, as we shall see, succumb elsewhere to Oriental influences.

Schiele had good reason to be confident at this time. During 1913
he was elected to the *Bund Österreichischer Künstler*, the association of
Austrian artists whose president was Klimt. His work was shown in
Vienna at the *Internationale Schwarz-weiss Ausstellung* (the Inter-
national Black-and-White Exhibition) and at the Secession. His
international recognition also grew. In June the Goltz Gallery staged
an exhibition in Munich. Thanks to Roessler and Goltz his work could
also be seen in such German cities as Hamburg, Breslau, Stuttgart,
Dresden and Berlin. In Berlin Schiele came to the attention of Franz
Pfemfert, founder and editor of the Expressionist and radical political
journal *Die Aktion*. Pfemfert asked Schiele to contribute drawings to
it. Only Kokoschka, by this time as famous in Germany as in Austria,
was better known abroad than Schiele – at least in the world of avant-
garde art.

The most important painting of 1913 is the large, square double
98, 99 portrait of Schiele's patron Heinrich Benesch with his son, Otto. The
portrait is remarkable for the way in which it combines physical
likeness with dramatic tension. It also manages to describe the deep
and complicated relationship between father and son. Otto, on the

130

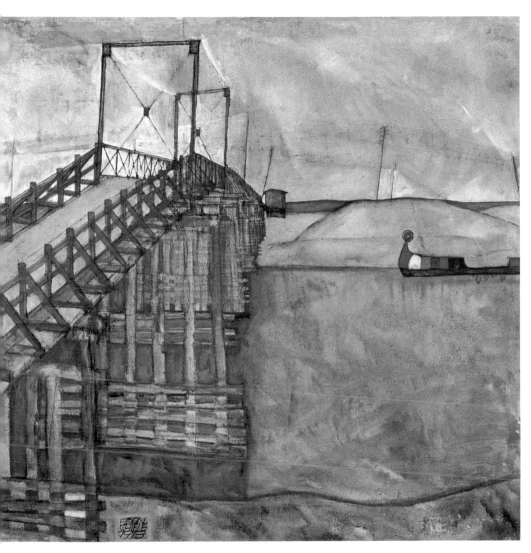

96 The bridge, 1913

threshold of manhood, about to gain his independence, is made to seem vulnerable, while the impressive and vital bulk of his father stands between him and the hostile world, his arm outstretched to protect him, his stern gaze issuing a warning to anyone daring to come near.

Years later, Otto's wife Eva wrote this about this painting:

Had Schiele – consciously or unconsciously – understood a deep psychological situation? Heinrich Benesch liked to dominate. The intellectual burgeoning of his son began to make him feel uneasy. Schiele recognized *the gaze into the world of the mind* beyond all external barriers already in the boy who was then seventeen and he expressed it in the portrait. It was a mental world in which Otto Benesch quite naturally dominated.

Perhaps, then, the gesture of the father's arm represents an attempt to delay the arrival of maturity, a final proclamation of his authority. The gesture is certainly powerful and its energy comes not only from its straightness. The arm also seems to move, for Schiele also painted it in another position, straight down, the hand in the father's coat pocket.

Otto once wrote down what he remembered of the long preparatory working sessions for the portrait:

Schiele drew quickly. The pencil skated over the white surface of the paper as though led by some ghostly hand . . . and he sometimes held the pencil in the manner of a painter from the Far East. He never used an eraser. If the model changed position, then new lines were placed beside the old with the same infallible certainty. Each sheet of paper followed the next without pause. . . . Inevitably a few drawings went wrong – there was always a heap of rubbish on the studio floor. . . . But the greatest master-

97 *Self-portrait with model*, 1913

pieces were also produced as though in a game – from the most relaxed, nonchalant and, yes, even from the most uncomfortable position taken by the artist. But how Schiele's eyes bored into his model! How he perceived every nerve and muscle!

Curiously, the portrait was not painted for Benesch. Its first owner was Reininghaus who bought it from Schiele for the not inconsiderable sum of 600 Crowns. The fact that 2 Crowns bought a good meal with wine in a first-class Viennese restaurant at the time provides some idea of what Schiele was now being paid for his paintings.

In 1913 Schiele felt ready to tackle extremely large formats and he produced a number of huge paintings which contained almost life-size figures. Unfortunately and mysteriously, these are now lost or exist only as fragments which do, however, provide some idea of what these monumental works looked like.

The fragment called *Self-portrait with model*, for example, was 97 executed in extremely thin paint and sombre colours and had a composition based on straight lines which extended throughout the painting and crossed to form irregular rectangles. Once again, the artist is the protagonist and, once again, he sees himself as a melancholy monk who reaches out towards a woman who looks very much like Wally. Significantly, he gazes not at her but at his audience.

These large paintings must have presented Schiele with many problems, not least those of storage and transport, which may explain why they were cut into pieces. But Schiele was clearly determined to rival and outdo Klimt who, like so many of his contemporaries (Munch and Hodler, for example), saw the full-scale decorative painting as the ultimate test of an artist's abilities.

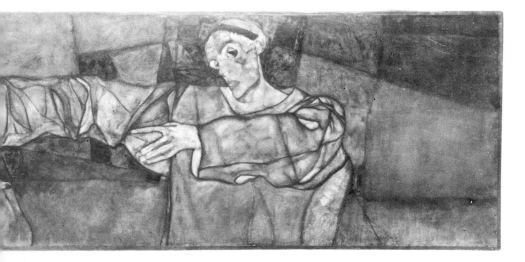

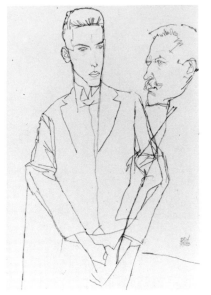

98 Sketch for *Heinrich and Otto Benesch*, 1913

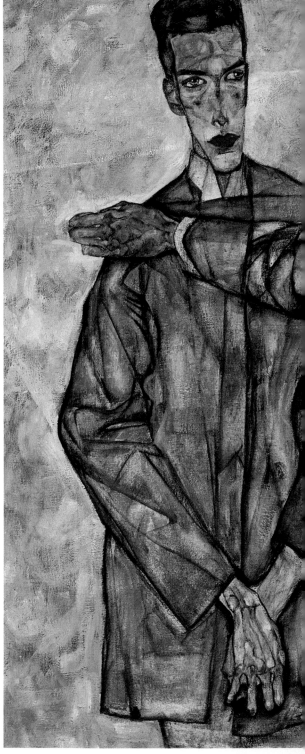

99 *Heinrich and Otto Benesch*, 1913

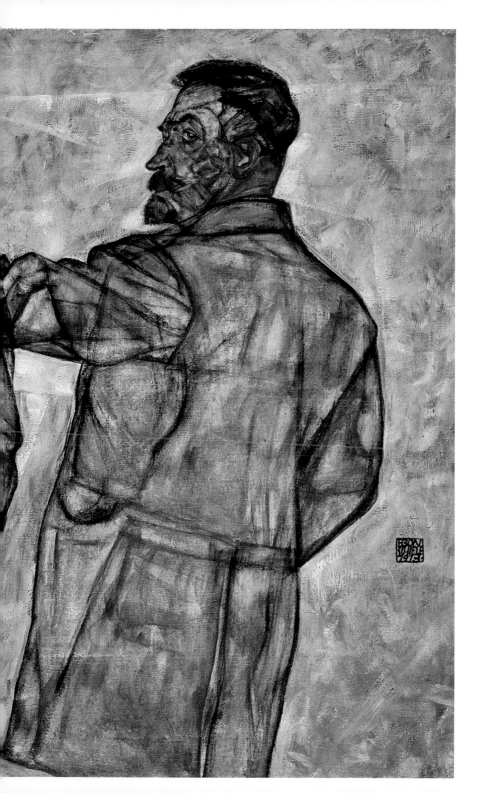

Printmaker, model and collector 1914

How good! – Everything is living dead.

From 'Pineforest', *c.* 1910

Money continued to be a problem in 1914, not because Schiele earned little of it but because he was reckless with whatever he had. Without his prodigality he might have been relatively secure, and the fact that Roessler, who had bought much from Schiele at the start of their friendship, acquired nothing more after 1912 suggests that Schiele's prices had already become too high for him.

An episode related by Benesch leaves one in no doubt about Schiele's attitude to money:

I sat with Schiele and his model (a girlfriend) Wally Neuzil in a café in Hietzing. While Schiele played billiards Wally told me that he had absolutely no money and did not know how he would pay for a lunch next day. I did not have much myself at the time, but after he had finished his game I gave him 10 Crowns for absolute necessities. What did our Egon do then? After we had said goodbye he took Wally to the Burgtheater and afterwards to a restaurant. There was just enough left from the 10 Crowns to get home on the tram.

In spite of the authority and importance of his paintings Schiele remained, essentially, a graphic artist, and it is in his drawings that his extraordinary gifts are most obvious. It is therefore surprising that printmaking never occupied his attention much, especially as German artists of the same generation – the painters of the *Brücke* for example – took it so seriously and had even brought about a revival of the art of the woodcut.

Schiele was not greatly attracted to any of the graphic techniques, however, and the catalogue raisonné of his prints runs to only seventeen items, including lithographs he designed for posters. In 1912 he made two drawings for lithographs, one of which was published, but he did nothing more until 1914 when he experimented with etching

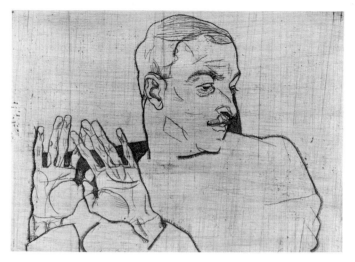

100 Etching of *Arthur Roessler*, 1914

for the first time partly, as he explained to Roessler (who paid for the materials), because 'I know from colleagues that graphics find takers more easily than paintings, especially when these are larger than the popular size suitable for the decoration of rooms.'

Schiele made eight etchings between May and August 1914, most of which (especially the portraits of Hauer and of Roessler) are of very high quality. The energetic, aggressive line which the artist had developed in his pen and pencil work was admirably suited to the graphic medium. It was emphasized, indeed, by the sharpness of line which etching uniquely confers on a drawing. 100

Schiele's optimism about sales of graphics proved unfounded, however. Only a very small number of prints were ever made during his lifetime and most of the graphics which appear on the market are posthumous pulls from plates which were never cancelled. Partly because of the lack of sales, partly because he became bored with the demanding technical discipline, Schiele made no more etchings after 1914 and gave away all the tools which Roessler had so generously given him.

There was one mechanical medium, however, which Schiele found endlessly fascinating: photography. In 1914 he worked closely with a highly gifted artist of his own age, Anton Trčka, who had recently taken up photography. Together they produced a series of remarkable portraits of Schiele, collaborative works which tell us a great deal about the way in which the artist saw himself.

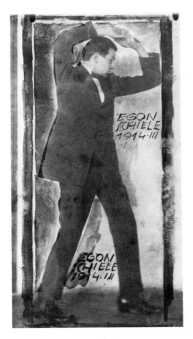

101 Schiele, by Anton Trčka, 1914

102 Schiele in front of his mirror, by Johannes Fischer, 1915

103 Schiele with his collection, by Johannes Fischer, 1915

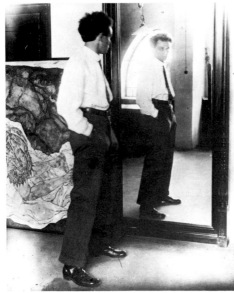

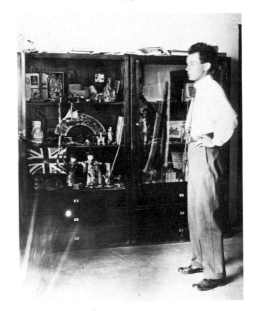

Schiele appears in these photographs, full-length, striking almost 101 acrobatic poses or, face in close up, frowning, grimacing or staring intently, his hands gesturing beneath the chin like some celebrated actor who recognizes no difference between art and life. Attempts were made, in the preparation of the prints, in the choice of format, in the positioning of Trčka's signature, to allude to contemporary portrait painting, especially Schiele's own.

Indeed, Schiele regarded these photographs as art works in their own right and had much more to do with them than simply acting as model. He frequently drew on the negative or on the completed print, signing it as though it were a work of his own. An example of this is the standing portrait, his hands linked above his head, which is signed not once, but twice, and which has been provided with heavy, enclosing lines and some quickly applied washes which exaggerate the unusual pose.

The idea of having carefully staged photographs of himself obviously appealed greatly to the narcissist in Schiele who was already accustomed to gazing at himself for hours in the mirror while drawing. Not only Trčka photographed him at this time. Another friend, the painter Johannes Fischer, also took many pictures of him which, although impressive, are less self-consciously artistic than Trčka's work.

Many of Fischer's photographs are, indeed, more of interest as documents than as aesthetic statements. One of them shows the artist in his studio standing before the full-length, black-framed mirror 102 that was the dominant feature in every room in which he worked. To judge from some of the self-portrait drawings clearly made after his reflection, he was in love with his image, enjoying a relationship with it as subtle and as complicated as with another person. Some people shy away from their reflection, frightened of what may be the truth; Schiele was apparently infatuated.

A second studio photograph by Fischer shows Schiele, a slim, 103 elegant figure in a white shirt with belted and carefully pressed trousers and highly polished shoes. The cabinet packed with objects in this picture not only tells us that Schiele now had enough money to collect but also says a great deal about his tastes and preferences.

The cabinet (designed in the contemporary Wiener Werkstätte style) contains objects ranging from a small Union Jack (was Schiele the first artist to find the British flag attractive as decoration?) to

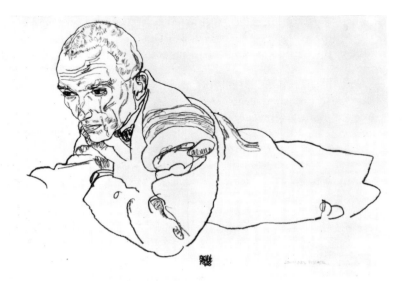

104 *Johannes Fischer*, 1918

105 Schiele in his studio, by Johannes Fischer, 1915

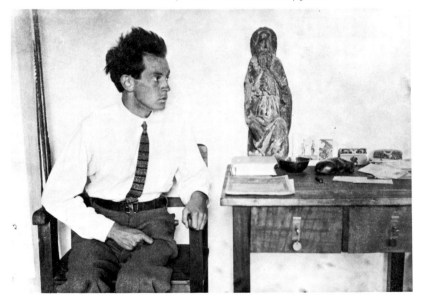

wooden toys. Schiele loved such things. As Benesch remembered, he 'was a collector, but he did not collect valuable things, rather small, trivial objects whose forms and colours appealed to his artistic sense'.

When he travelled around the country he bought bits and pieces of folk art and regularly looked for attractive toys at the open-air Christmas market in Vienna. Some of these things can be seen in the painting of his room at Neulengbach. But he also collected pieces 72 of exotic, primitive woodcarving and, especially, examples of Oriental art and craft. Many of these can be seen in his cabinet: a Chinese fan, Japanese dolls, a samurai sword in its scabbard, and a Japanese book illustrated with coloured woodcuts.

Interestingly enough, the *Blue Rider Almanac* can also be seen there, that rich compendium of essays and illustrations edited in Munich by Kandinsky and Franz Marc, who used the publication in part to publicize their belief that there is more true creativity in various kinds of primitive art than in the work of most trained and accomplished painters.

Schiele's collection was very important to him. As Roessler remembered: 'He often spent his last penny on curious examples of a dying folk art which he would carefully carry home . . . feeling like a child who had been lavished with presents.'

It was the Oriental, especially Japanese, art that had the greatest influence on his work. Schiele had a collection of Japanese objects and woodblock prints much larger and more distinguished than the photograph of the cabinet suggests, and the calligraphic line, the bright colours and eccentric compositions of such prints reappear, in a changed form, in many of Schiele's drawings and paintings.

The influence of the Japanese aesthetic, so important in French art from the time of Manet onwards, was broadcast in Vienna by the Secession and affected the work of all its members – architects, designers and sculptors as well as painters in an unmistakable way. Klimt had a large collection of Oriental art, including screens and tapestries, ceramic, masks, armour and woodblock prints. He habitually worked in a long robe which he had designed along Japanese lines, and frequently painted people standing against Chinese tapestries. Other Secessionists collected as eagerly and the Secession staged several impressive exhibitions of Japanese prints. *Ver Sacrum* frequently published articles about Oriental art.

Klimt's sinuous contour lines, his love of flat patterning and the tension he set up between richly decorated parts of his compositions and large, negative areas of a single colour, all derive at least in part from an understanding of Japanese pictorial methods.

Schiele's subjects as well as his style are related to Japanese examples. Certain woodblock-print artists loved to draw grimacing, wildly gesticulating figures, their bodies attenuated and emaciated. Others specialized in erotic scenes of extraordinary frankness which may have given Schiele confidence to persevere with the depiction of his own fantasies. He is, indeed, rumoured to have owned the best collection of Japanese pornographic prints in Vienna, a city in which the collecting of erotica drawn from every part of the world was a popular hobby.

On 28 June 1914 Austro-Hungary declared war on Serbia, after the heir to the throne had been assassinated by a nationalistic fanatic at Sarajevo. Within a month all Europe, long since divided into two armed camps, was in conflict. Germany joined Austro-Hungary against the allied might of Britain, France and Russia. Old Europe was doomed. The pessimistic visions of Kraus, Musil and others were about to become a reality. The Viennese society so enthusiastically celebrated by Klimt was already part of the world of yesterday.

But yesterday's world proved tenacious, at least for those Viennese without relatives on the Eastern Front. In Klimt's work one looks in vain for any allusion, however obscure, to the fact that times had changed. The aristocratic ladies still gaze confidently and seductively from their richly decorated surroundings, and the sleepy villages still nestle at the foot of wooded mountains, their gardens brilliant with summer flowers.

At first Schiele was spared conscription. He had doctor's certificates testifying to a weak constitution. Unlike Kokoschka, who immediately volunteered for a crack cavalry regiment and who saw himself as carrying out some chivalric mission in the service of his mistress, Alma Mahler, Schiele never intended to fight, believing that artists were too important to be put in danger. When things became so bad for Austro-Hungary that even the sick and the lame were called up, he managed to arrange things so that he never came near the fighting.

For the rest of 1914 Schiele was able to draw unimpeded. There is no sign whatever in his work that a war had suddenly begun: the disaster, deaths, disruption and decay which the war caused had long been present in his work. Like so many of the Expressionists, Schiele sensed the decline and passing away of a world before the catastrophe happened.

That year saw some of Schiele's most splendid drawings of female nudes, most of which seem to be of Wally, who lies, squats or stands, her nipples vermilion, her stockings green, yellow or blue, her pubic hair dark and luxuriant.

It is in this series of nude or semi-nude females that a stylistic change can be noticed. The relatively simple and smooth contour line which is made to carry out most of the description in the drawings of Wally becomes in other works more nervous, broken and tentative. In two drawings of a woman wearing a shift, the folds in the material are sharp and angular, almost Baroque in their relentless complication. Instead of being content with small areas of bright colour (as he was in the Wally drawings), Schiele now covers the drawings with dry brush marks which make the skin look rough and blemished.

107, 110

106, 108, 109

106 *Reclining woman with blond hair*, 1914

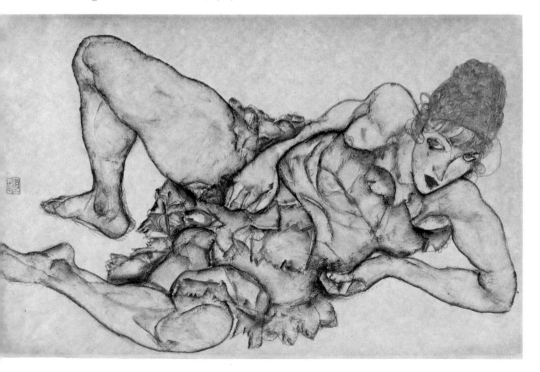

An additional element now also complicates the erotic content of some of these drawings. Whether lying or sitting, the model is rigid, her face is blank, her body and limbs stiff and motionless. Schiele makes these women look like a collection of dolls, calling to mind the dummy in Alma Mahler's likeness that Kokoschka had made to console himself after she had left him. But Schiele's doll-like figures offer no consolation. They are melancholy, lifeless creatures, their humanity gone, their purpose reduced solely to the sexual.

The most unusual painting Schiele produced in 1914 is a portrait. It shows the wealthy Jewish girl Friederike Maria Beer who moved in artistic circles, patronized the Wiener Werkstätte, was a girlfriend of the painter Hans Böhler and was also portrayed two years later by Klimt.

111 Friederike Beer, whose father owned two night clubs, is the most perfect example of the kind of wealthy Viennese bourgeois who believed that associating with advanced artists and patronizing the avant-garde brought reflected glory. An unwittingly revealing description of herself at this time, given years later to Comini, shows to what extent the middle classes now shared the interests of the aristocracy:

107 *Reclining woman with legs apart*, 1914

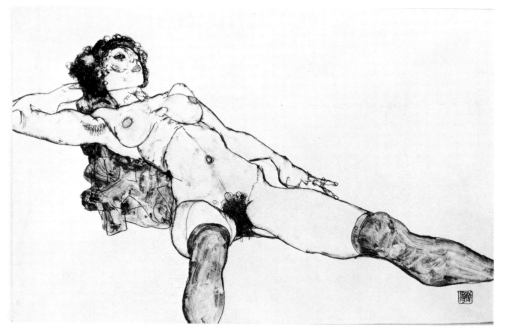

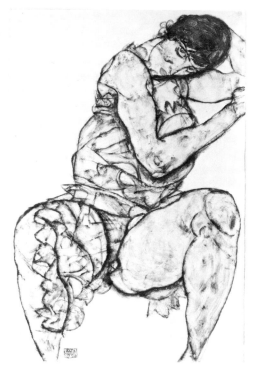

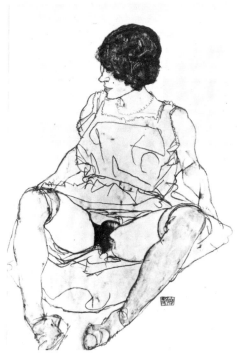

108 *Seated woman with hand in hair*, 1914 109 *Seated woman*, 1914

110 *Reclining woman with green stockings*, 1914

I was good-looking, young, and interested in music and art. What was I doing at twenty-three? Nothing! Just living – going to the theater, to art exhibitions, to the Opera. In those days I was so wild about the Wiener Werkstätte that every single stitch of clothing I owned was designed by them. When I got an apartment of my own all the furniture, even the rugs, was made by them. I was really a walking advertisement for the Wiener Werkstätte.

All commentators agree that Klimt's portrait of Friederike Beer is the better of the two, and some have suggested that none of Schiele's portraits of women is entirely successful. But the Klimt is considerably more conventional, its interest deriving chiefly from the Chinese wall-hanging before which she stands like some conjuror's assistant, dressed in a short richly decorated jacket and baggy pantaloons.

112 In Schiele's portrait Friederike Beer seems to levitate, her body contorted, her hands grasping the air. Her long shift, a Wiener Werkstätte design which she later gave to Wally, is brightly coloured. Schiele had her pose on a mattress on the floor and painted her from above while standing on a ladder. He also threw down some small Bolivian wool dolls on to her dress, incorporating them into the fabric design. Her maid commented that it looked as though her mistress had been painted lying in a tomb. Schiele then suggested that the picture be hung on the ceiling and viewed from below, and this Friederike Beer did.

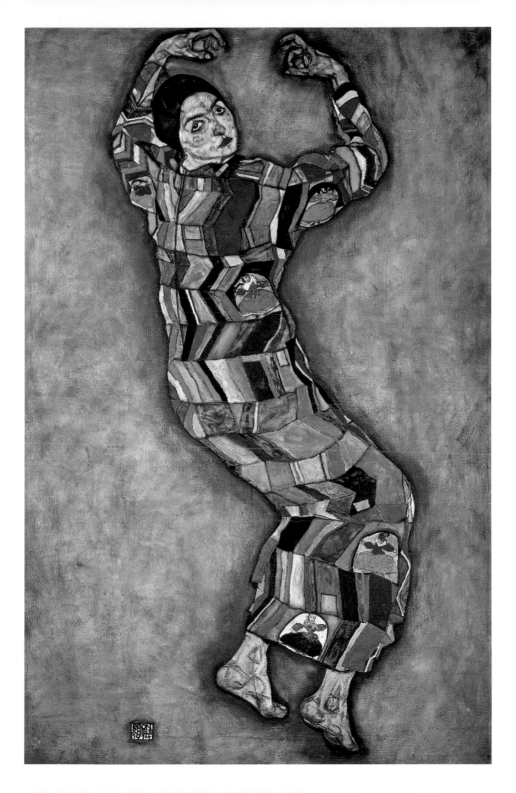

It is rather a mannered picture, but it does demonstrate the extent to which Schiele was prepared to take risks and the lengths to which he went to discover a new kind of portraiture. It remains the most unusual portrait he ever painted.

During the late 1960s, Friederike Beer sold both the Schiele and the Klimt to finance her last years in an old people's home in Hawaii.

In this portrait Schiele explores the narrow area between the demands of realistic description and the attractions of rigid decoration. He does the same in what is possibly his most original and daring painting of a building, *Façade with windows*, probably a view of somewhere in Krumau. The white wall confronts us directly; all sense of space and volume has been denied; the windows and roof tiles contribute to a simple but effective abstract design based on imperfect rectangles and a series of broad horizontal bands. Small patches of

113

113 *Façade with windows*, 1914

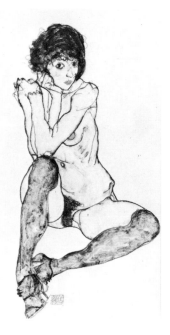

114 *Seated woman with elbows on knees*, 1914

vermilion, ultramarine, green, mauve and yellow twinkle like jewels set in the chalky façade. There is nothing else so abstract in Schiele's oeuvre.

At the end of 1914 the Arnot Gallery, situated on the famous Kärntnerring and one of the leading Viennese galleries specializing in modern art, opened a Schiele exhibition which consisted of sixteen oils and what the catalogue described as 'sundry watercolours and drawings'. For Schiele it was an important event, as it also was for the nineteen-year-old Otto Benesch, who wrote the catalogue introduction. This did not appeal to the artist, largely because Otto mentioned the names of other artists. In a letter to Heinrich Benesch, Schiele said that 'the whole thing is obviously well-written . . . but mention should not have been made of Klimt or Kokoschka'. Otto then wrote to the artist explaining his position: 'I did not say anything about Klimt himself. And Kokoschka is not so bad that it would have been a sin to mention his name or place it next to yours.'

If Press reviews are anything to go by, then the show was a success. Even Schiele's harshest critic, Seligmann, conceded that 'as a draughtsman he is often masterly'.

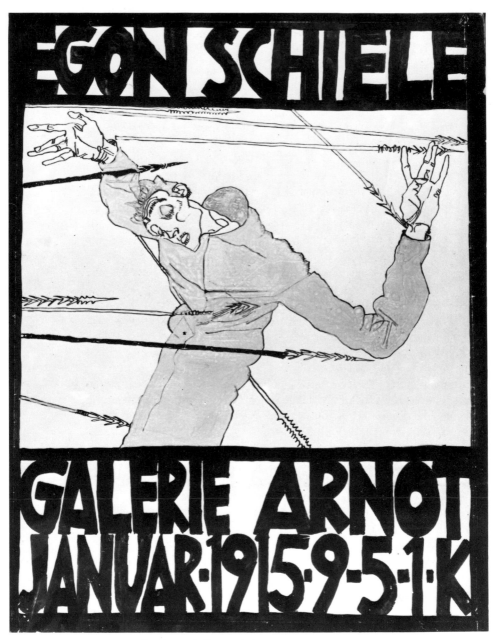

115 Poster for Arnot Gallery exhibition, 1914

Schiele designed a poster for the exhibition. Trapped between two 115 bands of heavy letters, stylized to look as though cut in wood, the artist shows himself as St Sebastian in a hail of what look less like arrows than whaling harpoons.

In view of Schiele's frequent use of religious symbolism and his conviction that he was a victim, it is surprising that this was the only occasion on which he assumed the guise of the saint who so perfectly symbolizes painful martyrdom. It might also be thought that such an unappetizing image would dissuade everyone from visiting the Arnot Gallery. In fact, ever since Kokoschka's poster for the 29 1908 *Kunstschau* theatre season, which shows a woman apparently about to tear a man limb from limb, sensational subjects had often been used to publicize events connected with avant-garde art. Oppenheimer's poster for his one-man exhibition of 1911, for example, depicts himself naked, exploring with his fingers a bloody wound in his side.

Comini sees Schiele's St Sebastian as marking a transition: he showed himself as a monk before; now he identifies with a saint. But it seems less a transition than a version of a recurring theme: whether as Christ, a monk or a saint, Schiele is simultaneously identifying himself with the sacred and untouchable and exploiting the blasphemous identification in order to shock. Maybe he did feel persecuted and misunderstood, but to express such feelings by portraying himself as a saint and martyr shows an immature appreciation of what, for an artist, is the mortal sin of bathos.

Love, marriage and the military 1915

I intend to get married . . . advantageously, not to Wally.

From a letter to Arthur Roessler, February 1915

Sometime in the Spring of 1914 Schiele became aware of the existence
of two attractive girls who lived immediately opposite his studio in
the Hietzinger Hauptstrasse. Watched over by their mother, who
clearly thought them too young for male companionship, Edith and
Adele Harms at first had contact with their handsome and interesting
neighbour only by waving across the road and through notes deli-
vered by messenger boys. Schiele also used to show off by drawing
large pictures of himself and holding them up at the window. It
sounds like a juvenile and harmless passion, which at first it was, for
none of the notes was answered for almost a year, although the Harms
girls kept them all, no doubt giggling over them in their bedroom.

116 One of these notes, written in December 1914, makes it clear that
Schiele unscrupulously intended to use the innocent Wally as an
accomplice: 'I believe that your mother will allow you both', he
wrote to the girls across the road, 'to come with Wally and me to the
cinema or to the Apollo Variety Theatre . . . you may rest assured that

116 Letter to Edith and Adele
Harms, 10 December 1914

I am in reality not at all like an "apache" – that is simply a temporary pose caused by arrogance.'

This is how any young man might try to have his cake and eat it: arouse the interest of a romantically inclined girl by playing the wild artist, but then assure her that it is all a façade and that he is, at bottom, as responsible and as home-loving as she would wish him to be.

Given Schiele's hostile attitude to his mother and uncle, it might seem strange that he bothered with anyone from the same, irredeemably bourgeois background, other than to have his fun testing the moral fibre of two good-looking, genteel young girls. In any case he was still living with Wally who must have thought by this time that her arrangement with the increasingly successful artist promised to be permanent. But a letter he wrote to Roessler in February 1915 reveals all: 'I intend to get married . . . advantageously, not to Wally.'

This decision also comes as a surprise because it reveals him as applying that same double standard which marked most of his male middle-class contemporaries. Maybe Wally had disqualified herself from marriage precisely because she provided that erotic excitement on which he relied so much.

In view of the way the Imperial Railways provided Schiele's life with a kind of leitmotif it should come as no surprise to learn that Johann Harms, the father of Edith and Adele, had also been connected with the railways before his recent retirement. His daughters were attractive although in no way exceptional. At first the cynical Schiele could not make up his mind whether he should press his intentions on Edith or Adele. After courting them together, both in and out of Wally's company, he finally decided on Edith after Adele had declared that she was 'really a nun'. Edith, sheltered though her life had been, immediately and wisely demanded that Wally should instantly depart from the scene.

A letter which Edith wrote to her future husband in April 1915 tells us a great deal about her attitudes:

Let them say what they will (I mean my family), my views are not theirs and I can consequently come completely to share your ideas and outlook. . . . I love you, but don't think that my love is blind and that it is jealousy that makes me demand the break with W. No, I only want a clean start. . . . You mean more to me than my family and don't underestimate that, for I love them very much. . . . I write this almost in darkness in the lavatory. . . . Believe in me as I do in you and then we shall be the happiest people on God's earth.

153

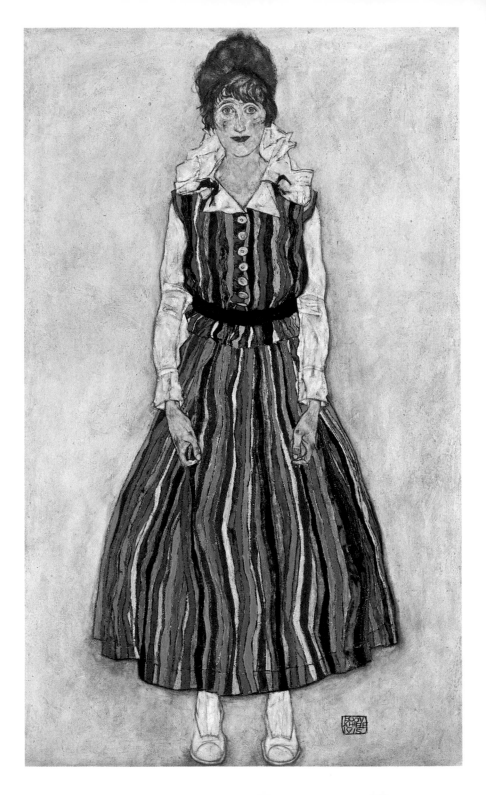

The break with Wally, who had helped Schiele get to know Edith and who had remained faithful to him during the Neulengbach affair, could not have been easy. According to Roessler, Wally and Edith met before the final decision was made:

Wally did not try to provide any counter-arguments against the clever, indeed devious points which Edith made with impressive eloquence, and she made up her mind for better or worse to overlook her 'rights of precedence'. . . . And so, on the following day, Egon met Wally for the last time. The meeting took place in the Café Eichberger, the 'local' where he played billiards towards the end of almost every day.

Instead of talking, Schiele handed his mistress a letter in which he suggested – incredibly – that they should have a holiday together every summer, without Edith, of course. Wally told him that such an idea was impossible and Schiele, resigned, 'lit a cigarette and stared dreamily at the smoke. He was obviously disappointed. Wally thanked him for the kind thought . . . and then departed, without tears, without pathos, without sentimentality.'

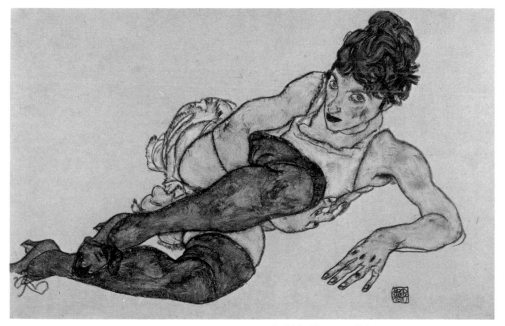

118 *Adele Harms reclining*, 1917

They never met again and Wally never married. She joined the Red Cross as a nurse and died of scarlet fever in a military hospital near Split in Dalmatia just before Christmas 1917.

To judge from her simply formulated and touching letters, Edith (to whom Schiele's friends and patrons immediately warmed) was deeply in love with her husband. Released from an overprotective home environment, she was directly plunged into a strange life with a man who, although not penniless, was reckless with what money he had, had a long and intense relationship with another woman behind him, the evidence of whose powerful sexuality Edith could inspect in the portfolios of erotic drawings in her husband's studio. Her husband, moreover, had been sent to prison for circulating pornography.

It is not difficult to imagine the pleading, tears and near hysteria with which Edith's parents sought to prevent the marriage. It was not merely that her intended husband was an artist notorious for his erotic drawings. The Harms family was Protestant while Schiele, nominally at least, was Catholic: opposites even more difficult to reconcile then than now. Edith had her way, however. The simple wedding took place on 17 June 1915.

Schiele's mother was not present at the ceremony. Relations with her son had long since cooled to the point of frost. Much later, when she was happy to be known as the mother of a celebrated artist, she spoke resentfully to a newspaper reporter about the marriage. Edith, she claimed, was always 'a little jealous, particularly of my son's beautiful models', and then added, presumably as a warning to others, that 'such artistic natures should never marry!'

It is probably true that Edith was jealous of her husband's models. She agreed to his employing a series of professionals only after growing tired of sitting for him herself. She insisted, incidentally, that her husband give the erotic drawings – for which even she occasionally posed – the face of another, imaginary woman.

What is known about his relationship with Edith, with her sister (who certainly also posed for him partially clothed, in spite of her belief that she was 'really a nun'), and with other women is fragmentary. Either this part of his correspondence has been destroyed (and it is unlikely), or Schiele never wrote a love letter to his wife or to anyone else and rarely allowed himself a warm or tender remark in what he did write to Edith.

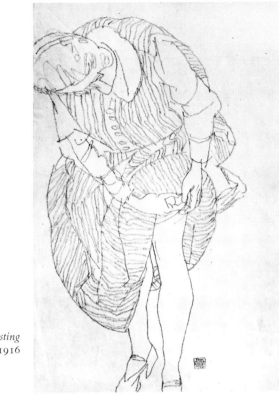

119 *Edith Harms adjusting her stocking*, 1916

Schiele painted Edith in 1915, and the picture confirms what we know of her. Nervously clutching at the front of her simple striped dress, standing awkwardly and smiling shyly, she seems like some young girl waiting to be asked for a dance at her first grown-up party. The artlessness of the pose and the uncomplicated expression on her face are quite different from anything that Schiele had painted before.

We sense here the conflicting emotions that Edith must have caused in Schiele: a quiet pleasure in her innocence, a satisfaction with her selfless loyalty mixed with frustration at her lack of sexual energy. Schiele makes her seem passive and whilst he found vulnerability attractive he must also have longed for those quite different qualities which Wally possessed in abundance: the kind of temperament and aggressive eroticism which made Schiele himself feel vulnerable.

Yet in this portrait – and in drawings of 1916 – it is also not fanciful to see already the expression of a growing contentment which was soon to cause a significant change in the artist's style. This may well have

117

119

157

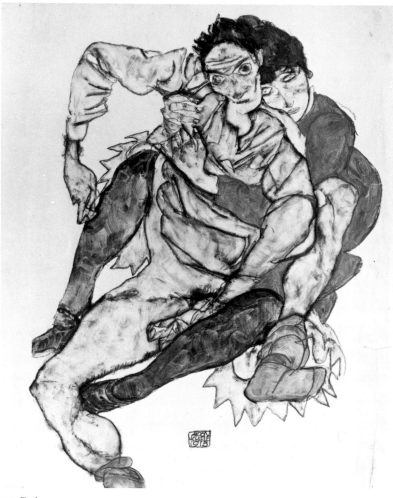

120 *Embrace*, 1915

come from a sense of emotional security provided by marriage. The
120 drawing *Embrace* suggests as much, for the woman with what looks
like Edith's face supports the doll-like figure which seems helpless,
totally dependent on her. That the figure represents Schiele himself
is beyond doubt.

 Several works of 1915 combine an obviously human figure with
121 what looks like a life-size doll. Such a couple appears in *Two women* in
which the rigidity of the doll dramatizes the lustful abandon of the
figure who lies across it, her arm beneath the doll's waist.

158

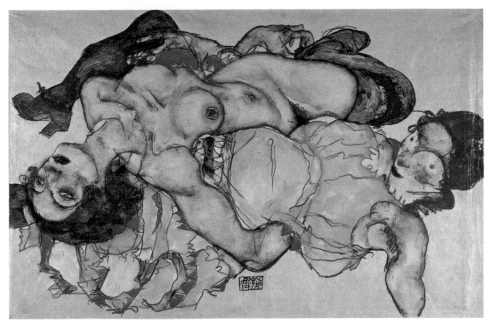

121 *Two women*, 1915

122 *Blind mother*, 1914

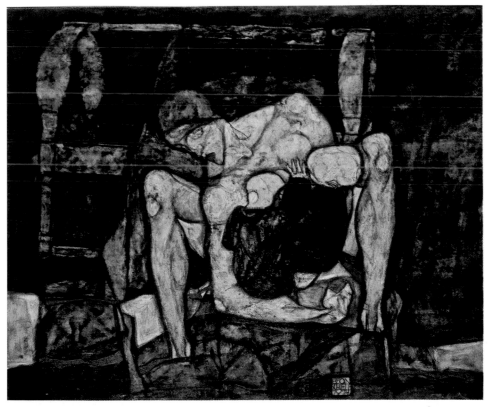

123 *Mother with children and toys,* 1915

124 *Mother and two children,* 1915

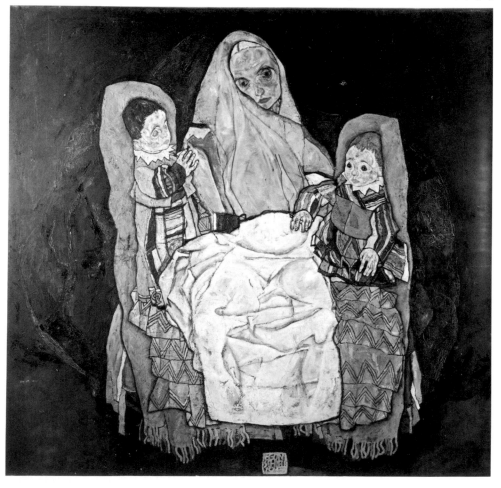

Schiele also painted several important, large-scale symbolic figure compositions that year. In spite of the presence among them of *Death* and the maiden, they are chiefly and significantly concerned with motherhood, and contrast sharply with the pessimistic *Blind mother* of 1914. The group of figures in *Mother and two children* is repeated in the main section of *Mother with children and toys*, a frankly decorative and highly colourful sketch which draws heavily on Schiele's collection of folk art and which was intended not as a study for a painting but as a design for a purse which Schiele wanted to have made for Edith.

Death and the maiden shows two figures lying on the ground, apparently seen from above – much as Friederike Beer is seen in her portrait. Death is a man in a monkish habit comforting a young woman who embraces him and rests her face on his chest. The rumpled white sheet which covers part of the ground suggests a bed, and the sexual implication, strong in all traditional treatments of this subject, is obvious. The girl, indeed, seems to be the red-haired Wally and the man's face is not unlike Schiele's own. Maybe the picture is Schiele's comment on the ending of his relationship with his mistress.

It is worth comparing this picture with Kokoschka's *The tempest* (1914), which Schiele might well have seen. Kokoschka shows himself as though in bed with Alma Mahler against a stormy, moonlit background of wind and cloud. In spite of the similar horizontal relationship of the figures, the similar format and large scale, however, the differences are as striking. Kokoschka's painting is as powerful and as energetic as his title suggests. Heavy brushloads of paint have been enthusiastically applied in swirling, concentric movements, communicating a sudden release of emotion. In spite of this the figures seem to be at rest in the eye of the storm: replete, all desires and tensions gone.

126

122

124

123

125

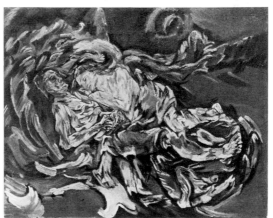

125 Oskar Kokoschka,
The tempest, 1914

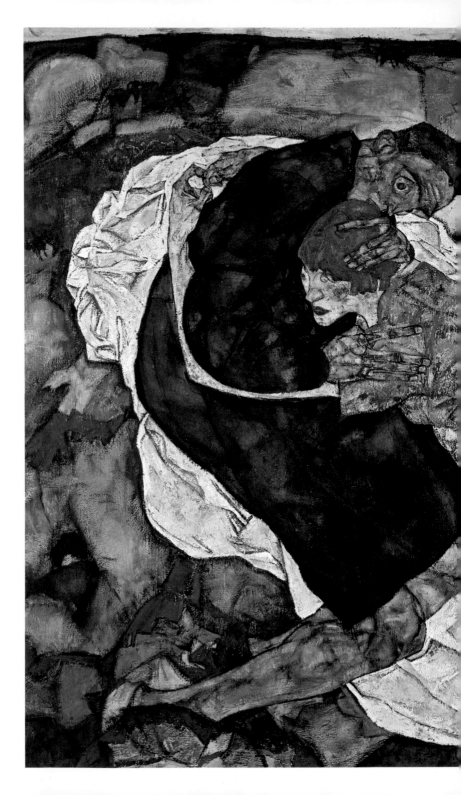

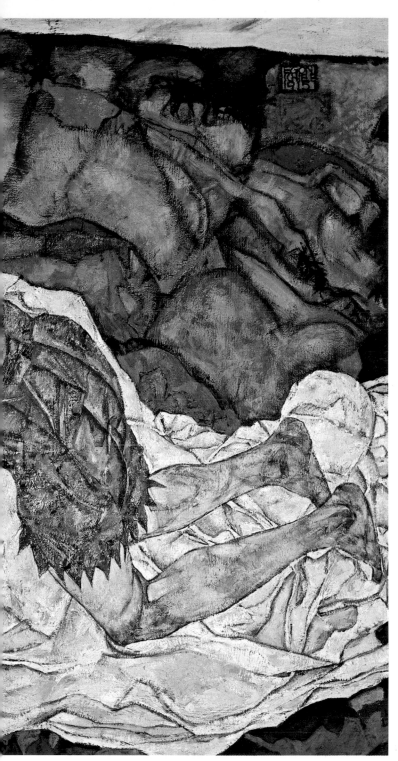

126 *Death and the maiden,*
1915

Death and the maiden is by comparison rigid and dry. Although the figures seem alive, rigor mortis has prematurely set in, locking them into an embrace from which they will never be freed. Kokoschka's is a 'baroque' painting, while Schiele's relates more to the Gothic tradition. *The tempest* is life-affirming, the Schiele is resigned to the inevitable, immobile and drained of life. Kokoschka's painting is clearly the work of a young, optimistic man; it is extraordinary that Schiele's should have been produced by someone so young.

Schiele's prospects still looked good. But any hopes that 1915 would be a successful year were quickly dashed.

Four days after his wedding Schiele was called up. The artist was mobilized, not in Vienna, but in Prague, where he at first lived in an exhibition hall with ten thousand other recruits while Edith, who had decided to follow him, put up in an hotel.

Training to be an ordinary soldier was not Schiele's idea of a honeymoon and his circumstances were indeed very miserable. As he wrote to Benesch in July:

We slept on straw and were closely guarded by soldiers – no one was allowed into town – by chance I was able to talk to Edith through a fence. People had heart attacks and fainting fits – I saw how a soldier hit a man who immediately died – I saw how the Czechs jumped over the fence – they were simply shot down. . . . We are woken at four, get black coffee at half past, at five we are ready and are marched off. . . . Oh God, how stupid it is!

Schiele hoped that his special status as an artist would soon be recognized. In a letter to Peschka, by this time his brother-in-law and also in the army (he had married Gerti in November 1914), he said that influential friends were trying to secure for him a position as a 'war and battle painter' in the War Press Office and that, if they were successful, 'I could create the most important work about our war'.

But this came to nothing and, to begin with at least, Schiele was forced to see the flat, dull and miserable side of the war through the eyes of a private soldier. If ever a man was ill-suited to army discipline it was he. But Schiele was also lucky. No doubt complaining, protesting his genius at every turn, he succeeded by the end of 1915 in being transferred to a detachment escorting Russian prisoners of war to and from Vienna. Not entirely a sinecure, it did keep him away from the Front and enabled him to sleep at home. In 1916 his circumstances were to become even easier.

The war continues 1916-1917

I smelled the sun.
Now the blue evening was here
singing and showing me the fields.
Still a red glimmer washed a blue mountain.
Around me all the many perfumes were dreaming.

From 'Evening Country', *Die Aktion*, 1916

Schiele's military duties did not prevent him from working, nor, indeed, from exhibiting. In 1916 he produced eight paintings and was represented at no less than four exhibitions: in the Berlin and Munich Secessions, in the Goltz Gallery in Munich and in a show of graphic art in Dresden.

One more exhibition was planned for 1916 but came to nothing. This was to have been the second show at the Arnot Gallery. It did not materialize because of difficulties between Schiele and Guido Arnot, the gallery's owner. A lengthy correspondence between them reveals what elevated ideas, especially about prices, Schiele entertained. 'If sales are made I am to receive the prices I want', Schiele wrote. 'I don't mind how much more than that you ask and are paid.' Eventually Arnot was moved to write: 'There cannot be an exhibition simply on the basis of the honour which Herr Schiele confers on the Arnot Gallery by showing there.'

In the Spring Schiele was posted to Mühling in Lower Austria as a clerk in a prison camp for Russian officers. He was apparently given the job because of his beautiful handwriting, although one of the first things he did there was learn to type, something the Schiele student, eyes grown tired with the trials of decipherment, must wish he had done much earlier.

Schiele's superiors at Mühling quickly became aware of his artistic gifts and allowed him the time and the facilities to get on with his painting. He drew his own officers who seized on the chance to have their likeness made by one of the best-known younger artists in Vienna, and he also drew many of the Russian officers in the camp.

127, 128, 129

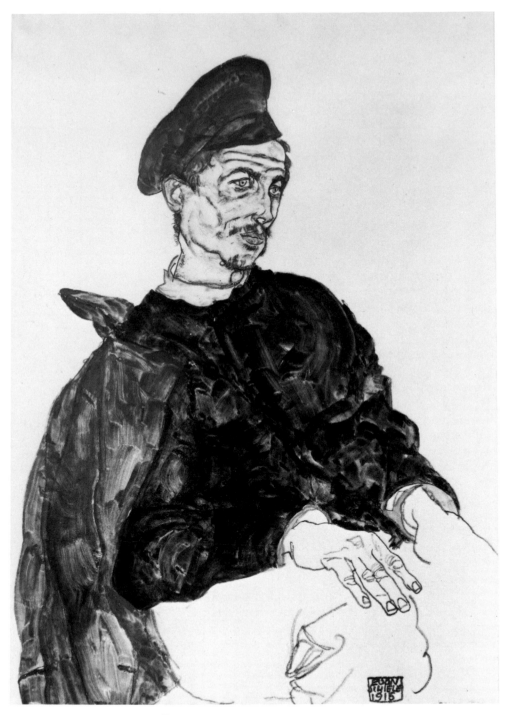

127 *Russian officer*, 1915

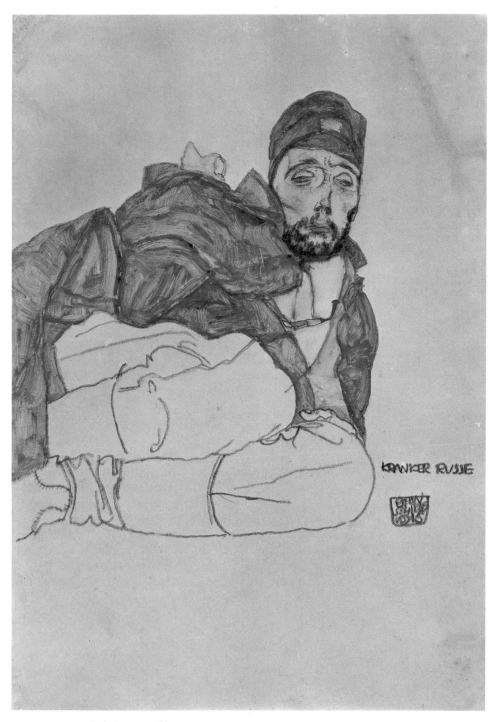

KRANKER RUSSE

128 *Sick Russian soldier*, 1915

For this improvement in his circumstances he had to thank an officer, Karl Moser, who later wrote about his first meeting with the artist. Moser had noticed the handwriting of the soldier ('typical of that of a highly intelligent person'):

I had him brought in to see me immediately. What a miserable figure stood before me! Lean, half-starved and in the worst uniform imaginable. When I asked his name and civilian profession he told me he was a painter called Egon Schiele. Since the military had no contact with artistic circles the name and its significance were totally unknown. I therefore thought at first that he was a painter and decorator . . . he thus became a clerk in our office. He kept the stores ledger and was most industrious.

But once Moser realized that Schiele was no house-painter but an artist with a considerable reputation he 'had a store room . . . turned into a studio. When the weather was good [Schiele] painted there for a few hours every day.'

In spite of references in Schiele's diary to conversations with the Russians about the state of Europe and the world, the war must have seemed far away. In any case, Schiele seems never to have been interested in politics and rarely to have worried about the future of his country. Only once, somewhat naïvely, did he admit that he tended 'much more to sympathize with the other side, with our enemies, therefore – their countries are much more interesting than ours – there true freedom exists – and there are more thinking people than here.' Since he had been speaking only to Russians, this is extraordinary indeed.

Edith also came to Mühling. Food was much easier to come by in this agricultural area than it had been in Vienna and Schiele's diary is full of descriptions of country walks and of rapturous prose passages about the glories of nature. But, instead of creating 'the most important work about our war', now that he had time to paint he did nothing of the sort.

130 He painted landscapes such as the *Ruined mill at Mühling* and the
131 *View of Krumau* which was based on sketches and vivid memories of the place. Neither of these pictures has the sense of death and decay about it which distinguishes earlier works such as those of Stein and
132, 133 Wachau on the River Danube. Their colours are bright, joyful even, and the white water which boils and bubbles in the mill race seems like an affirmation of life.

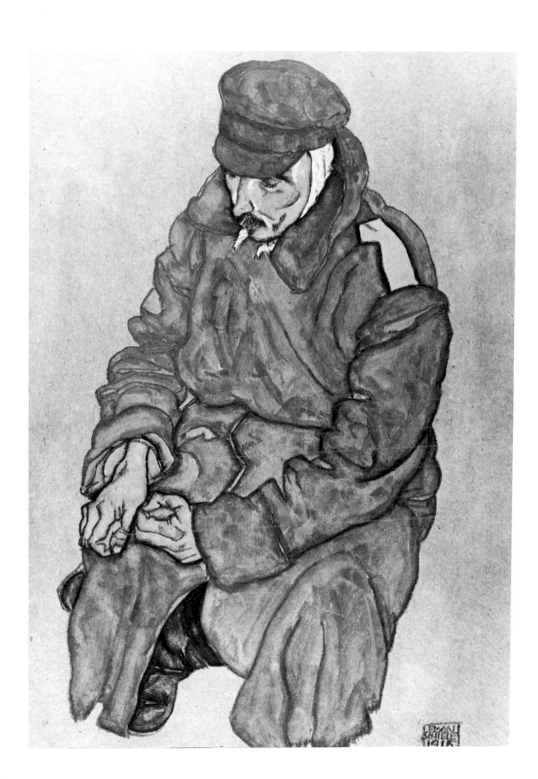

It is tempting to see not only in the *View of Krumau* but also (perhaps more so) in the earlier townscapes, a response to Cubism, the style invented by Georges Braque and Picasso which had reached its climax in Paris before the outbreak of the war. There is an exaggerated geometry in Schiele's paintings, a preference for the unusual, especially very high viewpoints, and an attempt to reconcile the three-dimensional motif with the two-dimensional picture plane which can look like a synthesis of Cubist pictorial conventions and the decorative approach which Schiele had learned from Klimt.

130 *Ruined mill at Mühling*, 1916

Although the connections between the Parisian and Viennese avant-gardes were tenuous and although a knowledge of French Cubism was virtually non-existent in the Austrian capital, Schiele probably saw Goltz's stocks of contemporary French art when he visited his dealer in Munich in 1912. Certainly the term Cubism was familiar to him and he even described one of his landscapes as a 'cubistic town' on the back of a postcard reproduction of it. But whatever the formal connections between Cubism and Schiele's townscapes, they belong to two diametrically opposed kinds of

131 *View of Krumau*, 1916

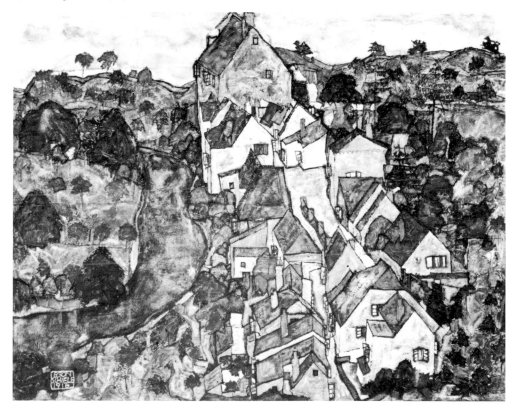

painting. The Cubists were concerned with the objective, dispassionate act of looking, Schiele with feeling. His townscapes, such as *Dead Town*, only succeed when they function as metaphors for emotional (and usually melancholy) states.

Schiele also produced one important portrait in 1916, that of his father-in-law Johann Harms, a tired old man, slumped in an uncomfortable wooden chair, his head resting on his left hand. The pose, which makes it look as though Harms is sliding off the chair out of the picture, emphasizes the frailty of age; and the frock-coat, which Harms habitually wore about the house, seems too large, suggesting that the body has withered beneath it. In this portrait, the resemblance to the

74

135

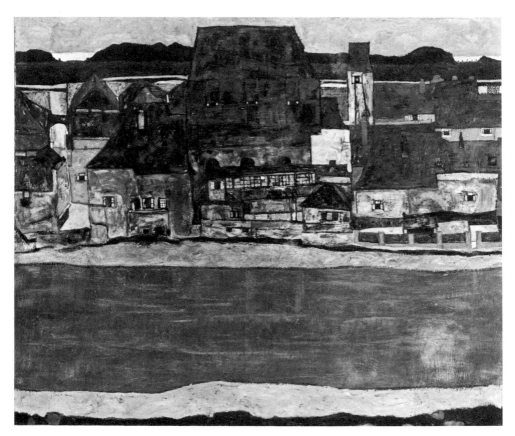

132 *Wachau on the Danube*, 1914

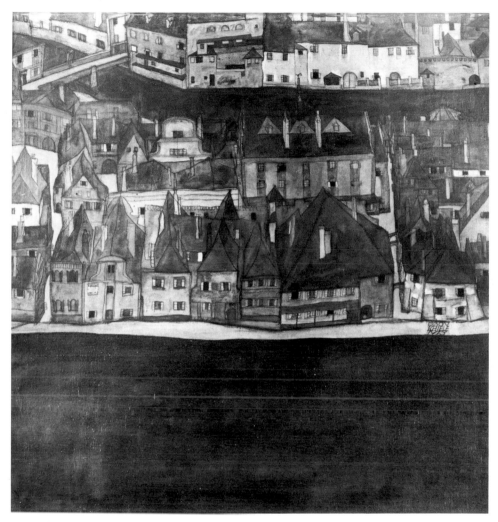

133 *Little town: Krumau on the Danube, 1913*

sitter's true features is made subservient to other elements which make a statement about old age in general. Harms, in his seventy-third year, is alone with his thoughts, weighed down by the knowledge of his mortality.

Schiele also made some self-portraits that year. One of them, which shows him squatting, his trousers pulled down around his ankles, his gaze worried and questioning, makes the young man seem almost as tired as Harms. The contorted pose suggests not energy but resignation, a weary acceptance of his sexuality.

In Mühling, Edith was as happy as her husband. They were able to live together, to take long walks through the countryside and they did not suffer from the shortages that were now commonplace in Vienna. According to Edith, life was good for the prisoners, too. As she naïvely wrote to her mother: 'The prison camp is equipped with every comfort, yet some repeatedly try to escape.'

Schiele was happy in Mühling but not content. He was still in the army and still had to carry out military duties, however light. As a letter to one of his officers reveals, he was convinced that artists

134

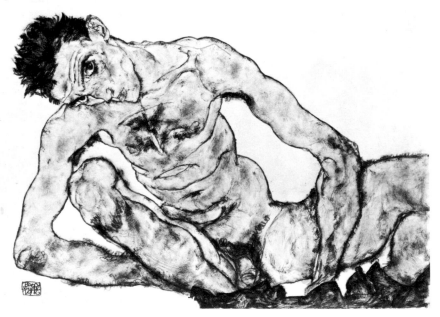

134 *Self-portrait squatting*, 1916

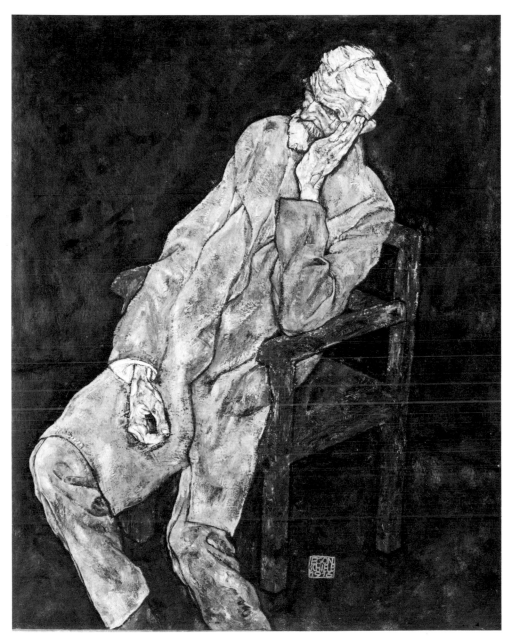

135 *Johann Harms*, 1916

required special treatment, not only for their own sake, but for the good of the country. 'It has to do with art and the future,' he wrote, heavily underlining the words; and continued: 'men of culture CAN build the nations up again'.

One of the most important events for the growth of Schiele's reputation in Germany was the publication in September 1916 of a special 'Egon Schiele Issue' of *Die Aktion*. It was an honour which Pfemfert conferred on very few artists.

Together with *Der Sturm*, *Die Aktion* was the most important periodical of the Expressionist movement. It concerned itself not only with contemporary art and literature, but also with politics, although wartime censorship prevented Pfemfert from being as outspoken in his radically left-wing and pacifist views as he had been before 1914.

1, 136 The special Schiele issue was a fine tribute to the artist. In addition to the self-portrait reproduced on the cover, it included five further Schiele drawings, a portrait of him by the artist Felix Harta, a Schiele wood-cut on the back cover and one of his poems (see p. 165).

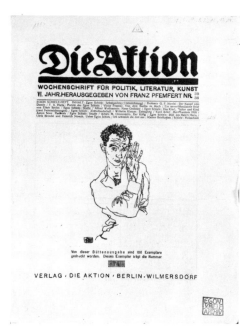

136 Cover of *Die Aktion*, 1916

137 *Supply depot with civilian worker*, 1917

Things got even better for Schiele in 1917. In January he was moved back to Vienna and to the 'Imperial and Royal Commissary for the army in the field': a depot which supplied food, drink, tobacco and other comforts to the fighting forces. The authorities had finally recognized that Schiele needed as much time as possible to get on with his work and now provided him with what, in wartime, was a miraculous combination of delights: the attractions of the metropolis, permission to sleep at home, and all the food, drink and tobacco the stores could offer. As Schiele wrote to a friend: 'I'm getting cigarettes, lard, sugar, coffee, etc., and I'm also enthusiastically testing varieties of schnaps.'

137

The artist's career continued to flourish even at this increasingly serious juncture in the war and in that year he was able to produce thirteen paintings and a large number of drawings. The Moderne Galerie, a public museum, bought a series of drawings and in May he

showed work at the *Kriegsausstellung* (Austrian War Exhibition) including a work of 1913, *Resurrection*, retitled to make it seem more appropriate – *Resurrection, fragment for a mausoleum*. He also exhibited nineteen drawings, most of them of Russian prisoners of war or of Austrian officers. He shared a room at the exhibition with Gütersloh. The other artists there (the exhibition took place in a building on the Prater, an unlikely venue for any art show) have all been forgotten since.

In July a portfolio of reproductions of drawings and watercolours appeared. This portfolio is evidence of Schiele's substantial reputation at this time. More evidence is provided by a fulsome article, entitled *In Egon Schiele's Studio*, which appeared in the *Neues Wiener Journal* in July. 'He is someone', the author concluded, 'for whom his motherland is too small.'

Schiele was now commonly regarded as one of the leading younger Austrian artists, as someone qualified to assume the mantle of Klimt. Nor was he regarded thus only in advanced artistic circles. In 1917 he was invited to take part in a government-sponsored exhibition in Stockholm and Copenhagen, a propaganda exercise designed to show the neutral countries that Austro-Hungary, far from being a barbaric aggressor, had a civilization and culture worth fighting for.

Schiele's unusual war service speaks eloquently of the artist's continuing luck. However, he seems to have failed to appreciate this. In a typical letter he sent to Leopold Liegler, a writer and critic, at the beginning of 1917, he complained in self-pitying tones:

You can't believe how weary of life I am. Outside there's a storm and it rains continuously. All the fields are flooded far and wide and one almost becomes stuck in the streets. . . . My shoes and all my clothes are soaked through and quite apart from these physical troubles I have to waste the most valuable time doing nothing and waiting . . . in these circumstances I also have to earn money, for my wife and I are not alone . . . since my mobilization I have earned, on average, 1,000 Crowns a month less than before.

In a letter to his mother he grumbled: 'My comrades constantly get cakes, tarts and post from home. I have received nothing from anywhere.' Since Schiele was feeding himself well from the stores it was obviously not hunger for food that distressed him but rather hunger for attention.

However, real tragedy was not far away.

178

Deaths

There will always be misunderstandings between myself and others. But now praise or misunderstanding do not matter any more!

<div align="center">Schiele's last words, according to Arthur Roessler.</div>

On 6 February 1918, Klimt, the artist whom Schiele admired above all others and the most celebrated living Austrian painter, died of the influenza epidemic that had by then begun to spread throughout the world. It was, astonishingly, to be responsible for more deaths than the war itself.

Schiele made three drawings of the dead Klimt in the hospital 138 mortuary, his beard gone, his cheeks pale and sunken. As he did so, Schiele must have known that he had now taken Klimt's place as the leading contemporary artist in Vienna. Kokoschka was his only serious rival, and he, seriously wounded, was convalescing in Dresden.

138 *The dead Klimt*, 1918

As though to offer proof of Schiele's new status, the Secession, still the most important body exhibiting contemporary Viennese art, invited Schiele to be the major participant in its forty-ninth annual exhibition. In the large central room he showed some nineteen paintings and twenty-nine drawings, some of which sold for unusually high prices.

Aware that this Secession exhibition marked a climax in his life, Schiele designed a poster which shows a number of figures sitting around a table. The allusion to the Last Supper is unmistakable and Schiele himself sits at the far end of the table at the top of the picture in the place where Christ would be. Opposite him at the bottom end of the table is an empty chair. The poster was based on an unfinished painting, *The friends*, in which the faces of the figures are delineated

139 Poster for the Secession exhibition, 1918

with reasonable clarity. In the painting the empty chair is occupied by a balding figure with his back to us. His absence from the poster suggests that it was Klimt, the first president of the Secession, Schiele's friend and mentor who, now dead, was unable to take his place around the table, unable to celebrate the triumph of his disciple.

Extracts from reviews published at the time reveal not only the extent of Schiele's reputation but also the way in which his work was commonly interpreted. The critic of the *Illustriertes Wiener Extrablatt* wrote:

Schiele lives in a clouded world with his terrifyingly distorted figures filled with fear, horror, fright and despair. His women are mostly of a terrifying depravity. But he is a moralist to the extent that he has never depicted sin as something beautiful, laughing seductively. . . . His views of old German towns with their many roofs look as though they were taken from some sad picture book or from a desolate, melancholy box of building blocks. . . . As a portraitist Schiele has a frightening ability to penetrate the personalities of his sitters. He is a discoverer who knows souls, a revealer of the most hidden secrets.

The critic of the *Wiener Abendpost* was less aware of Schiele the moralist. Schiele belonged, he wrote,

to what are doubtless the very great and compelling talents . . . Klimt was infinitely tender, hypersensitive, thoroughly feminine; Schiele on the other hand is filled with a robust, radical virility. Klimt drew and painted an hysterical, lascivious, sweet-toothed and coquettish sensuality and sinfulness – Schiele prefers to paint and draw the ultimate vice and the most extreme depravity, the woman as a creature of the herd from whom all restraints of morals and shame have fallen away. His art – and it is art! – does not smile; it grins terrifyingly at us in dreadful distortion.

The Secession exhibition was indeed a triumph. It led to a host of portrait commissions; Schiele was asked to design murals for the Burgtheater; prices for his drawings trebled; he engaged a secretary to help with his correspondence. Much was sold for high prices, and the exhibition confirmed Schiele's place as Klimt's worthy successor. He and Edith moved from their flat in the Hietzinger Hauptstrasse to a small house in the suburb of Hietzing which had a large, two-storey studio in the garden. Klimt's studio had been in Hietzing, too, and this must have made Schiele think that he had finally managed to emulate Klimt in his domestic circumstances also.

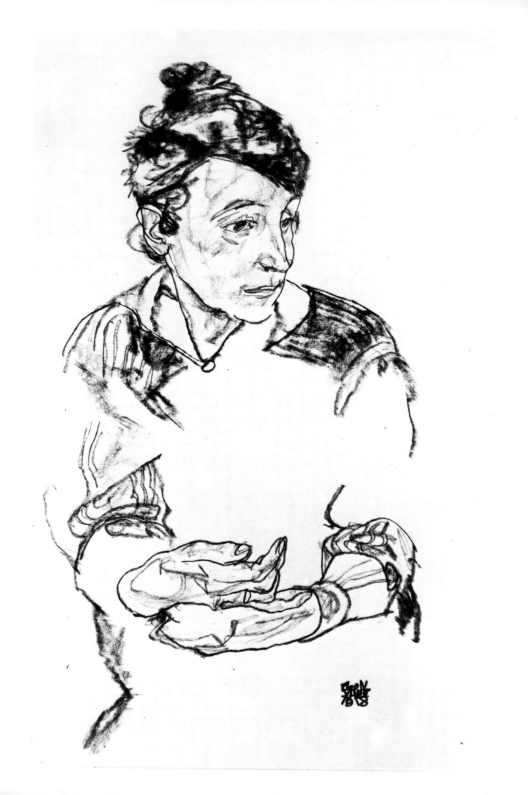

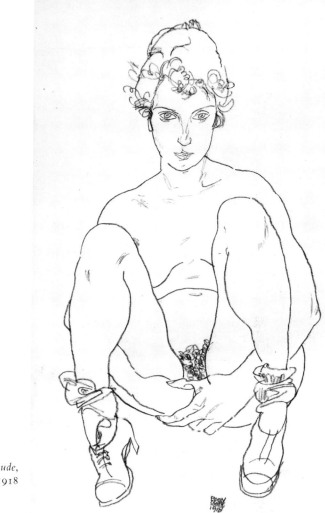

140 *The artist's mother,* 1918

141 *Crouching nude,* 1918

Although the reviews of the Secession exhibition accurately and colourfully describe the major characteristics of much of his art, their emphasis on depravity and horror is exaggerated and considerably less applicable to work produced in 1918 than to earlier paintings and drawings. Much of the art Schiele was now making is melancholy and disturbing, but in general the marked pessimism and aggression have given way to a more relaxed, contented kind of description.

140

141, 142, 143 The drawings of women are as frank as ever, but their sexual urgency has gone. Even when they look directly at us, their gaze has no obvious meaning. If they are sexual objects at all, then lust has given way to tenderness. At the same time Schiele's line has become softer. It caresses more than it attacks, strokes more than it cuts. The emphasis is now on the flesh rather than on the bone beneath.

144 We can already sense such contentment in a monumental work of 1917, *The embrace*, which depicts two life-size, naked figures with a

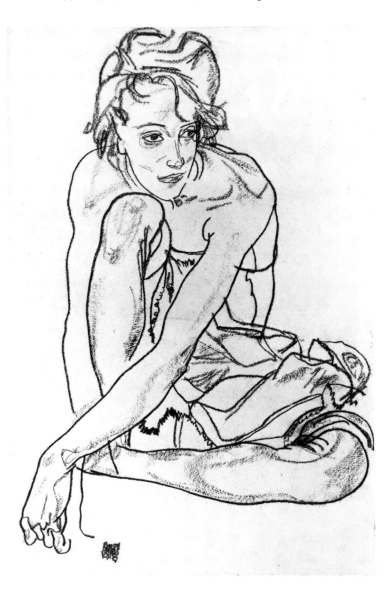

142 *Crouching nude,*
1918

tenderness that is absent in earlier paintings and drawings of similar subjects. The anonymous couple is relaxed and the predominantly yellow background, sharpened by the blue folds in the pillows and sheets, helps to communicate a feeling of tenderness and relaxed enjoyment.

The change clearly owes everything to the happiness of the artist's life with Edith. He married her for what seem to have been the wrong reasons, and her narrow background together with his difficult

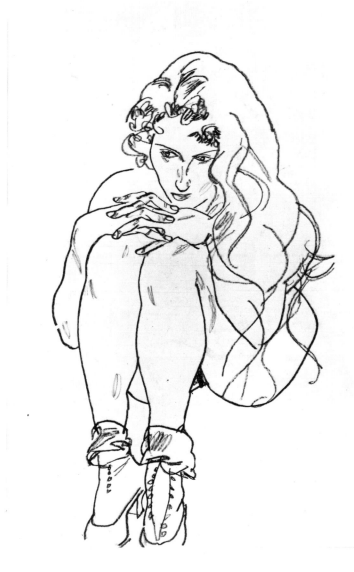

143 *Crouching nude,*
1918

144 *The embrace*, 1917

personality might have seemed like a recipe for disaster. But the marriage was a success. For the first time in his life Schiele seems to have found real love. This, at least in part, seems to be the message of his last great painting, *The family*.

145

It shows a naked man and woman together with a small child. That the male figure is a self-portrait is enough to suggest that the almost square, large-scale painting refers in some way to the artist's own life, but we should not jump to hasty conclusions. The original title was not, in fact, *The family*, but *Crouching couple*. The present title derives from Schiele's friend, Faistauer, who published his interpretation of the painting in 1923:

145 *The family*, 1918

Here for the first time, a human face gazes out from one of Schiele's pictures. . . . The body is strongly built, a human organism is at work within it, the breast curves round a heart that beats. Who could ever have thought about the heart and lungs when faced by his earlier pictures? Here life has suddenly gained strength and has built a body around itself . . . a body swollen with vitality and organs from which a soul mysteriously looks out.

The shift in Schiele's work towards humanity and common feelings is clear. The predatory relationship between the sexes, implicit in so much of Schiele's earlier work, has been replaced by a self-contained group which is formally interlocked like a secular Holy Family. The man's raised legs enclose the woman just as her limbs enclose the child. They form as coherent an emotional unit as they do a compositional one.

In spite of all that, it is not a happy painting; each figure gazes in a different direction, and their expressions seem melancholy; they seem vulnerable, defenceless, an impression created not only by the nakedness of the two adults and the relatively tiny size of the child. The background against which they appear, brightly illuminated as though by a spotlight, is dark and menacing. It does not so much enclose them as push them forward, objects for our inquisitive gaze.

The mood of Schiele's last paintings may have become less aggressive, less febrile, but it is as complex as ever. This is partly due to the new range of sombre colours, mixed as much on the canvas as on the palette, which the artist now exploits. The marks of his brush are now more obvious, communicating an energy and a rhythmic sense of form absent from his earlier work which was, as we have seen, largely concerned with flat, decorative areas of colour. Schiele now emerges as a painterly painter, as an artist no longer chiefly concerned with the expressive qualities of line but with the physical qualities of his materials and with their ability not only to describe form and volume but to suggest mood.

Interesting in this context is the portrait of Edith which Schiele, 146, 147 having completed in 1917, substantially repainted in 1918. In place of a bright check skirt the artist's wife now wears something plain which Schiele has made visually interesting by covering it with heavy impastoes. The background has been treated in similar fashion. Clearly, the artist's lifelong delight in creating areas of pattern, however minor, had begun to wane. In its place he has set a loose, energetic

146 *The artist's wife, 1918*

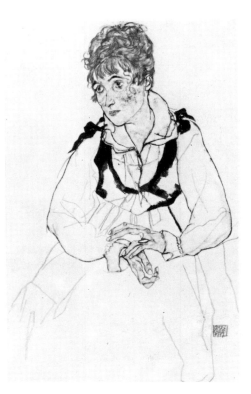

147 Study for the artist's wife, 1917

variety of brushwork which, significantly, relates directly to the kind of emotionally charged handling introduced by Kokoschka and developed by the Expressionist portrait painters of Vienna about ten years before. By so doing, Kokoschka had thrown off the influence of Klimt. Only now, in the last year of his life, could Schiele be said entirely to have done the same.

It is, incidentally, a mark of Schiele's reputation at this time that the portrait of Edith was acquired, not long after it was finished, by the Austrian State for the considerable sum of 3,200 Crowns.

The portrait of Gütersloh is even more emotionally charged than 148, 149 the painting of Edith. Gütersloh sits, his hands raised in a gesture of alarm or of sudden revelation, against a fiery, swirling background of reds, yellows and browns. The folds in his shirt and trousers have been hastily drawn in, and even their calligraphic brevity communicates tension and energy.

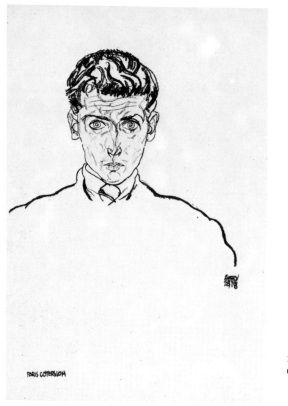

FORIS GÜTERSLOH

148 Sketch for *Paris von
Gütersloh*, 1918

In spite of this new loose handling of paint, the exaggerated gesture
and intense facial expression hark back to the dramatic psychological
portraits of friends and colleagues done in 1910. Gütersloh had exhibi-
ted with Schiele many times. Not only was Gütersloh's painting
firmly in the Expressionist mould; his novel, *Die tanzende Törin*
(The Dancing Fool) of 1913, is one of the earliest manifestations of
Expressionism in fiction.

In spite of the power of such portraits, the greatest work of 1918
remains *The family*. In spite of its original title and the attempt to
make it embody a universal statement there must indeed be something
autobiographical about it. Although Schiele and Edith were still on
their own it would not be for much longer. Sometime in April or
May 1918 Edith realized that she was pregnant.

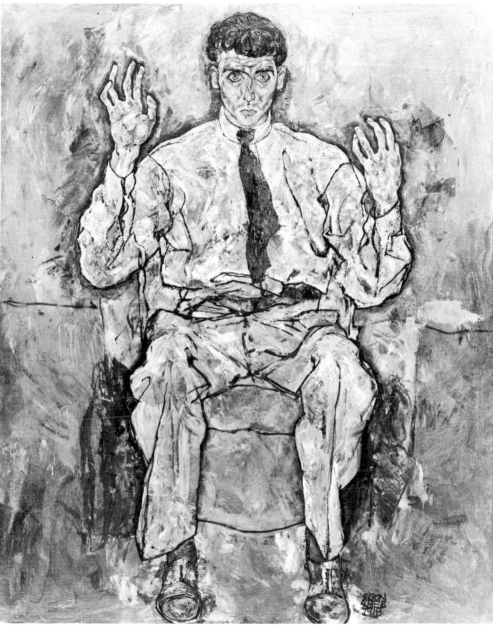

149 *Paris von Gütersloh, 1918*

She never gave birth. On 28 October she died from the same influenza epidemic that had dispatched Klimt eight months before. The day before her death Schiele wrote this to his mother: 'Nine days ago Edith caught Spanish influenza and inflammation of the lung followed. She is also six months pregnant. The illness is extremely grave and has put her life in danger – I am already preparing myself for the worst since she is permanently short of breath.'

This matter-of-fact letter is revealing. Although Schiele's mother regularly reminded him of his filial duties, even sending him postcard reproductions of Whistler's mother from time to time, their relationship had been so cool for so long that he had not told her until now that Edith was expecting a child.

Although Schiele had done his best to avoid infection by cancelling all appointments and staying at home and even though his diet, thanks to the military food stores, was better than most, his constitution was weaker than the epidemic. When he himself caught influenza a matter of days later he asked to be taken in not by his own mother but by his mother-in-law. It was in the Harms house in the Hietzinger Hauptstrasse that he died, at the height of his reputation and on the threshold of a significant shift in his artistic development.

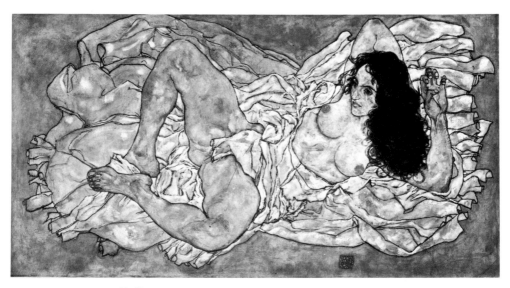

150 *Reclining woman*, 1917

Schiele's style had just begun to register a significant change. Moved by a growing emotional maturity, he had loosened and softened his line; the curve had taken the place of the cutting edge. In his painting a concern for the inherent quality of his materials resulted in a less markedly graphic approach. The thickness and texture of his paint and the marks of his brush were now allowed to play a more important part than before.

This change in style betrays a shift in attitude to his subjects. The soft arabesques of his drawings and the painterly qualities of his oils reveal a more balanced view of other human beings and a growing ability to contemplate his own sexuality without pain or torment.

The increasing humanity of his late portraits, the fleshy ease of his late figure drawings and the uncomplicated celebration of sex seen at its most obvious in *The embrace* provide evidence of this.

Whether this stylistic change was entirely positive is another matter. For with its appearance were lost the demonic power, the sense of isolation and the unresolved conflict which make so much of Schiele's earlier work memorably disturbing. It is as though he achieved personal happiness by jettisoning those traumas which were vitally necessary to his art.

There were many obituaries and few of them failed to dramatize the irony of Schiele's death. Not only had he died not long after the Secession exhibition had made his name a household word, at the point where he was clearly soon to become the richest and most celebrated painter in Vienna. He had also died virtually at the same moment as the old Imperial Austria had passed away. For the *Interessenten Blatt* he was 'the Expressionist painter [who] was one of the greatest hopes of our young art world'. He was still only twenty-eight.

Seligmann pointed in his obituary to another irony:

An artist in the prime of life . . . has been snatched away by the same sickness that he, as perhaps no other, has depicted with a kind of passion An exceptional graphic ability and an unusual feeling for colour were his and he employed these gifts like a virtuoso in order to depict a small number of constantly reappearing, dreadfully distorted and frightening figures, or in landscapes which, seen as though from the bird's-eye view, also have something grimacing and caricatured about them. . . . Schiele was to the fullest extent what people used to call a Mannerist; nowadays no one wants anything to do with this description which contains a pejorative element within

it. One would rather speak of the subjective approach. . . . Such subjective approaches are the mark of Romantic periods. . . . Whoever saw the thin, young man with his narrow lined face, his bushy black hair and his penetrating eyes, formed the impression that Schiele was forced to consume himself from within.

Much later Roessler put on paper what he claimed were the artist's last words:

On earth people will now – perhaps – become free. But I must now leave them. That is sad and to die is difficult. But it is not more difficult than life, my life which caused offence to so many. After my death, sooner or later, people will certainly praise me and admire my art. Will they do this as completely as they abused, mocked, slandered, prohibited and misunderstood my art? Possibly. There will always be misunderstandings between myself and others. But now praise or misunderstanding do not matter any more!

As the last words of a man in a high fever these do not ring true. Roessler and others were already at work creating a highly romanticized picture of the dead artist, reshaping his image in terms of some of the more familiar clichés surrounding the lives of great and tragic men. The myth-making had begun.

Posthumous opinions

The war is over – and I must go – My pictures shall be shown in all the world's museums.

Schiele's last words, according to Adele Harms

Every artist contributes to his own myth, and Schiele, as we have seen, was more energetic than most in its cultivation. The picture of the young, effortlessly brilliant, misunderstood, persecuted and penniless artist, already complete upon his death, was amplified and expanded immediately afterwards. Over the years since 1918, sometimes in a flood, sometimes in a trickle, popular articles, essays in learned journals, catalogue introductions and monographs have pointed out how misunderstood the artist was during his lifetime and how unknown he remains – or remained until comparatively recently.

In the catalogue of the first British exhibition of Schiele's work in 1964, for example, the Viennese collector and scholar Rudolf Leopold published an article about the history of the artist's reputation. In it he claimed that while Schiele was alive most critics thought his work more interesting to the psychoanalyst than the art lover and maintained that even Roessler failed to recognize the artist's true importance. According to Leopold, after Schiele's death, and until the Nazis sought to destroy his reputation, his work was the object of constant and bitter controversy. Only in the 1960s did Schiele's art achieve world standing.

In the introduction to his oeuvre catalogue published in 1966 Otto Kallir told a similar story, adding that exhibitions organized by Kallir himself had met with little success and that the first edition of his own book, *Egon Schiele, Persönlichkeit und Werk* (1930), had been destroyed on Nazi instructions.

We have already seen that reports of Schiele's lack of success during his lifetime are wildly exaggerated. True, he was criticized, just like every advanced artist, by journalists who believed that all modernism was offensive and socially and morally dangerous. But he was supported by critics besides Roessler, and although a substantial reputation

failed to materialize before his Secession exhibition in 1918 he was by no means unknown before then.

Indeed, in view of his age, Schiele's success in his lifetime was extraordinary. He had a handful of devoted patrons. He was known abroad. His financial circumstances were not bad and would have been better had he been less prodigal with his money.

When he died the many obituaries were united in praise of his unusual gifts. Even the art critics of the conservative papers had good things to say about him. For the *Neues Wiener Tageblatt* he was the strongest of the Viennese Expressionists, 'above all a virtuoso draughtsman and colourist of frequently great sensitivity. . . . He was not one of the bluffers of modern art, not one of the operators.'

Even Seligmann, who had never liked Schiele's work, had always found things to admire in it. He concluded his obituary with these words: 'What he had to say he said well. It does not have to appeal to everyone – thank God! – but as the expression of an unusually strong talent and of a technical virtuosity it will always be respected, and also admired here and there.'

Most of the obituaries entertained no reservations. Schiele was, quite simply, the greatest living Viennese painter, a worthy successor to Klimt who would certainly have gone on from triumph to triumph had he not been cut down so young. Only Tietze, writing in the specialist art magazine, *Bildende Künste*, thought that the young artist had 'given us everything that he had to give' and that he would not have developed further 'simply because he was finished, because he had expended all his vitality racing across a narrow space'. Schiele was, Tietze implied, ripe for death even in his youth. 'He is a child, an adolescent, a mature and an old man all at the same moment. A child who possesses the maturity of all experience, an adolescent who feels himself to be dying, a man from whom all the abundant energy of youth has not evaporated, an old man who lives in the sweet dreams of childhood.'

Accounts of Schiele's continuing lack of recognition after 1918 are also exaggerated. Although it is true that there was some controversy about his importance, and that his recognition outside Austria diminished (unlike Kokoschka he no longer had a dealer working for him), exhibitions staged in Vienna, books and articles published there all testify to the high regard in which his work was now held in his native country.

Fritz Karpfen's *Das Egon Schiele Buch*, in which Roessler's memoir first appeared, was published in 1921 as was Roessler's edition of Schiele's letters and prose. Roessler's account of the Neulengbach affair, allegedly written by Schiele himself, *Egon Schiele im Gefängnis* (*Egon Schiele in Prison*) came out a year later. The first catalogue raisonné was published in 1930. In 1937 a feature appeared in the *Neues Wiener Journal* floridly entitled 'Careers ruined by Fate'. It dealt, of course, with Schiele, comparing him with similar 'unfortunates', among them Rudolph Valentino.

Exhibitions of the artist's work, while not frequent, were regularly staged in Vienna: in 1923, 1925, 1926 and 1928. As Seligmann wrote in connection with one of the two shows held in 1928:

We are in no way dealing with a 'discovery' here. During recent years there have been frequent opportunities of seeing in Vienna and elsewhere both larger and smaller collections of . . . Schiele's work. Two or three large portfolios of reproductions of his work have appeared and have been widely circulated as have a whole series of books . . . about him.

He concluded his review by saying that there was 'scarcely anything weak' in the exhibition.

Seligmann was virtually alone in pointing out that in Vienna Schiele was very well-known indeed. Other writers continued to cultivate the myth of an artist who, misunderstood in life, had since failed to achieve the recognition he deserved. 'Seldom', wrote Ferdinand Eckardt in 1931, 'was a young artist . . . rejected by the Press in so shamelessly aggressive a form'.

Although the Nazis attacked Schiele's art, and indeed that of every other modern artist, they did not obliterate it completely. In 1943 no less a paper than Goebbels's *Völkischer Beobachter* published a notice of a Schiele exhibition in Vienna that year. Schiele's work was perhaps not quite well enough known for the Nazis to realize that they were dealing with 'degenerate' dynamite. It was not well represented at the time in either Berlin or Dresden, the only important art centres in Central Europe.

Schiele's apologists are largely correct, on the other hand, about the way in which his art was commonly construed. Many writers and critics did indeed discuss Schiele's work in terms which have more to do with psychoanalysis than art criticism, pointing out that Schiele and Freud were working in Vienna at the same time.

Here, for example, is Max Ermer writing in *Die Zeit* about the 1925 exhibitions at the Würthle Gallery:

His portraits were analyses like those of Freud's disciples for whom he will himself eventually become an object for study. His compositions illuminate a world with a divided soul, a world in which the horrifying towers above the pleasant. Behind each bloodless, deep-eyed and decomposing head . . . we think we discover the characteristics of his own countenance which, as contemporaries report, was in reality handsome and melancholy, expressive and reserved. When his bloody scalpel cuts beneath the skin of the world of the spiritually disturbed – of our own spiritually disturbed times – and reveals it in colours like those of pus, filth, putrefaction and dirt we could scream and turn as white as snow, as Laotse did when he saw the beautiful girl tear her apple-coloured skin from her cheeks.

Schiele the artist who cut through the flesh to reveal the skeleton beneath, who tore down the façade and let the light into the terminal ward and torture chamber, is largely the figure we recognize today. The decline of the Imperial world in which Schiele grew up (a world which sometimes seems to prefigure our own), the horrors of the war which swept it away, the rise of totalitarianism and the brutalized society it created, all seem to be registered by Schiele's art.

Schiele's art was still only well-known in Austria between the wars. The rise of his reputation in Britain, the USA and on the continent during the last two decades has been extraordinary, however. Although the first American Schiele exhibition was staged in New York in 1945 it attracted more attention in Vienna than it did across the Atlantic. Although the first purchase of a major work by an American public collection occurred in 1954, it was by a museum in Minneapolis, a city with strong Austrian connections. It was not until 1960 with a retrospective at the Boston Institute of Contemporary Art that Schiele's work became known to an American public. An important exhibition of Viennese Expressionism at the University of California at Berkeley in 1963 showed Schiele's work against its contemporary background, and in 1965 a large Klimt and Schiele joint retrospective at the Guggenheim achieved the status for Schiele in American eyes that he had enjoyed in Austria for years.

An enthusiasm for Schiele's work and for Expressionism occurred in America earlier than in Britain mainly because America had a

151 Schiele meets Klimt for the first time: scene from the television film by Fischer and Goldschmidt, 1979

larger share of refugees who, like the film director, Billy Wilder, had left Austria with their art collections almost intact. These collectors and dealers helped to create the enthusiasm for Schiele. Refugee collectors in Britain were not so lucky. In the early 1950s Schiele's *The hermits* and *Hovering* were owned by Arthur Stemmer of London. Unaware of their real value he sold them to Rudolph Leopold for a few hundred pounds.

There has never been a Schiele exhibition at any of the British public galleries or museums, but the first showing of Schiele's work at a commercial gallery (Marlborough Fine Art in 1964) was followed by a fairly regular succession of shows both at the Marlborough and at Fischer Fine Art. Schiele's work also attracted much attention when it was included in an exhibition of the Vienna Secession at the London Royal Academy in 1970.

All this activity pushed up prices, which provide at least one measure of an artist's reputation. The most expensive gouache at the Marlborough show in 1964 was just over £2,000. In 1974 a gouache of similar quality fetched the equivalent of more than £60,000 in New York.

Three monographs have appeared in English, the first of them Comini's extensive study of the portraits in 1974. In 1979 and 1980 three films about Schiele appeared, one of them in English. The best of them, produced for Austrian and German television, was written by Wolfgang Fischer and directed by John Goldschmidt, both Londoners with Viennese backgrounds. The English film was subsidized by the Arts Council.

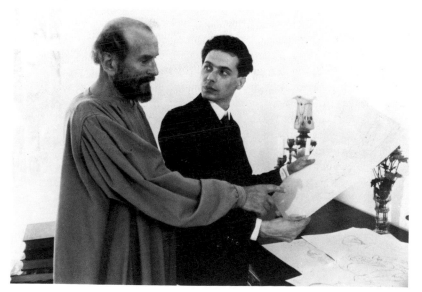

Apart from Klimt and Kokoschka no other modern Austrian artist has received such attention as Schiele. Indeed, maybe not even Koschka is as widely appreciated in the English-speaking countries – in spite of his long association with England.

How can we account for Schiele's present popularity in England and America and for the half century of obscurity that preceded it? The obscurity is easy enough to explain. For both the English and American publics modernism was synonymous with French painting until at least the 1950s. Educated not only in the French taste but also in the French version of art-historical priorities, the English-speaking world scarcely bothered to look beyond France for painters to admire. If it did glance towards Germany, then what it found seemed like a cruel parody of French originals, appeared to be the insensitive, untutored, agonized and strident declamations of a generation of misfits who had nothing to say to anyone but the equally mad. And if German modernists were so repellent, why bother to look further south towards Austria? Surely, all that would be found would be more of the same.

It is more difficult to explain Schiele's present popularity. What can be said is that it occurred in the wake of an uncritical vogue for the work of Klimt, and that Klimt's star rose with that of Art Nouveau in general. The public, once aware of the obvious delights of Klimt's richly decorated, colourful and beautifully composed work, could easily be persuaded of the virtues of his disciple, Schiele, especially since Schiele's relatively obscurity meant that dealers could lay their hands on quantities of his work for reasonable prices.

Clearly, it is the sexual content of so much of Schiele's work which appeals to today's prurient public. Explicit depictions of genitalia and even of young girls masturbating seem the more interesting because the melancholy atmosphere which surrounds them hints at abnormal appetites and desires. Schiele sees the individual as primarily a sexual being and views sex as a destructive force. Sex is a curse that will never be lifted. Schiele's men and women are victims of their own sexuality who know that whatever pleasure they might experience will immediately be followed by pain.

Schiele's obsession with death and decay is equally compelling. Schiele found Autumn the most beautiful season because it was then that he sensed most acutely the mortality of all things. His figures, even in the bloom of youth, have the look of death in their eyes and

their skin bears the marks of sickness and disease. Even when sexual activity is suggested or described it is not life-affirming but is presented as a metaphor of death. The figure drawings, symbolic compositions and landscapes – at least until near the end of his life – speak of physical decline and of mental collapse into madness; but these states are described in a way which suggests that Schiele found them irresistible.

No other modern artist has defined and described this aspect of the human condition in so powerful a fashion. The only other artists to concern themselves with similar themes were some of Schiele's contemporaries to the north in Germany, those artists so conveniently and misleadingly labelled Expressionists. A description by Otto Benesch isolates some of the Expressionist traits in Schiele's figure studies:

Whatever seems characteristic in a face is exaggerated: the pointed nose, the sensual lips, the energetic jowls. The skeleton, the skull, the anatomical aspects of a figure are emphasized. But no impression of death, of lifelessness, results from this, since a balance is achieved by means of an incomparable intensity of the spiritual. A new formal language was necessary for the creation of such spiritual intensity. The same exaggeration and simplification can also be seen in the use of colour. Each part of the skin that is flushed with blood is shown as fiery red while the other parts are olive green and those covering the bones are blue. The eyebrows remain white and give to the head an inner light in the midst of which dark eyes burn almost like glowing coals.

Telling though such a description is, Schiele's work, as we have already seen, cannot be described as Expressionist in every sense. There is always a sense of firm discipline and concern about the look of a work that are at variance with the Expressionist deliberate disregard of all traditional aesthetic conventions.

Indeed, the most obvious characteristics of his style are ultimately irreconcilable and it is this, perhaps even more than his subjects, which makes his work disturbing. As Hans H. Hofstätter wrote in his history of Art Nouveau:

Schiele never finally frees himself from the dualism of tradition and a fresh start. The contrast between them rather escalates into the painful. His pictures reveal the principle of the Klimtian, small-scale structuring of planes and of linear description. But his contours no longer describe comfortable arabesques and the planes within them are no longer filled with

decorated mosaic: they rather break the picture from within, attempt to rupture a form to which they remain firmly connected.

What Hofstätter calls the 'dualism of tradition and a fresh start' can be seen at its most obvious in the large symbolic figure compositions which Schiele saw as his greatest challenge and the proof of his importance as an artist. They belong irredemably to a moribund nineteenth-century tradition which itself derived from the principles of academic history painting. Schiele, like Klimt before him, sought to breathe new life into that tradition by refusing to work with symbols and gestures that possessed a generally understood set of meanings and attempting to invent a new kind of symbolic language based on pattern and decoration. Unlike Kandinsky, who grappled with a similar problem in a much more radical way, Schiele failed to realize that, if the tradition were to be revived, then only highly original methods were likely to be effective. That is why so many of his figure compositions fail to work in the way he intended.

An inner formal conflict, a style imprisoned within a moment of great change, unable to go backwards or forwards: is it these characteristics which make Schiele's art so fascinating and so disturbing? And is it that sense of being trapped, of being unable to move in any direction while everything outside is undergoing a great transformation that makes Schiele's art seem so relevant today?

Bibliography

The most important sources of unpublished documents relating to Schiele are the Egon Schiele Archive, preserved in the Albertina, Vienna, and the Estate of Arthur Roessler in the Vienna City Library. Other Austrian museums, notably the Historisches Museum der Stadt Wien, also possess a small number of letters and other material.

Happily, a vast quantity of original and previously unpublished source material has recently been edited by Professor Christian M. Nebehay and appears in his *Egon Schiele, Leben, Briefe, Gedichte* (Salzburg and Vienna 1979), a richly illustrated book which contains biographies of all those associated with the artist, examples of his verse and a full biographical commentary. It is an essential tool.

Also essential are the two extensive catalogues of Schiele's oeuvre: Otto Kallir-Nirenstein, *Egon Schiele, Oeuvre-Katalog der Gemälde* (Vienna 1966) and Rudolf Leopold, *Egon Schiele, Gemälde, Aquarelle, Zeichnungen* (Salzburg 1973). A catalogue raisonné of the drawings, a monumental task, is overdue but there is a catalogue raisonné of Schiele's limited print production: Otto Kallir, *Egon Schiele, das druckgraphische Werk* (Vienna 1970).

Many personal reminiscences of the artist and appreciations of his work by contemporaries have appeared in both book and magazine form. These are the most rewarding: Heinrich Benesch, *Mein Weg mit Egon Schiele* (New York 1965); Otto Benesch, *Egon Schiele als Zeichner* (Vienna 1950) and 'Egon Schiele' in *Art International*, II, 1958–59, Nos. 9 & 10; Anton Faistauer, *Neue Malerei in Österreich, Betrachtungen eines Malers* (Vienna 1923); Paris von Gütersloh, *Egon Schiele, Versuch einer Vorrede* (Vienna 1911); Fritz Karpfen ed., *Das Egon-Schiele-Buch* (Vienna 1921); Leopold Liegler, 'Egon Schiele' in *Die graphischen Künste*, 3, 1916, p. 70f; Arthur Roessler, *Erinnerungen an Egon Schiele* (Vienna 1922; 2nd edn 1948), 'In Memoriam Egon Schiele' in *Deutsche Kunst und Dekoration*, XLIV: I, 1919, p. 227f. Roessler also edited an edition of Schiele's writings, *Briefe und Prosa von Egon Schiele* (Vienna 1921) and what purports to be the artist's prison diary, *Egon Schiele im Gefängnis* (Vienna 1922). This document, of which no original manuscript exists, has been translated and edited

by Alessandra Comini in her *Schiele in Prison* (London and New York 1973). Two other articles by the artist's contemporaries are worthy of note: Hans Tietze, 'Egon Schiele', in *Die bildenden Künste*, II, 1919, p. 99f, and Herbert Waniek, 'Egon Schiele und ich' in *Ver*, 15 November 1917, p. 107f.

There are two important monographs. Alessandra Comini's *Egon Schiele's Portraits* (Berkeley, Los Angeles and London 1974) does considerably more than just discuss the portraits and remains the standard critical study in English. Erwin Mitsch's *Egon Schiele* (Salzburg and Vienna 1974) is much shorter but contains many stimulating descriptions of individual works and many fresh insights into Schiele's art and personality. It has also appeared as a paperback (Munich 1975) and in English translation as *The Art of Egon Schiele* (London 1975).

A brief but impressive study of a single painting has also appeared in Reclam's valuable series of *Bildmonografien*. It is Werner Hofmann's *Egon Schiele, Die Familie* (Stuttgart 1968).

Of the many articles about specific aspects of Schiele's life and work the following are especially enlightening: A. Comini, 'Egon Schieles Kriegstagebuch 1916' in *Albertina-Studien*, IV, 1966, p. 86f; R. Feuchtmüller, 'Egon Schieles Städtebilder von Stein an der Donau', in *Alte und moderne Kunst*, 103, 1969, p. 29f; Wolfgang Fischer, 'Egon Schiele als Miltärzeichner' in *Albertina-Studien*, IV, 1966, p. 70f, 'Unbekannte Tagebuchblätter und Briefe von Egon Schiele und Erinnerungen einer Wiener Emigrantin in London', in *Albertina-Studien*, II, 1964, p. 172f; Peter Selz, 'Egon Schiele' in *Art International* IV, 10, 1960, p. 39f; Kristian Sotriffer, 'Vincent van Gogh und sein Einfluss in Wien' in *Alte und moderne Kunst*, 74, 1964, p. 26f; and Alfred Werner, 'Schiele and Austrian Expressionism' in *Arts*, XXXV, 1, October 1960, p. 46f.

Those exhibition catalogues that are most valuable either for their reproductions, documentation or critical essays are: *Viennese Expressionism, 1910–1924*, Berkeley, University Art Gallery of the University of California, 1963; *Egon Schiele*, London, Marlborough Fine Art, 1964; *Gustav Klimt and Egon Schiele*, New York, The Solomon R. Guggenheim Museum, 1965; *II. Internationale der Zeichnung*, Darmstadt, Mathildenhöhe, 1967; *Egon Schiele – Gemälde*, Vienna, Österreichische Galerie, 1968; *Egon Schiele, Leben und Werk*, Vienna, Historisches Museum der Stadt Wien, 1968; *Gustav Klimt und Egon*

Schiele zum Gedächtnis ihres Todes vor 50 Jahren, Vienna, Albertina, 1968; *Egon Schiele and the Human Form*, Des Moines, Art Center, 1971.

One of the most curious of all the books relating to Schiele, and mentioned here only because of its curiosity value, is a novel, an uneasy mixture of sensationalized fact and pedestrian fiction, Siegfried Freiberg's *Ihr werdet sehen . . .* (Vienna 1967). It was later reissued as *Egon Schiele – wilder Trieb auf altem Stamm* (Vienna and Munich 1976).

Books about the art and architecture of Vienna during Schiele's lifetime are too numerous to mention. Two studies in English must suffice. They are: Nicolas Powell, *The Sacred Spring: The Arts in Vienna 1898–1918* (London 1974) and Peter Vergo, *Art in Vienna 1898–1918* (London 1975).

General historical studies, autobiographies and other reminiscences of Imperial Vienna which touch on cultural matters or deal with them extensively are even more numerous. The following are especially stimulating: Ilsa Barea, *Vienna* (London 1966); Edward Crankshaw, *Vienna: The Image of a City in Decline* (London and New York 1938); Allan Janik and Stephen Toulmin, *Wittgenstein's Vienna* (London and New York 1973); Helene von Nostitz-Wallwitz, *Aus dem alten Europa* (Hamburg 1964) and Stefan Zweig, *The World of Yesterday* (New York 1943).

List of illustrations

207

8 Oskar Kokoschka, illustration for his play, *Mörder, Hoffnung der Frauen* (Murderer, the Hope of Women), performed at the 1908 *Kunstschau*. From *Der Sturm*, 14 July 1910

9 Josef Maria Olbrich, Vienna Secession Building, 1898. For *Ver Sacrum*, 1898

10 Gustav Klimt, 1912/14. Photo Österreichische Nationalbibliothek, Vienna

11 Gustav Klimt, *Adele Bloch-Bauer*, 1907. Oil on canvas, $74\frac{3}{4} \times 74\frac{3}{4}$ (190×190). Österreichische Galerie, Vienna

12 Wiener Werkstätte signet, *c.* 1905. Design by Josef Hoffmann

13 Postcard of Tulln, 1898. Photo Graphische Sammlung Albertina, Vienna

14 Drawing of trains, *c.* 1898. Pencil. Anton Peschka collection

15 Schiele with his mother and sister Gerti, *c.* 1903. Photo Graphische Sammlung Albertina, Vienna

16 *Klosterneuburg*, 1906. Gouache on cardboard, $14\frac{1}{2} \times 18\frac{1}{8}$ (37×46). Niederösterreichisches Landesmuseum, Vienna

17 *Self-portrait*, 1906. Charcoal, $17\frac{3}{4} \times 13\frac{3}{4}$ (45.5×35). Graphische Sammlung Albertina, Vienna

18 *The artist's guardian*, 1906. Charcoal, $17\frac{1}{2} \times 13\frac{5}{8}$ (44.6×35.5). Graphische Sammlung Albertina, Vienna

19 Academy class, Schillerplatz, Vienna, June 1907. Photo courtesy Wolfgang Fischer

20 Birthday greeting for Marie Czihaczek, 1907. Ink and watercolour, $8\frac{1}{2} \times 8\frac{1}{4}$ (21.5×21). Anton Peschka collection

21 Gustav Klimt, illustration for *Ver Sacrum*, 1900: 'To thine own self be true: the ages will be true to thee.'

22 *Young woman in a black dress*, 1907. Oil on canvas, 12×10 (30×25). Oberösterreichisches Landesmuseum, Linz

23 *Sunflowers*, 1907. Oil on paper, $17\frac{3}{8} \times 13$ (44×33). Niederösterreichisches Landesmuseum, Vienna

24 *Trieste harbour*, 1907. Oil on cardboard, $9\frac{3}{4} \times 7\frac{1}{4}$ (25×18). Neue Galerie am Landesmuseum Joanneum, Graz

25 Drawing for a Wiener Werkstätte postcard, 1908. Ink and wash, $6\frac{1}{4} \times 3\frac{3}{4}$ (15.5×9.9). Graphische Sammlung Albertina, Vienna

26 Wiener Werkstätte postcard, after a drawing of Gerti Schiele. Graphische Sammlung Albertina, Vienna

27 *Meadow with flowers and trees*, 1908. Pencil, watercolour and gouache, $11\frac{1}{2} \times 15\frac{3}{4}$ (29×40). Anton Peschka collection

28 *Madonna and child*, 1908. Coloured chalks, $23\frac{5}{8} \times 17\frac{1}{4}$ (60×43.5). Niederösterreichisches Landesmuseum, Vienna

29 Oskar Kokoschka, *Pietà*, lithograph poster for the garden theatre at the 1908 *Kunstschau*. Österreichisches Museum für angewandte Kunst, Vienna

30 *Hans Massmann*, 1909. Oil on canvas, $47\frac{1}{4} \times 43\frac{1}{4}$ (120×110). Private collection

31 *Woman with a black hat*, 1909. Oil with gold and silver leaf on canvas, $39\frac{3}{8} \times 39\frac{1}{4}$ (100×99.9). Private collection. Photo Fischer Fine Art Ltd, London

32 *Danae*, 1909. Oil on canvas, $31\frac{1}{2} \times 49\frac{1}{4}$ (80×125). Private collection

33 *Nude self-portrait*, 1909. Oil on canvas, $29 \times 11\frac{1}{2}$ (73.5×29.2). Private collection. Photo Marlborough Fine Art Ltd, London

34 *Self-portrait*, 1909. Coloured crayon on paper, $15\frac{3}{4} \times 7\frac{3}{4}$ (40.2×20). Historisches Museum der Stadt Wien

35 *Sunflower*, 1909. Oil on canvas, $59 \times 11\frac{3}{4}$ (150×29.8). Graphische Sammlung Albertina, Vienna

36 *Plum tree with fuchsias*, c. 1909. Oil on canvas, $35\frac{3}{4} \times 35\frac{3}{4}$ (90.5×90.5). Hessisches Landesmuseum, Darmstadt

37 Oskar Kokoschka, *Herwarth Walden*, 1910. Oil on canvas, $39\frac{3}{8} \times 26\frac{3}{4}$ (100×68). Staatsgalerie, Stuttgart

38 Richard Gerstl, *Self-portrait laughing*, 1907. Oil on board, $15\frac{3}{4} \times 11\frac{3}{4}$ (40×30). Österreichische Galerie, Vienna

39 Oskar Kokoschka, *The juggler's daughter*, 1908. Pencil and watercolour, $17\frac{1}{2} \times 12\frac{1}{4}$ (42×29). Private collection. Photo Fischer Fine Art Ltd, London

40 *Three street urchins*, 1910. Pencil, $17\frac{5}{8} \times 12\frac{1}{4}$ (44.8×30.8). Graphische Sammlung Albertina, Vienna

41 *Seated nude girl*, 1910. Pencil and gouache, $17\frac{5}{8} \times 11\frac{3}{4}$ (44.8×29.9). Graphische Sammlung Albertina, Vienna

42 *Girl with striped stockings*, 1910. Gouache, $12\frac{3}{8} \times 17\frac{3}{8}$ (31.5×44). Private collection. Photo Marlborough Fine Art Ltd, London

43 *The scornful woman*, 1910. Chalk, watercolour and gouache, $16 \times 12\frac{3}{8}$ (40.5×31.4). Anton Peschka collection

44 *Arthur Roessler*, 1910. Oil on canvas, $39 \times 39\frac{1}{8}$ (99.6×99.8). Historisches Museum der Stadt Wien

45 *Heinrich Benesch*, 1917. Chalk and gouache, $18 \times 11\frac{1}{4}$ (45.8×28.5). Graphische Sammlung Albertina, Vienna

46 *A hill near Krumau*, 1910. Watercolour, $12\frac{1}{4} \times 17\frac{1}{2}$ (30.9×44.3). Graphische Sammlung Albertina, Vienna

47 Moa and Erwin Osen. Photo Deutsches Theatermuseum, Munich

48 *Erwin Osen*, 1910. Black chalk and watercolour, $15 \times 11\frac{5}{8}$ (38×29.6). Neue Galerie am Landesmuseum Joanneum, Graz

49 *Erwin Osen*, 1910. Black chalk and gouache, $17\frac{3}{4} \times 12\frac{1}{4}$ (44.5×31.5). Private collection. Photo Fischer Fine Art Ltd, London

50 *Herbert Rainer*, 1910. Oil on canvas, $39\frac{1}{2} \times 39\frac{1}{8}$ (100.3×99.8). Österreichische Galerie, Vienna

51 Edvard Munch, *Puberty*, 1895. Oil on canvas, $59\frac{5}{8} \times 43\frac{3}{8}$ (151.5×110). Nasjonalgalleriet, Oslo

52 *Eduard Kosmak*, 1910. Oil on canvas, $39\frac{3}{8} \times 39\frac{3}{8}$ (100×100). Österreichische Galerie, Vienna

53 *Poldi Lodzinsky*, 1910. Pencil and gouache. $17\frac{3}{4} \times 11\frac{1}{4}$ (45×28.5). Thyssen-Bornemisza collection, Castagnola-Lugano

54 *Max Oppenheimer*, 1910. Pencil, ink and watercolour, $17\frac{3}{4} \times 11\frac{3}{4}$ (45×29.9). Graphische Sammlung Albertina, Vienna

55 *Karl Zakovsek*, 1910. Oil on canvas, $39\frac{3}{8} \times 35\frac{3}{8}$ (100×89.8). Albert W. Grokoest collection

56 *Self-portrait standing*, 1910. Pencil and watercolour, $22 \times 14\frac{1}{2}$ (55.7×36.8). Graphische Sammlung Albertina, Vienna

57 *Self-portrait with tooth*, 1910. Pencil and gouache, $17\frac{3}{8} \times 10\frac{3}{4}$ (44×27.8). Private collection. Photo Phaidon Press Archive

58 *Self-portrait pulling cheek*, 1910. Black chalk, watercolour and gouache, $17\frac{1}{2} \times 12$ (44.3×30.5). Graphische Sammlung Albertina, Vienna

59 *Self-portrait drawing a nude model in front of a mirror*, 1910. Pencil, $20\frac{1}{8} \times 12\frac{3}{4}$ (51×32.5). Graphische Sammlung Albertina, Vienna

60 *Seated girl*, 1910. Pencil, $22 \times 14\frac{1}{2}$ (56×37). Neue Galerie am Landesmuseum Joanneum, Graz

61 *Reclining woman*, 1911. Pencil and gouache, $12\frac{3}{8} \times 17\frac{3}{4}$ (31.5×44). Fischer Fine Art Ltd, London

62 *Reclining girl*, 1910. Pencil, $21\frac{3}{4} \times 14\frac{1}{2}$ (55.7×37). Neue Galerie am Landesmuseum Joanneum, Graz

63 *Standing nude girl*, 1910. Pencil and watercolour, $21\frac{3}{8} \times 12\frac{1}{8}$ (54.3×30.7). Graphische Sammlung Albertina, Vienna

64 Félicien Rops, *Serre-Fesse*. Etching.

65 Viennese postcard, *c*. 1910. Author's collection

66 *Seated young girl*, 1910. Watercolour and gouache, $21\frac{3}{8} \times 12\frac{1}{8}$ (54.3×30.7). Graphische Sammlung Albertina, Vienna

67 *Nude girl with crossed arms*, 1910. Black chalk and watercolour, $17\frac{5}{8} \times 11\frac{1}{8}$ (44.8×28). Graphische Sammlung Albertina, Vienna

68 Gustav Klimt, *Naked woman turning to the right*, 1913. Pencil, $22\frac{1}{4} \times 13\frac{3}{4}$ (56.5×35). Viktor Fogarassy collection

69 Gustav Klimt, *Judith*, 1901. Oil on canvas, $30\frac{5}{8} \times 16\frac{1}{2}$ (84×42). Österreichische Galerie, Vienna

70 *Wally in red blouse lying on her back*, 1913. Pencil, watercolour and tempera, $12\frac{1}{2} \times 19\frac{1}{4}$ (31.5×49). Private collection, courtesy Serge Sabarsky Gallery

71 *Wally*, 1912. Pencil and gouache, $11\frac{5}{8} \times 10\frac{1}{4}$ (29.7×26). Private collection. Photo Galerie im Griechenbeisl, Vienna

72 *The artist's room in Neulengbach*, 1911. Oil on board, $15\frac{3}{4} \times 12\frac{1}{2}$ (40×31.7). Historisches Museum der Stadt Wien

73 *Self-portrait with black clay vase*, 1911. Oil on wooden panel, $10\frac{3}{4} \times 13\frac{3}{8}$ (27.5×34). Historisches Museum der Stadt Wien

74 *Dead Town*, 1911. Oil on wooden panel, $14\frac{1}{2} \times 11\frac{3}{4}$ (37.1×29.9). Private collection. Photo Fischer Fine Art Ltd, London

75 Gustav Klimt, *Schloss Kammer on the Attersee*, 1910. Oil on canvas, $43\frac{1}{4} \times 43\frac{1}{4}$ (110×110). Österreichische Galerie, Vienna

76 *Dead Mother*, 1910. Oil on board, $12\frac{3}{4} \times 10\frac{1}{8}$ (32.4×25.8). Private collection. Photo Fischer Fine Art Ltd, London

77 *Pregnant woman and Death*, 1911. Oil on canvas, $39\frac{1}{2} \times 39\frac{3}{8}$ (100.3×100.1). Narodní Galerie, Prague

78 *The prophet*, 1911. Oil on canvas, $43\frac{1}{2} \times 19\frac{3}{4}$ (110.3×50.3). Private collection. Photo Marlborough Fine Art Ltd, London

79 *The self-seers*, 1911. Oil on canvas, $31\frac{5}{8} \times 31\frac{1}{2}$ (80.3×80). Private collection. Photo Marlborough Fine Art Ltd, London

80 Ferdinand Hodler, *Truth*, 1902. Oil on canvas, $77\frac{1}{8} \times 107\frac{1}{2}$ (196×273). Kunsthaus, Zurich

81 *Nude against coloured background*, 1911. Pencil, watercolour and gouache, $19 \times 12\frac{1}{4}$ (48×31). Private collection. Photo Fischer Fine Art Ltd, London

82 Sketch for *Nude against coloured background*, 1911. Pencil, $18\frac{3}{4} \times 12\frac{3}{8}$ (48.2×31.5). Anton Peschka collection

83 *Nude with mauve stockings*, 1911. Watercolour, $17\frac{3}{4} \times 12\frac{3}{8}$ (45×31.4). Private collection. Photo Marlborough Fine Art Ltd, London

84 *Two women*, 1911. Watercolour, 11×15 (28×38). Private collection. Photo Fischer Fine Art Ltd, London

85 *Self-portrait masturbating*, 1911. Watercolour, $18\frac{3}{4} \times 12\frac{3}{8}$ (48×32.1). Graphische Sammlung Albertina, Vienna

86 *Self-portrait as prisoner*, 1912. Pencil and watercolour, $12\frac{1}{2} \times 19\frac{1}{4}$ (31.7×48.7). Graphische Sammlung Albertina, Vienna

87 *Self-portrait as prisoner*, 1912. Pencil and watercolour, $12\frac{1}{2} \times 18\frac{3}{4}$ (31.8×48.2). Graphische Sammlung Albertina, Vienna

88 *Self-portrait as prisoner*, 1912. Pencil and watercolour, $15\frac{1}{8} \times 12\frac{1}{2}$ (38.2×31.7). Graphische Sammlung Albertina, Vienna

89 *Autumn tree*, 1912. Oil on canvas, $31\frac{1}{2} \times 31\frac{1}{2}$ (80×80). Private collection. Photo Fischer Fine Art Ltd, London

90 *Ida Roessler*, 1912. Oil on wooden panel, $12\frac{1}{2} \times 15\frac{1}{2}$ (31.6×39.4). Historisches Museum der Stadt Wien

91 *Agony*. 1912. Oil on canvas, $27\frac{1}{2} \times 31\frac{1}{2}$ (70×80). Neue Pinakothek, Munich

92 Gustav Klimt, *The kiss*, 1907–8. Oil on canvas, $74\frac{3}{4} \times 70\frac{3}{4}$ (189.9×180). Österreichische Galerie, Vienna

93 *Cardinal and nun*, 1912. Oil on canvas, $27\frac{1}{2} \times 31\frac{1}{2}$ (69.8×81.1). Private collection

94 *The hermits*, 1912. Oil on canvas, $71\frac{1}{4} \times 71\frac{1}{8}$ (181×180.5). Private collection. Photo Fischer Fine Art Ltd, London

95 *Erich Lederer*, 1913. Pencil and watercolour, $18\frac{3}{4} \times 12\frac{5}{8}$ (48.1×32.1). Graphische Sammlung Albertina, Vienna

96 *The bridge*, 1913. Oil on canvas, $35\frac{1}{4} \times 35\frac{3}{8}$ (89.7×90). Private collection. Courtesy Galerie St Etienne, New York

97 *Self-portrait with model*, 1913. Oil on canvas, $27\frac{1}{2} \times 95\frac{1}{2}$ (70×241). Private collection, courtesy Serge Sabarsky Gallery

98 Sketch for *Heinrich and Otto Benesch*, 1913. Pencil, $18\frac{1}{2} \times 12\frac{3}{4}$ (47×32.4). Private collection. Photo Marlborough Fine Art Ltd, London

99 *Heinrich and Otto Benesch*, 1913. Oil on canvas, $47\frac{5}{8} \times 51\frac{1}{8}$ (121×130). Neue Galerie der Stadt Linz/Wolfgang Gurlitt-Museum

100 *Arthur Roessler*, 1914. Etching, $9\frac{3}{8} \times 12\frac{5}{8}$ (23.9×32). Photo Fischer Fine Art Ltd, London

101 Schiele, by Anton Trčka, 1914. Photo Graphische Sammlung Albertina, Vienna

102 Schiele in front of his mirror, by Johannes Fischer, 1915. Photo Graphische Sammlung Albertina, Vienna

103 Schiele with his collection, by Johannes Fischer, 1915. Photo Graphische Sammlung Albertina, Vienna

104 *Johannes Fischer*, 1918. Black chalk, $11\frac{5}{8} \times 18\frac{1}{8}$ (29.7×46.2). Historisches Museum der Stadt Wien

105 Schiele in his studio, by Johannes Fischer, 1915. Photo Historisches Museum der Stadt Wien

106 *Reclining woman with blond hair*, 1914. Pencil, watercolour and gouache, $19\frac{1}{8} \times 12\frac{1}{2}$ (48.5×31.7). Baltimore Museum of Art

107 *Reclining woman with legs apart*, 1914. Pencil and watercolour, $11\frac{3}{4} \times 18\frac{1}{2}$ (30.4×47.2). Graphische Sammlung Albertina, Vienna

108 *Seated woman with hand in hair*, 1914. Pencil and gouache, $19\frac{1}{8} \times 12\frac{3}{8}$ (48.5×31.4). Graphische Sammlung Albertina, Vienna

109 *Seated woman*, 1914. Pencil and watercolour, $19\frac{1}{8} \times 12\frac{5}{8}$ (48.5×32). Graphische Sammlung Albertina, Vienna

110 *Reclining woman with green stockings*, 1914. Watercolour, 32×48 (81.2×121.9). Private collection. Photo Fischer Fine Art Ltd, London

211

111 Friederike Beer, *c.* 1914. Photo courtesy Wolfgang Fischer

112 *Friederike Beer*, 1914. Oil on canvas, 74½ × 47½ (190 × 120.5). Private collection. Photo Fischer Fine Art Ltd, London

113 *Façade with windows*, 1914. Oil on canvas, 43½ × 55⅝ (110 × 140). Österreichische Galerie, Vienna

114 *Seated woman with elbows on knees*, 1914. Gouache, 19 × 12½ (48.3 × 32). Graphische Sammlung Albertina, Vienna

115 Poster for Arnot Gallery exhibition, 1914. 26⅜ × 19⅝ (67 × 50). Historisches Museum der Stadt Wien

116 Letter to Edith and Adele Harms, 10 December 1914. Pencil and coloured crayon. Graphische Sammlung Albertina, Vienna

117 *Edith Harms*, 1915. Oil on canvas, 70¾ × 43¼ (180 × 110). Haags Gemeentemuseum, The Hague

118 *Adele Harms reclining*, 1917. Watercolour, 17¾ × 11⅛ (45 × 28). Private collection. Courtesy Galerie St Etienne, New York

119 *Edith Harms adjusting her stocking*, 1916. Chalk, 19 × 12¼ (48 × 31). Private collection. Photo Marlborough Fine Art Ltd, London

120 *Embrace*, 1915. Pencil and gouache, 20⅝ × 16¼ (52.5 × 41.2). Graphische Sammlung Albertina, Vienna

121 *Two Women*, 1915. Watercolour, 12¾ × 19½ (32.8 × 49.7). Graphische Sammlung Albertina, Vienna

122 *Blind mother*, 1914. Oil on canvas, 39¼ × 47½ (99.5 × 120.4). Private collection. Photo Fischer Fine Art Ltd, London

123 *Mother with children and toys*, 1915. Oil on paper, 6¾ × 17⅛ (17.5 × 43.5). Neue Galerie der Stadt Linz/Wolfgang Gurlitt-Museum

124 *Mother and two children*, 1915. Oil on canvas, 59 × 62½ (150 × 158.7). Österreichische Galerie, Vienna

125 Oskar Kokoschka, *The tempest*, 1914. Oil on canvas, 71⅛ × 86⅝ (181 × 220). Kunstmuseum, Basle

126 *Death and the maiden*, 1915. Oil on canvas, 59 × 70¾ (150 × 180). Österreichische Galerie, Vienna

127 *Russian officer*, 1915. Pencil and gouache, 17⅝ × 12¾ (44.9 × 31.4). Graphische Sammlung Albertina, Vienna

128 *Sick Russian soldier*, 1915. Pencil and tempera, 17¼ × 11¼ (43.8 × 29.2). Private collection. Photo Fischer Fine Art Ltd, London

129 *Russian soldier*, 1916. Watercolour, 15¼ × 10¾ (39.4 × 27.3). Private collection. Photo Marlborough Fine Art Ltd, London

130 *Ruined mill at Mühling*, 1916. Oil on canvas, 42⅞ × 55⅛ (109 × 140). Niederösterreichisches Landesmuseum, Vienna

131 *View of Krumau*, 1916. Oil on canvas, 43½ × 55½ (110.5 × 141). Neue Galerie der Stadt Linz/Wolfgang Gurlitt-Museum

132 *Wachau on the Danube*, 1914. Oil on canvas, 39½ × 47½ (100.3 × 120.6). The Solomon R. Guggenheim Museum; gift, Mr and Mrs Mortimer M. Denker, New York

133 *Little town: Krumau on the Danube*, 1913. Oil on canvas, 34¾ × 34½ (88.3 × 87.6). Private collection. Photo Fischer Fine Art Ltd, London

134 *Self-portrait squatting*, 1916. Chalk and watercolour, 11⅞ × 18 (29.5 × 45.8). Graphische Sammlung Albertina, Vienna

135 *Johann Harms*, 1916. Oil on canvas, 54½ × 42½ (138.4 × 107.9). The Solomon R. Guggenheim Museum, New York

136 Cover of *Die Aktion*, 1916. Graphische Sammlung Albertina, Vienna

137 *Supply depot with civilian worker*, 1917. Black chalk, 18⅛ × 11⅝ (46.2 × 29.5). Private collection. Photo Marlborough Fine Art Ltd, London

138 *The dead Klimt*, 1918. Black chalk, 18½ × 11¾ (47.1 × 30). Anton Peschka collection

139 Poster for the Secession exhibition, 1918. Colour lithograph, 26¾ × 20¾ (68.3 × 53). Graphische Sammlung Albertina, Vienna

140 *The artist's mother*, 1918. Black chalk, 17¾ × 11⅝ (45 × 29.5). Graphische Sammlung Albertina, Vienna

141 *Crouching nude*, 1918. Black chalk, 18¾ × 12½ (47.5 × 21.5). Private collection. Photo Marlborough Fine Art Ltd, London

142 *Crouching nude*, 1918. Chalk, 17¾ × 11⅝ (45 × 29.5). Graphische Sammlung Albertina, Vienna

143 *Crouching nude*, 1918. Chalk, 18⅛ × 11¾ (46 × 29.7). Graphische Sammlung Albertina, Vienna

144 *The embrace*, 1917. Oil on canvas, 39⅜ × 67 (100 × 170.2). Österreichische Galerie, Vienna

145 *The family*, 1918. Oil on canvas, 59 × 59 (150 × 150). Österreichische Galerie, Vienna

146 *The artist's wife*, 1918. Oil on canvas, 55 × 43 (139.5 × 109.2). Österreichische Galerie, Vienna

147 Study for *The artist's wife*, 1917. Pencil and gouache, 18⅛ × 11⅝ (46 × 29.7). Graphische Sammlung Albertina, Vienna

148 Sketch for *Paris von Gütersloh*, 1918. Black crayon, 12½ × 12 (46.8 × 30). D. Thomas Bergen collection

149 *Paris von Gütersloh*, 1918. Oil on linen, 55⅛ × 43½ (140 × 110.4). The Minneapolis Institute of Arts; gift of the P. D. McMillan Land Company

150 *Reclining woman*, 1917. Oil on canvas, 37⅝ × 67¼ (95.5 × 171). Private collection. Photo Royal Academy of Arts, London

151 Still from the film *Egon Schiele das Leben des Malers*, written by Wolfgang Fischer and directed by John Goldschmidt, 1979. Reproduced by courtesy of ÖRF and ZDF.

Index